THE WORLD AT NIGHT

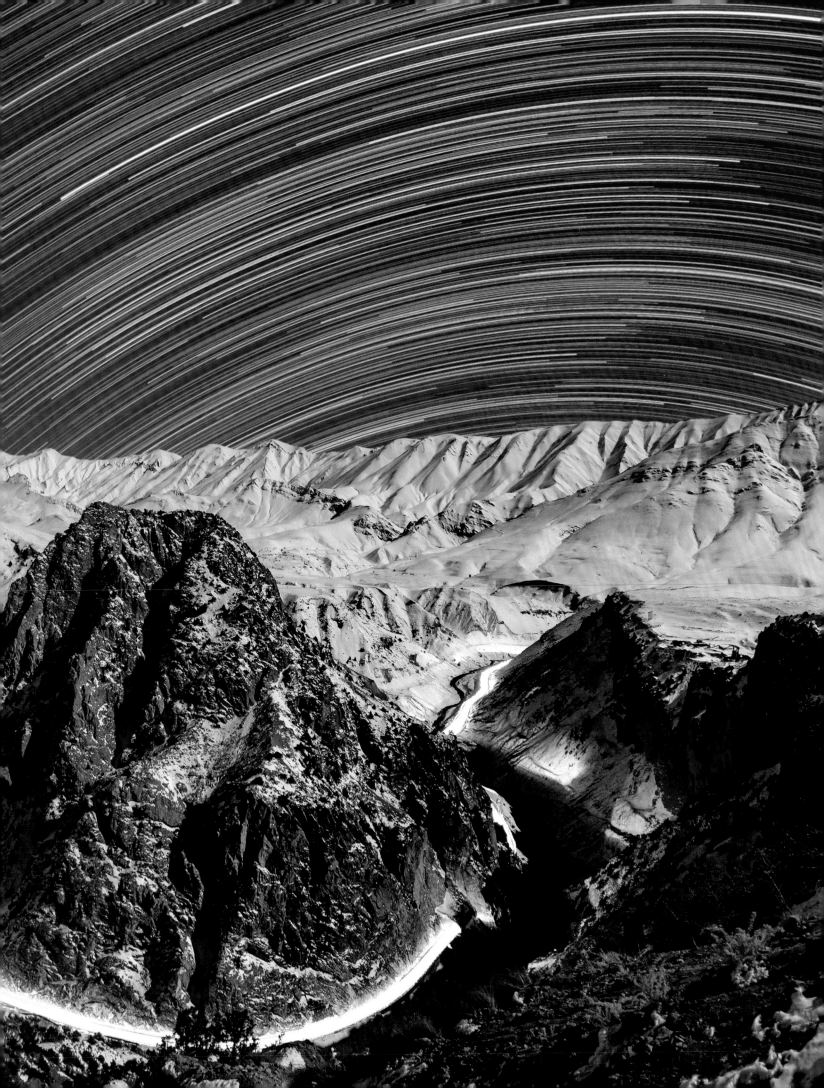

THE WORLD AT NIGHT

BABAK TAFRESHI

WHITE LION PUBLISHING

CONTENTS

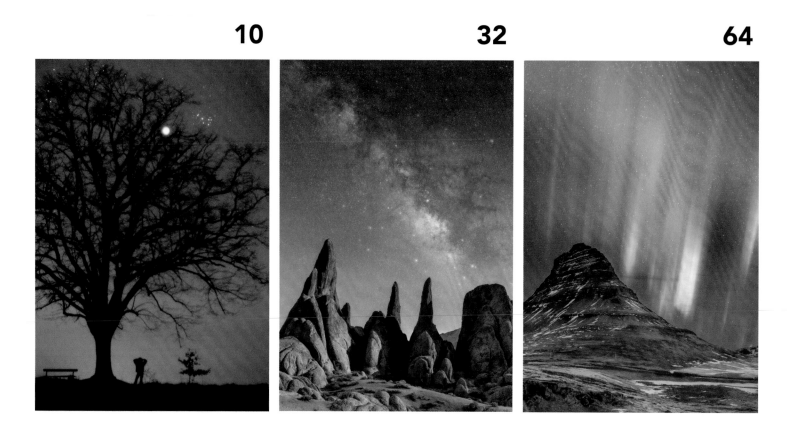

Our planet is embraced by one sky of endless beauties, an eternal roof above symbols of all nations and religions, attesting to the unified nature of Earth and mankind. The sky connects us through time and space, takes us back to our roots and shows us our future. It connects us with our ancestors and with others around the world.

Some of the most remarkable cultural and natural landmarks on the planet are listed by UNESCO as World Heritage Sites. The skies above these iconic sites resonate with the viewer on an instinctive level, while also revealing the well-known sites in a less familiar light.

These nightscapes show the hidden beauties of the world at night. Learn the basics of astronomy and stargazing, from the Milky Way and constellations in various seasons to planets and sky motions, the wonders of the southern sky, the colours of stars and spectacular auroras.

110 **162** **192**

CHAPTER 04

Events That Shook the World

Countless celestial events happening within our solar system (or inside our atmosphere) create a natural theatre above us. From Great Comets to spectacular eclipses, elegant conjunctions of the moon and planets to unusual atmospheric phenomena, these events often have great political and cultural impact, as well as increasing public awareness of astronomy.

CHAPTER 05

Fragile Beauty of Darkness

When we lose the night sky, we lose our connection with our past and future. These images show the importance of preserving the dark skies as part of our natural heritage, revealing the shocking difference between starry skies and the grey light-polluted urban sky that over half of the human population experiences.

CHAPTER 06

Dark Sky Refuges

A journey to the world's best night skies, from International Dark Sky parks to a growing number of other stargazing and astrotourism destinations seeking to reclaim our natural starry nights.

FOREWORD

BY DAVID MALIN

How things have changed.

I took some of my earliest photographs in the mid-1950s. They are in black and white and I processed them in a darkroom, using an enlarger to make prints. Colour film was available in those distant days, but it was both insensitive and expensive. Very few would think to use it to photograph the night sky, it was just too complicated and unrewarding. In any case the world at night appeared to be colourless and not very interesting, to a photographer at least. But here we have a book that celebrates the darkness, and its main purpose is to reveal the variety and colourful beauty of the night sky and the landscape beneath it. All that is needed today is an off-the-shelf digital camera, some skill, imagination and processing know-how to create inspiring and colourful images of the night – or of the dark of day, in the case of solar eclipse pictures.

Of course these scenes have always been there, if we had eyes to see them, but we don't. The eye loses its sense of colour once the sun is well below the horizon. The sun's light reflected by a full moon is no substitute; its feeble glow does not reveal to us the blue of the night sky or the colours of the moonlit landscape. The moonlit world appears as various shades of grey. However, the colours have not vanished; the grass and the leaves are still green and the walls of the Grand Canyon still glow in warm shades of red and yellow. Happily, however, while we cannot see the vanished colours, modern digital cameras can reveal a whole new, unexpected world of visual delight. The world at night is what we celebrate in these beautifully illustrated pages.

On one level you may enjoy these photographs as spectacular but unusual landscapes, where the images are captured by the light of the stars alone. Or perhaps you will be intrigued by night-time portraits of well-known cities or obscure ancient monuments where artificial light is an essential ingredient in the photograph. Many images combine a cityscape with the moon, either casting its light on the scene playing out before us, or appearing as an actor in the drama. Elsewhere, clouds are an important ingredient, perhaps lit from beneath

Born in England and living in Sydney since 1975, David Malin is widely considered the world's most accomplished astrophotographer. As a Photographic Scientist, using large telescopes in Australia's Siding Spring Observatory, his pioneering images merged front-edge science with the power of the art to revolutionize our understanding of the universe. They have been a visual source for astronomy communication globally.

davidmalin.com

or behind. In one example at least, the image is dominated by the shadow of a mountain at sunset, cast upon the very air we breathe.

All of the pictures in this beautifully produced book are eye-catching and, to my eyes at least, a few are minor works of art. Some, indeed, make my heart leap at what can be done in the wide outdoors with a camera and tripod, some imagination and an exposure of just a few seconds. But, however you look at them, these are not ordinary photographs of the world around us. Like all good drama, they make you think, long after the show is over.

The thoughts that come to me, inspired by these images, are all, in one way or another, connected to the way human life has transformed the planet we live on, for both good and bad. The bad is most obviously concerned with wasted resources. Though the images here are mostly concentrated on presenting scenes of the natural world, there is still plenty of evidence of light pollution. The contributors to this publication are mostly intrepid travellers. They have to be, to find the truly dark places where the night reveals its natural beauty. Almost any artificial light that illuminates the sky above represents wasted energy.

On a more positive note, the other thoughts that occur involve interpreting what these images reveal about the natural world, mainly through their amazing colours. Why, for instance, is the whole horizon yellow all the way around, when we see a total solar eclipse? And why is the moon such a deep red when it is totally eclipsed? The answer is the Earth's atmosphere of course, filtering and scattering sunlight, removing the shorter blue wavelengths of light. Many examples of light scattering are in these pages, beautifully portrayed. Scattered sunlight and the solar wind also give comet tails their subtle colours and graceful curve, and create the huge but elusive glow of the *gegenschein* long after sunset. Why are the aurorae coloured and often curved, and why don't we see them near the equator? Why does the ocean sometime glow blue, and what on earth is STEVE!? There is much more to see and question in these inspiring pages. Read on, and enjoy the how-to-do-it notes at the end. How things have changed!

INTRODUCTION

This world-exclusive night-sky collection is the work of an elite team of highly accomplished photographers from twenty countries. Between them, over the years, they have spent thousands of nights beneath the stars, recording nightscape scenes that are often missed by the rest of the world. This most diverse, carefully curated selection of images transports you to six continents, forty countries, and some of the most remote corners of the planet. Readers can enjoy these true nightscape photographs in the knowledge that all of the images are original and were made in accordance with the rules of documentary photography, which excludes the digital blending of images taken at different places or through different lenses. There are no added moons or manipulated skies! Many of the images are single-exposure captures or a series of photos stitched together to create a digital panorama. On the few occasions where a composite of various exposures has been made, and is due to technical limits or for its educational benefits, this is explained fully in the captions. The majority of images are fresh captures, taken in the last few years, but rare images of the most spectacular celestial phenomena in the past three decades also feature. These earlier photos were captured on film, as were the two accompanying this introduction.

Taking photos of the hidden Earth and the shining sky offers experiences that go beyond any technical or artistic enjoyment of photography. It builds a connecting bridge to the entire universe. I grew up in Tehran in the early 1990s and the first time I saw the moon through a small telescope, at the age of thirteen, it changed my life. Not long after, photographing nightscapes became my passion. Packing a simple, manual, film camera I would travel to villages in Iran, away from city lights, with Oshin Zakarian, a contributor to this book. The celestial views reminded us of our planet's cosmic standpoint, but also revealed how the night sky embraces the entire Earth – a uniting roof above all of us. In June 2001, I travelled to Africa to photograph the southern sky and a total solar eclipse. My companions were the German-French explorer couple Gernot Meiser and Pascale Demy, who explored the roads from Europe to Zambia producing a documentary on eclipse-chasing and its cultural connections. Photographers from several other nations joined us at the remote camp in Kafue National Park. One starry night, sitting around the camp fire, listening to occasional roars of faraway lions, I was struck by the diversity of our skin tones and languages, and visualized how a common passion for the night sky could bring peace and understanding between cultures.

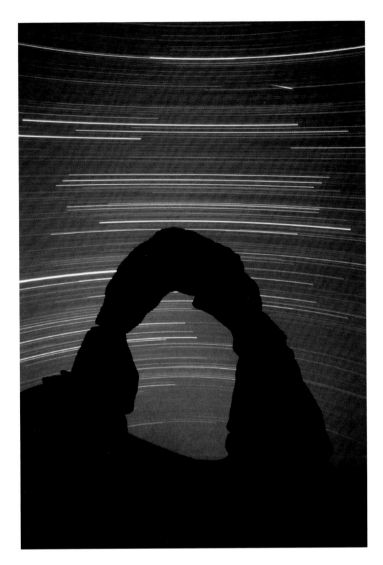

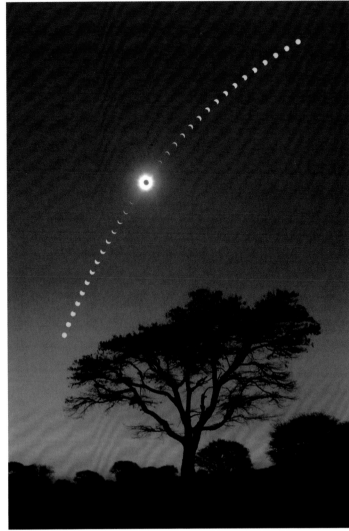

In the following years, I met other sky photographers with the same goal, and this led to the idea of transforming our random efforts into an international programme with a global voice. It finally became real when Astronomers Without Borders (AWB) was founded in 2006, by my colleague Mike Simmons. This US-based, nonprofit organization brings people together through their common interest in astronomy. The first programme in the AWB was to establish my brainchild idea of The World at Night, or TWAN, project in 2007. A dream team quickly formed and, two years later, UNESCO and the International Astronomical Union designated TWAN as the first special project for the International Year of Astronomy 2009. This recognition paved the way for a programme of exhibitions and public talks across the world. Today, the TWAN team continues to produce new images and to share its members' visual stories with the public. The World at Night images reach millions of people worldwide, allowing them to reclaim a night sky that most modern people have lost. It is work that calls to mind the beauty of the universe and human life on our planet. This neglected element of our lives can be reintroduced by better knowing the light pollution and how we can control it. It's been an amazing journey to establish this group that has now set a world standard for nightscape photography.

SEE MORE OF **THE WORLD AT NIGHT** PHOTOGRAPHY AT
WWW.TWANIGHT.ORG @TWANIGHT

[left]

Arches National Park, Utah USA

A single exposure of 3 hours on film captured stars of Orion (the Hunter) and Canis Major (the Big Dog) trailing above a beautiful sandstone arch, representing a natural window to the sky. A bright short meteor is captured at top right. The pink trail in the middle is the Orion Nebula.

[right]

Chisamba ZAMBIA

Two side-by-side cameras were used to create this dramatic multi-exposure composite of the June 2001 total solar eclipse above Chisamba, Zambia. One camera captured totality and a thorn acacia tree while the second camera recorded the partial phases at 5 minute intervals through a solar filter.

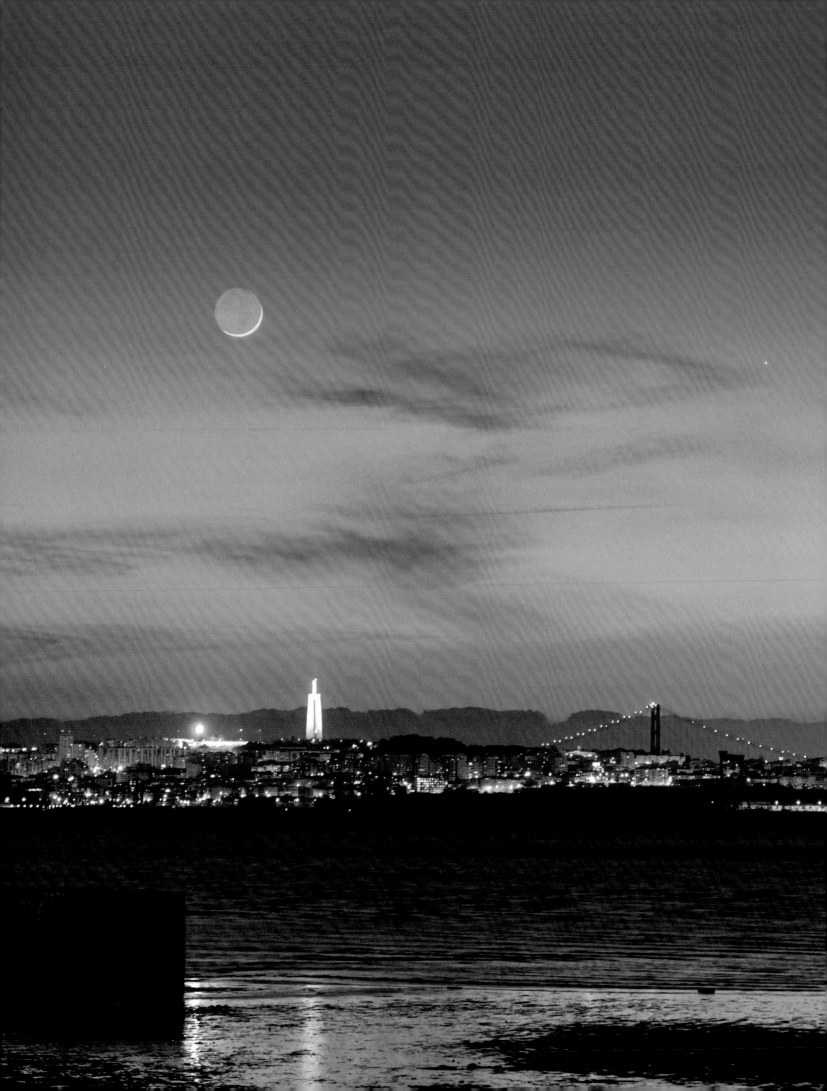

One People, One Sky

THERE IS MORE THAN BEAUTY CAPTURED IN THESE NIGHTSCAPE PHOTOGRAPHS - EACH IMAGE ALSO REVEALS A STORY.

Hovering in the Boston twilight, the elegant new moon beguiles onlookers just hours after skygazers in Iran have admired its thin form. That same crisp crescent hangs gracefully above the Vatican's domes, just as it inhabits the skies over Jerusalem's Temple Mount and the Shwedagon Pagoda in Myanmar. This single celestial element is a shared window for every one of us. Our moon connects us to distant cultures – to every poet, writer and artist who has been inspired by its mesmerizing glow. The same moon that appears in Vincent van Gogh's iconic painting 'The Starry Night' traverses our skies month after month, a new wonder for all to see. It skims the western horizon above the panoramic town of Safranbolu in Turkey; an hour later, it's bathing the shores of Hungary's Lake Balaton in romantic moonlight. Yet another hour passes, and with the arrival of sunset in Paris, the moon is shining in the dark-blue sky over the City of Light. Moments later, just before the fall of night starts its journey across the Atlantic Ocean, the sky above London is already dark, with the moon suspended beyond the capital's iconic Big Ben.

Elsewhere, in North America's Rocky Mountains, the magnificent Milky Way in zodiacal constellations Scorpius (the Scorpion) and Sagittarius (the Archer) spans the sky above the Grand Teton National Park. That same night, it glitters above Algeria's Tassili n'Ajjer National Park, with its endless sand dunes and giant rock formations, in a pitch-black moonless night deep in the Sahara Desert. In places unspoiled by light pollution, the Milky Way galactic core is still visible all the way across North Africa to the grasslands of Europe, though lower on the horizon.

Nightscapes capture far more than the beauty of the places they depict, for each image also reveals a story. There are tangible connections here, where the Earth meets the sky and art merges with science, but something more lies beyond. As a collection, these photographs connect the living with an ancient heritage,

charting past histories against the constancy of the night sky – the landmarks of civilizations long gone beneath the vast ocean of the universe.

Most poignant, perhaps, are the photographs made using long exposures and time-lapse sequences. In these scenes, the stars appear to fill the whole sky, leaving graceful circular trails as testimony to their long night of travel. With the camera directed at one of the poles, the concentric trails centre around it, creating an immensely bright rainbow of stars. These stunning scenes remind us that Earth is a planet within a solar system, permanently rotating on its own axis as well as pursuing its own path around the sun.

In the northern hemisphere, the familiar stars of Ursa Major (the Big Bear) circle the North Celestial Pole above an ancient pagoda in Nepal, just as they do over the otherworldly spires and buttes of Utah's Monument Valley in the United States. In the southern hemisphere, the smallest constellation in the entire sky, Crux (the Southern Cross), is the most familiar sight. On a crystal-clear night over the Pacific Ocean, from a hidden paradise in the Cook Islands, this constellation rises high above the southern horizon, its lowest star pointing towards the unmarked South Celestial Pole. Thousands of kilometres away, but on a similar latitude, the same constellation appears above the Atacama Desert in Chile. These views are shared by many, unhindered by borders or boundaries. Back on Earth, boundaries have long been associated with territory – fought over and shifted in the name of politics, religion, economy or race, but it is the view of our planet from space that reveals the true nature of our cosmic home – a borderless world divided only by land and sea. The same can be said in reverse: the night sky above us – a view that is accessible to every single person on the planet – has no visible borders either. Under this single roof, we all belong to one family inhabiting one single planet.

[previous]

Lisbon PORTUGAL
Planet Mercury and a thin crescent new moon low on the horizon at dusk above the Tagus River and the city lights of Lisbon.

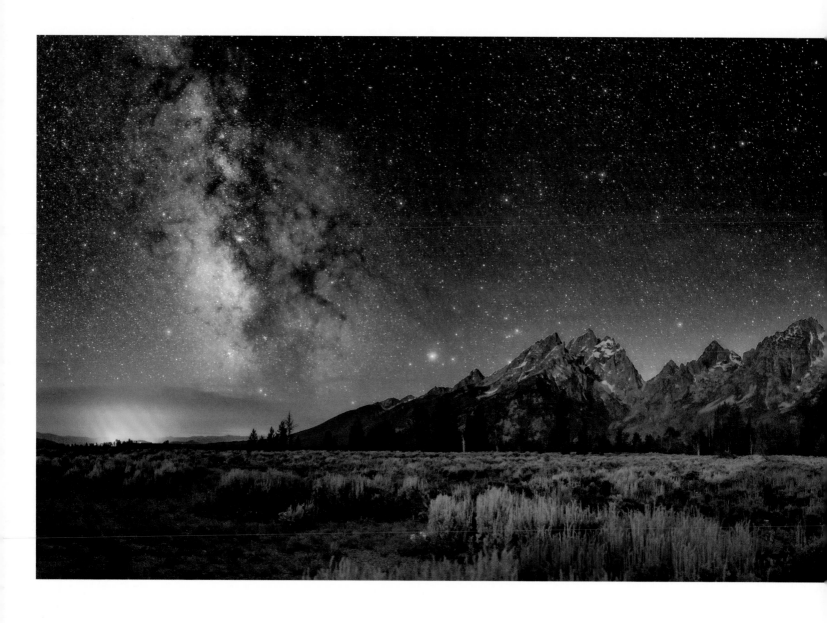

HORIZONS

For nightscape photographers, day-to-day life is far from conventional. They visit places when no one is around, entering national parks just as everybody else is leaving. A day's work begins as night starts to fall, often in freezing temperatures, while the rest of the world is settling down to a night's relaxation in front of the TV. But when there is true passion for the work, this absence of a normal lifestyle is a sacrifice worth making. For the nightscape photographer, the night sky is a second home. It brings opportunities for travel and forges deep-rooted connections with the natural world. Through their work, these photographers are also able to have a profound impact on others, inviting viewers to engage with a part of the natural world that so often goes unnoticed.

The US National Parks Night Sky Program has been incredibly successful in preserving starry skies above magnificent natural landscapes. In the state of Wyoming, the two large neighbouring parks, Grand Teton and Yellowstone, are fine examples of this. Far from any major cities and with very few streetlights in the area, the night skies stun visitors to this bear-inhabited territory, where the mountains and the galaxy roar together. One of the most compelling scenes is the rugged Teton mountain range in Wyoming, just one stretch of the Rocky Mountains that snake their way through western Canada and the United States. At 4,200 m (13,800 ft), Grand Teton is the tallest mountain in this range.

Grand Teton Mountains, Wyoming USA

A last-quarter moon rises at midnight in July, illuminating the Grand Teton Mountains, while the bright summer Milky Way, still prominently visible in constellations Scorpius (the Scorpion) and Sagittarius (the Archer), spreads out over the lights of nearby town Jackson. In the middle, burning brightly, is Arcturus and, on the right, facing north, is the Big Dipper, the prominent figure in the constellation Ursa Major. The green and red bands that resemble aurorae are in fact airglow – natural emissions in Earth's upper atmosphere.

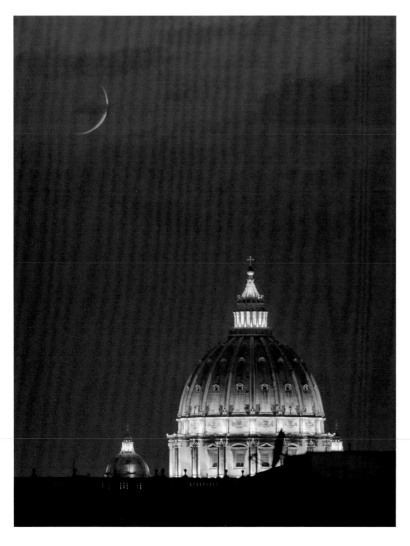

[above] **Vatican City** ITALY

For a brief moment after sunset, the thin crescent of a new moon appears between the clouds on the horizon above Vatican City. The moment is fleeting – captured here using a telephoto lens from a vantage point in Rome. The distance enables the photographer to align the rising moon perfectly with the massive 42 m (140 ft) dome of St Peter's Basilica.

[right] **Veszprém** HUNGARY

Sharing the wonders of the night sky with her child, a mother points to the new moon on the evening of the vernal (spring) equinox. The elegant triple conjunction of Venus (the brightest point), Mars and the crescent moon appears over the western horizon.

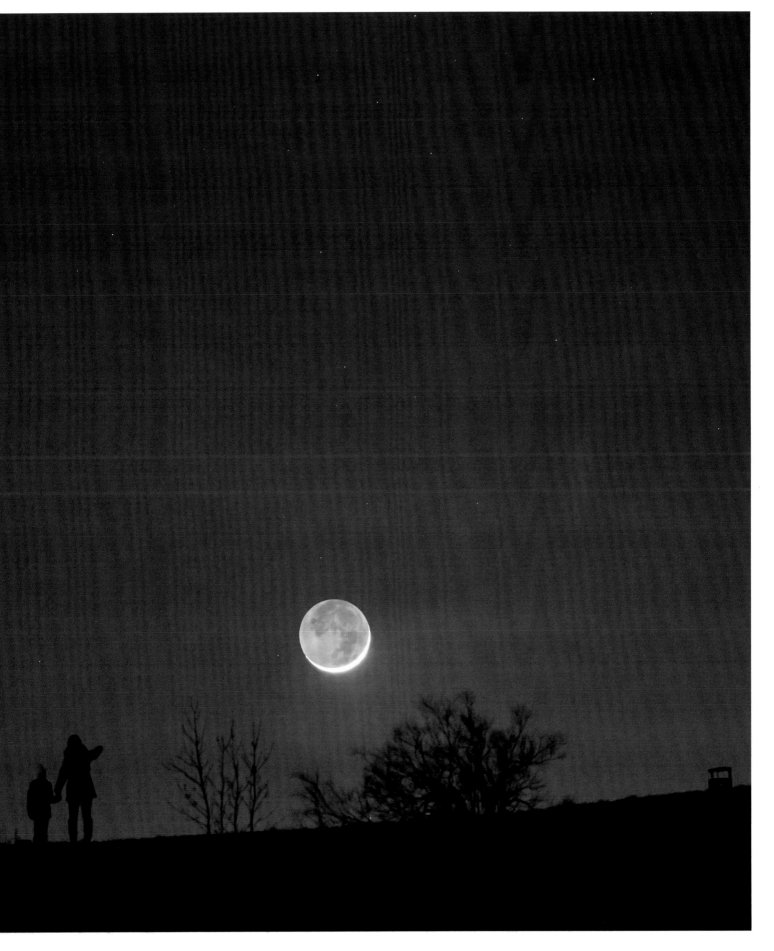

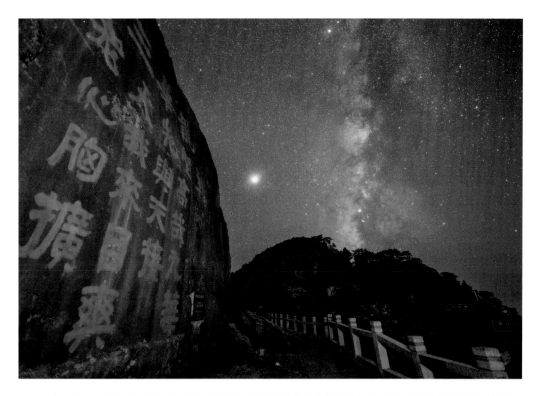

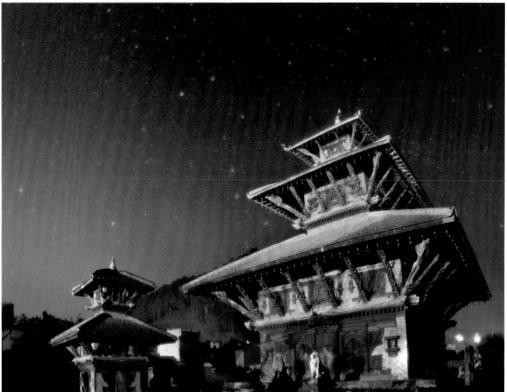

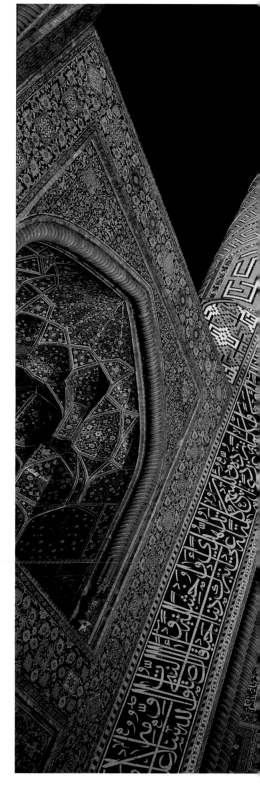

Mount Jiuhua CHINA [top]

Mars, at its brightest, and the summer Milky Way from Mount Jiuhua in Anhui province, one of the four sacred mountains of Chinese Buddhism. This rich landscape is known for its ancient temples. During the golden periods of the Ming and Qing dynasties (fourteenth–nineteenth centuries), there were as many as 360 temples. Some 5,000 monks and nuns may have gazed at this same view of the Milky Way on nights gone by.

Panauti NEPAL [bottom]

The Big and Little Dippers are a common sight in the northern hemisphere night sky, appearing closer to the horizon in low latitudes and almost overhead in the far north. These are the stars of Ursa Major and Ursa Minor, photographed here above the delicate wooden architecture of Indreshwar Temple, one of the largest and tallest pagoda-style temples in Nepal. Dating from 1294, it is also the oldest surviving temple in the country.

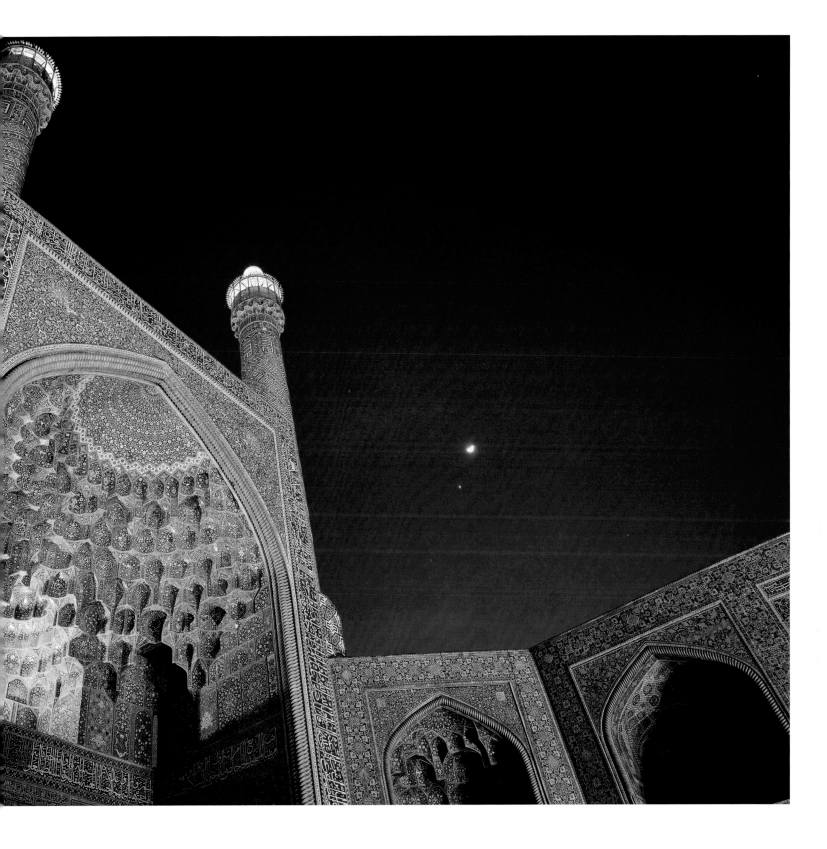

Isfahan

IRAN

In this wide-angle photograph, the conjunction of the moon and Venus is seen at dusk from the World Heritage site of Naghsh-e Jahan Square, Isfahan. On the southern edge of the square is the Shah Mosque (Royal Mosque), built during the Safavid period in the early seventeenth century, a masterpiece of Islamic architecture. Much of its splendour lies in the beauty of its seven-colour mosaic tiles and calligraphic inscriptions. The port of the mosque, itself measuring 27 m (90 ft) tall, is crowned with two minarets, each 42 m (140 ft) tall.

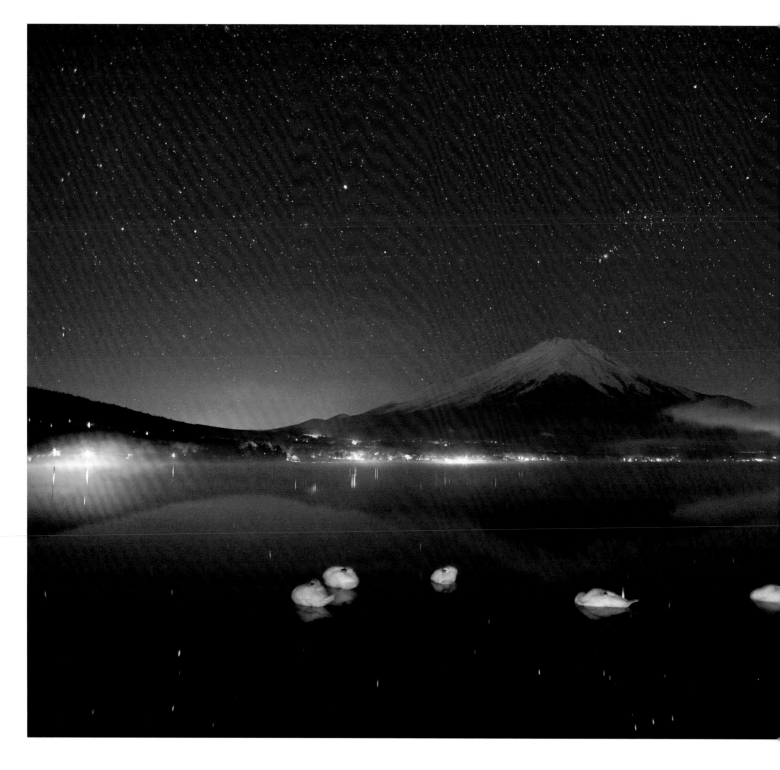

Mount Fuji JAPAN

Swans sleep on a lake in Yamanashi prefecture, Japan, with the symmetrical volcanic cone of Mount Fuji rising in the distance. A symbol of Japan and the highest mountain in the country at 3,800 m (12,400 ft), Mount Fuji last erupted 300 years ago. Above this early spring evening scene, stars of the winter constellations are about to set, from Taurus (right) to Orion (centre) and Canis Major (left) with its dazzling star, Sirius.

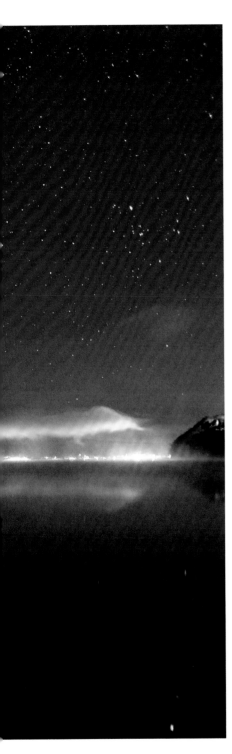

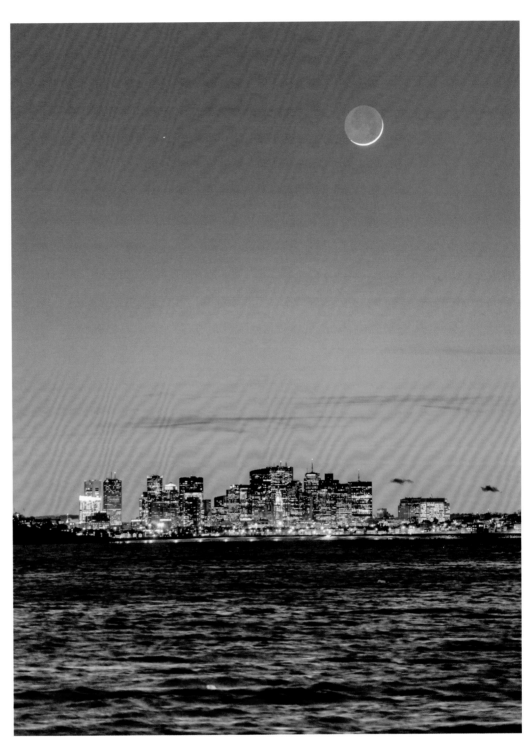

Boston, Massachusetts USA

A crystal-clear night begins with this colourful dusk and the new moon hanging above the Atlantic Ocean and Boston skyline, pictured here from several miles away. This photograph, made using a one-second exposure, reveals more than the thin crescent; it also shows the night-time darker face of the moon. Made visible due to the light emitting from Earth, it is easy to see with the naked eye when the sky becomes dark enough. This subtle light is called 'earthshine'. First described by Leonardo da Vinci in the sixteenth century, it is also known as the 'da Vinci glow'.

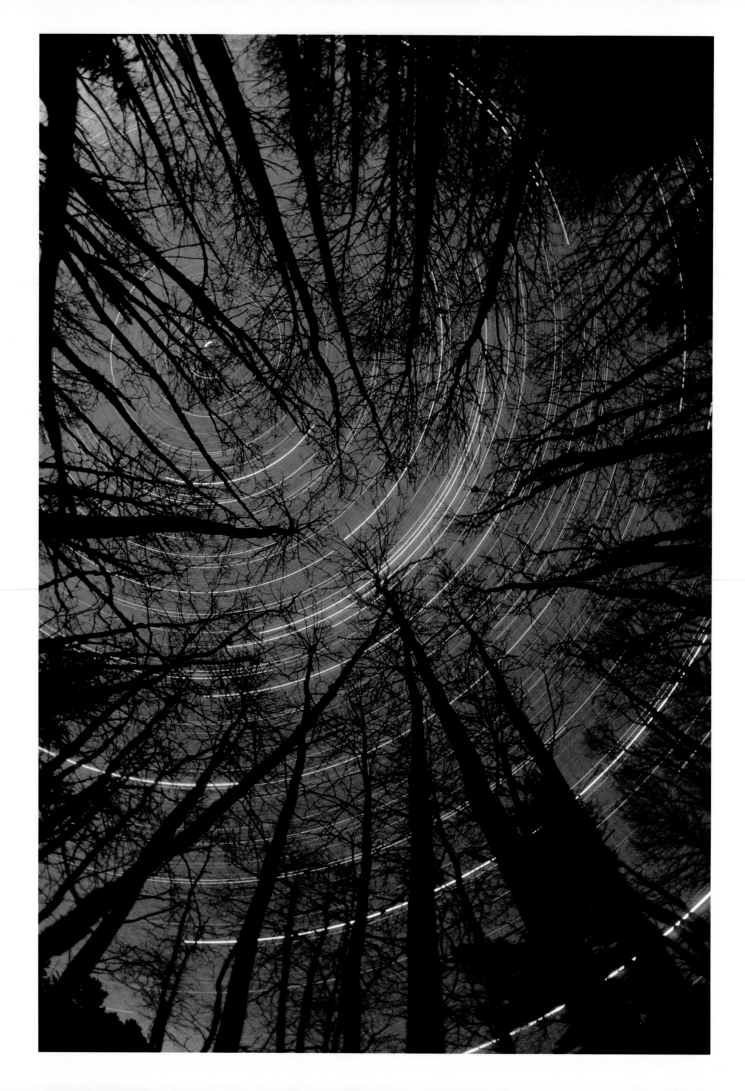

POLAR

Long-exposure photographs of the night sky create wonderful trails of stars. These unique visuals reinforce that timeless constancy of the sky above a world in which civilizations come and go. Freezing several hours of night-time in a single image, such photographs are bold illustrations of the nonstop passage of time, offering glimpses into our home planet's speedy rotation in space. Rarely do we consider, as we go about our daily lives, that Earth's rotation is transporting us faster than a jet aeroplane.

When directed towards the celestial north or south pole, a long-exposure view aligns with Earth's rotation axis, resulting in beautiful circumpolar star trails. In the northern hemisphere, the relatively bright star Polaris lies at the centre of these trails, whereas in the south the centre of the trails are empty, with no polar star. The location of the pole in these images gives an indication of latitude. The higher the pole in the image, the closer the location is to the polar latitudes. In the case of the North Pole, Polaris appears at zenith (overhead), and will be right on the horizon at the equator.

In technical terms, some of these photographs – such as the one featured opposite – are single, long exposures on film or have been made using a low-sensitivity setting on a digital sensor. Others have been made using time-lapse photography, where a series of shorter exposure photos are combined digitally to create the final image. This allows a higher sensitivity setting that reveals more stars. Very short individual exposures also help to avoid the glare of bright foregrounds and city skies.

Uusimaa FINLAND

On this exceptionally cold, clear, starry winter's night in a sub-Arctic forest, a five-hour single exposure on film captures sharp tree branches and the rotation of our planet above them. Photographed from a latitude of 60 degrees north, a few hours' drive from Helsinki, Polaris appears high in the sky. The exposure is long enough to show that even Polaris is affected by the sky's rotation – the North Star is not exactly on the pole, but about 1 degree away. Theoretically, had this exposure lasted a full twenty-four hours, and had the night been never-ending, the circles would be complete, formed by the 360-degree rotation of the planet.

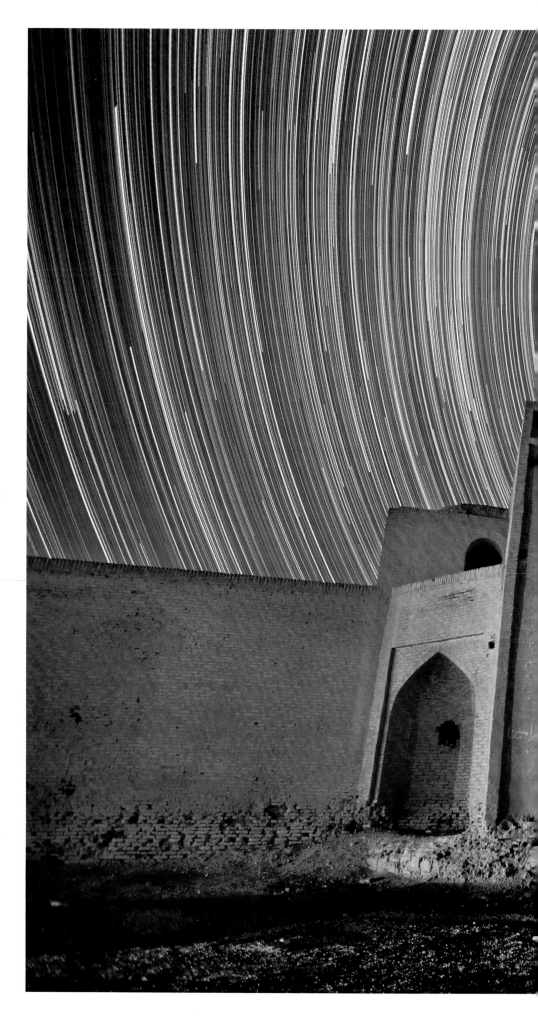

Damghan IRAN

This five-hour combined exposure of stars rotating around the geographic North Pole shows the Caravanserai of Qusheh at Damghan, Iran. It once stood on the edge of the ancient city of Qumis, which is now buried beneath the desert. Several hundred years ago, such roadside caravanserais were a common sight throughout the Middle East and central Asia, and provided resting places along the Silk Road – the network that supported the flow of commerce, information and people on principal trade routes between Asia, North Africa and southeastern Europe. Some 500 caravanserais remain in Iran today. Many of them were built during the reign of Shāh Abbas I of Persia, around 400 years ago.

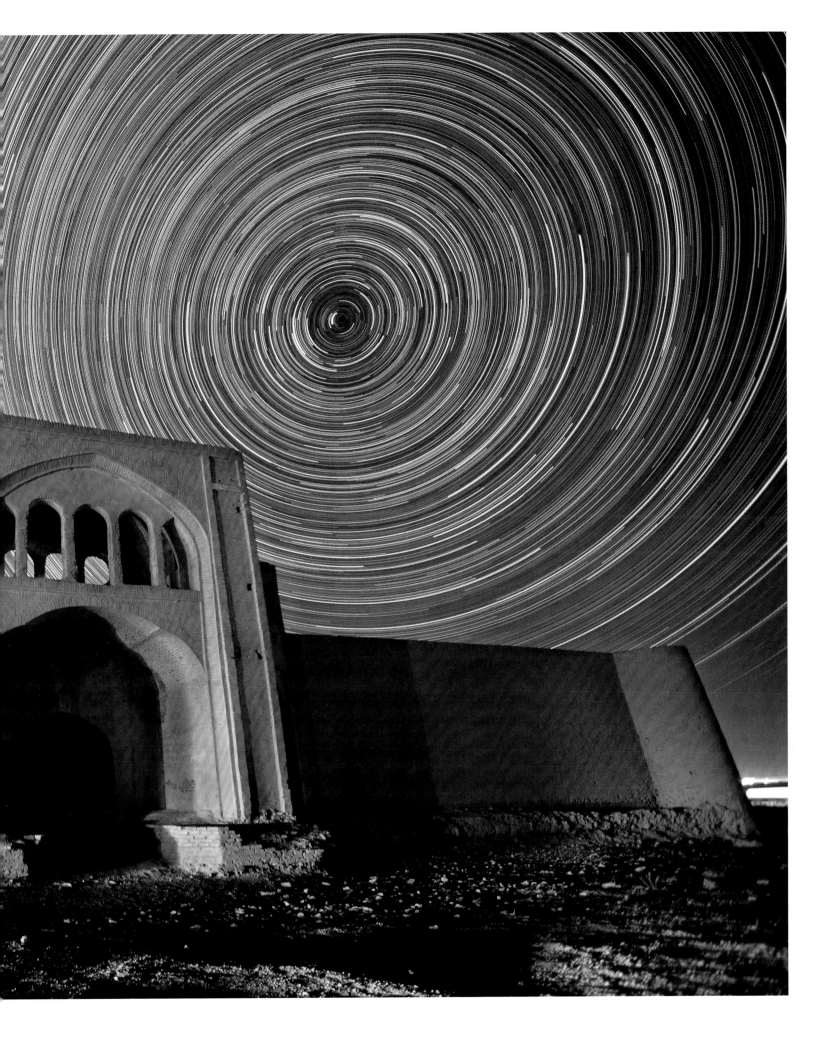

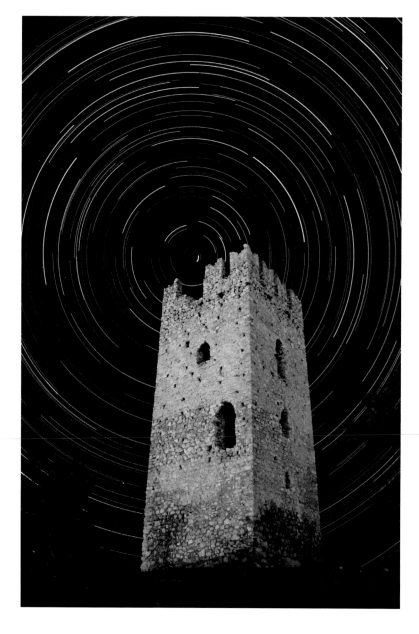

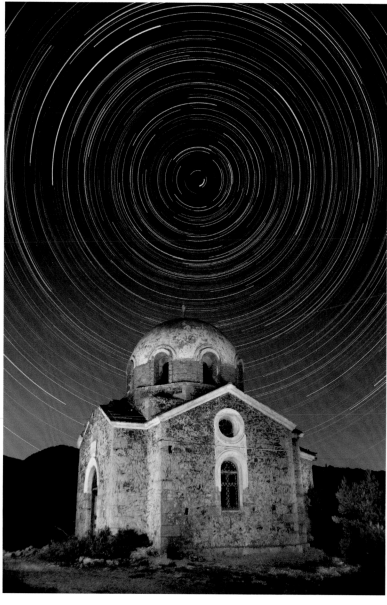

[above]

[opposite]

Euboea & Cape Sounion GREECE

Here are two similar polar star trails above Greek landmarks, each a three-hour combined exposure with Polaris near the centre. Both show clearly the various colours of the stars – a rough indication of their surface temperatures, with hotter blue stars and cooler red ones. On the left is a Byzantine-period watchtower at Mytikas on Greece's second-largest island, Euboea. On the right is the impressive abandoned Church of Saint Ioannis Prodromou from 1919, not far from the ancient Temple of Poseidon at Cape Sounion.

Paris FRANCE

Made from a sequence of short exposures, this image shows how it is possible, technically, to reveal stars in some of the world's largest and brightest cities on a clear, transparent night and at the right time. This particular image of Paris was made using shots taken from 2 a.m., a time when the lights of the Eiffel Tower and most other monuments in the city are turned off in order to save energy. The stars of the Big Dipper are visible to the left of the tower's top and Polaris is to the right.

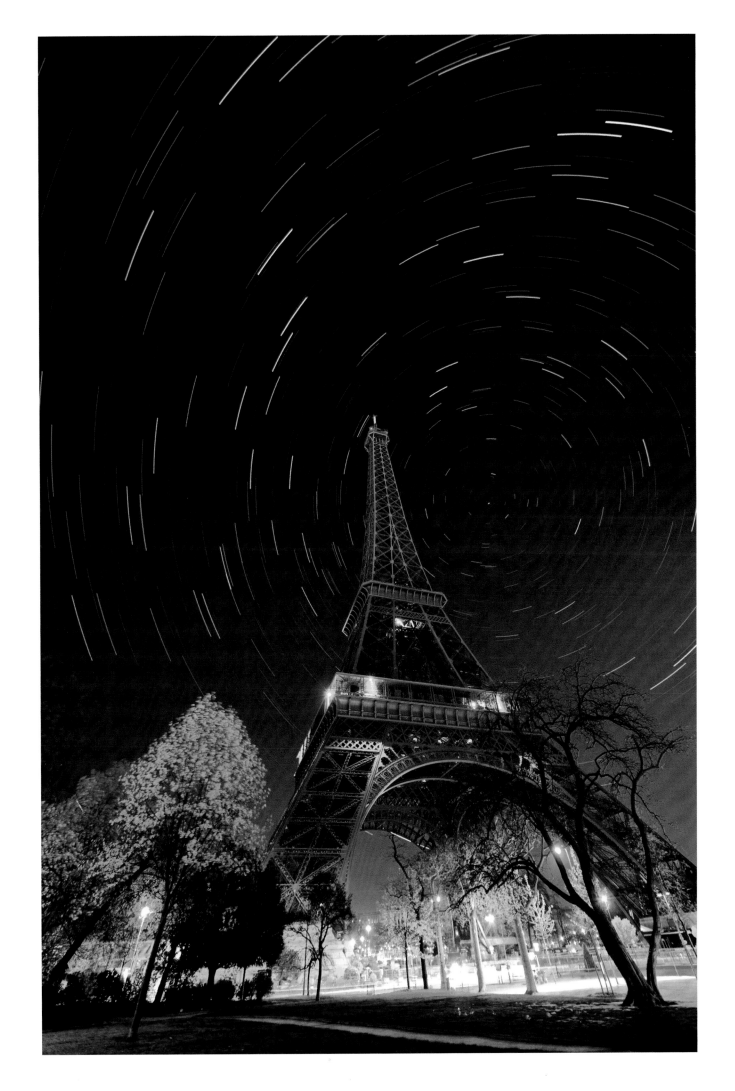

STARGAZING

We are connected to the night sky in many ways. It has always inspired people to wonder and to imagine. Since the dawn of civilization, our ancestors created myths and told legendary stories about the night sky, elements of which became embedded in the social and cultural identities of many generations. On a practical level, the night sky helped past generations to keep track of time and create calendars – essential to developing societies as aids to farming and seasonal gathering. For many centuries, it also provided a useful navigation tool, vital for commerce and for exploring new worlds. Even in modern times, many people in remote areas of the planet observe the night sky for such practical purposes.

The night sky is a freely available laboratory to all nations. It helps us to understand the universe and our place within it, to investigate our origin and our destiny. It inspires every individual to consider more than the here and now, to be curious beyond our physical needs and simply to be different from other species on this planet.

At the most basic level, the night sky forms half of our night-time environment. Its raw beauty resonates with anyone who cares for nature. Some simply enjoy gazing at the starry sky with the naked eye, not necessarily knowing the constellations, nor the physics behind the various celestial phenomena. Others are avid stargazers and amateur astronomers who passionately study every corner of the sky, growing to know it better than maps of their own cities. Regardless of our level of interest, our common passion for this unifying roof above our planet can break boundaries between us.

Färnebofjärden SWEDEN

On a late-summer's night, family members gaze at the night sky in a forest clearing at Färnebofjärden National Park. Some 140 km (90 miles) north of Stockholm, this spot beside the Dalälven River is far enough from the metropolitan lights to see a fairly dark sky. On this occasion, the family has a pair of binoculars and a small telescope to explore the sky beyond the limits of the naked eye.

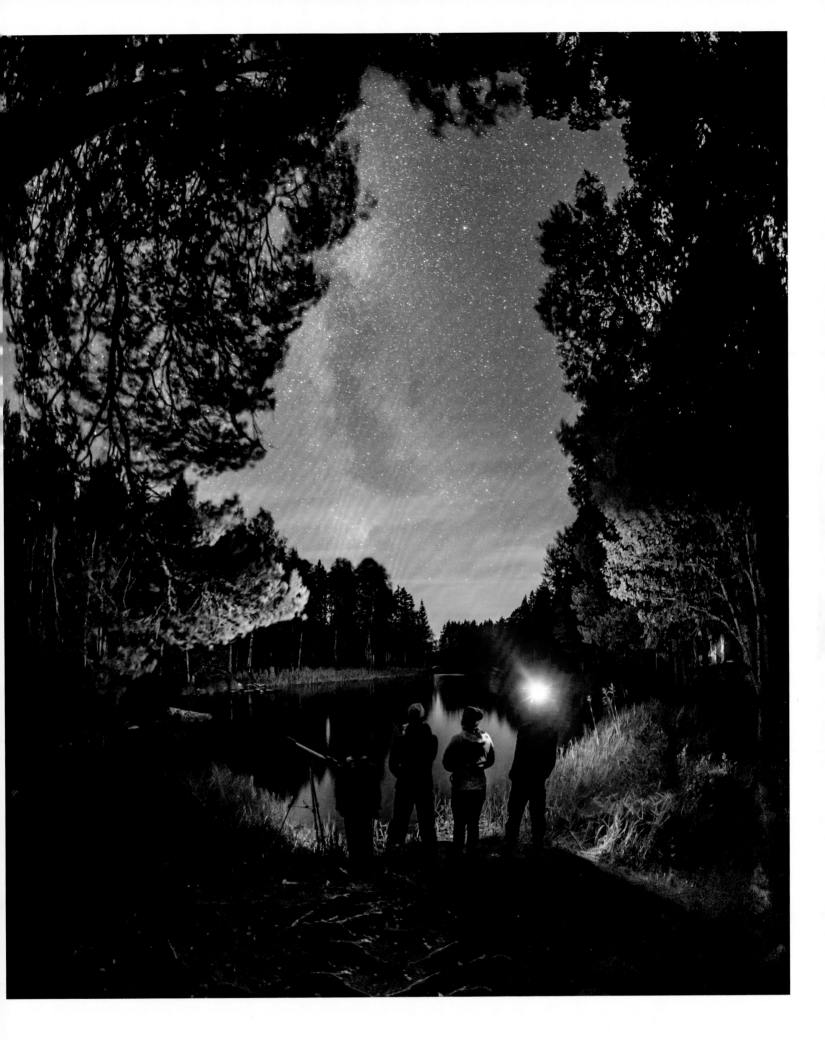

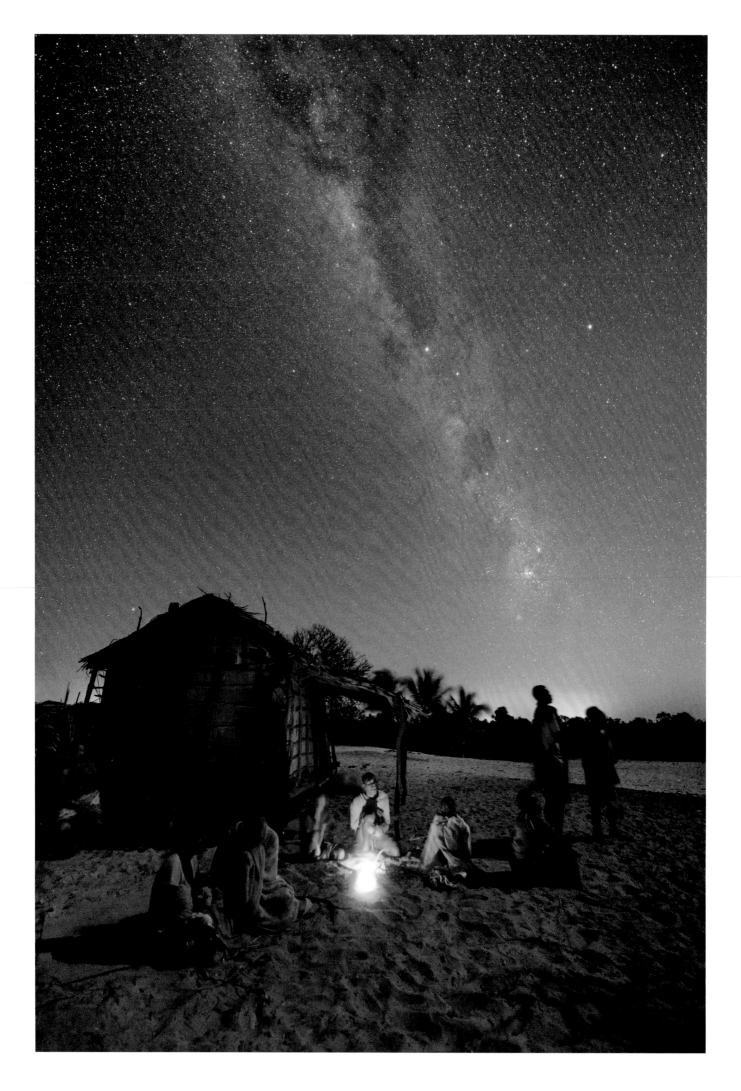

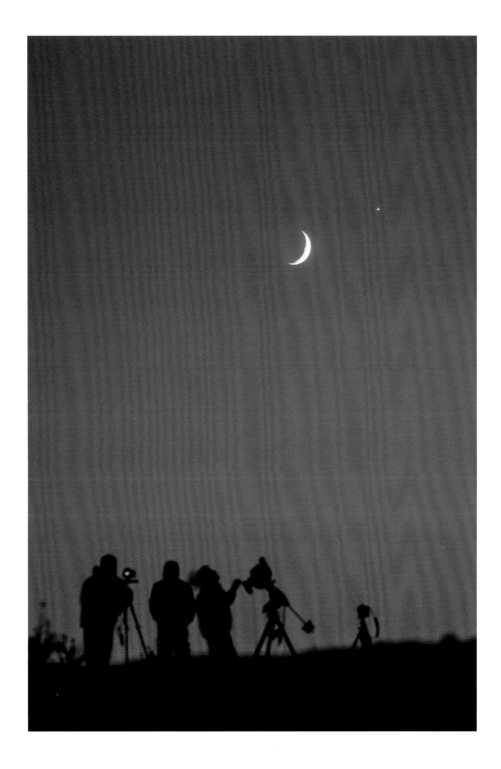

[opposite]

Morondava MADAGASCAR

A small group of local people gather to marvel at the night sky in this little village on Coco Beach in Madagascar. In the distance, lights from the city of Morondava glow on the horizon. Above them, the scene opens onto the southern sky along the galactic band, from the Carina Nebula to the Crux constellation, and includes the bright stars Alpha and Beta Centauri.

[above]

Alborz Mountains IRAN

Presenting an elegant celestial conjunction, this photograph shows the crescent moon in a close pairing with the bright planet Venus in the evening twilight above a group of skygazers and astrophotographers. While there are only around 10,000 recorded professional astronomers in the world, the number of amateurs who are members of astronomy clubs or frequently use a telescope exceeds 1 million.

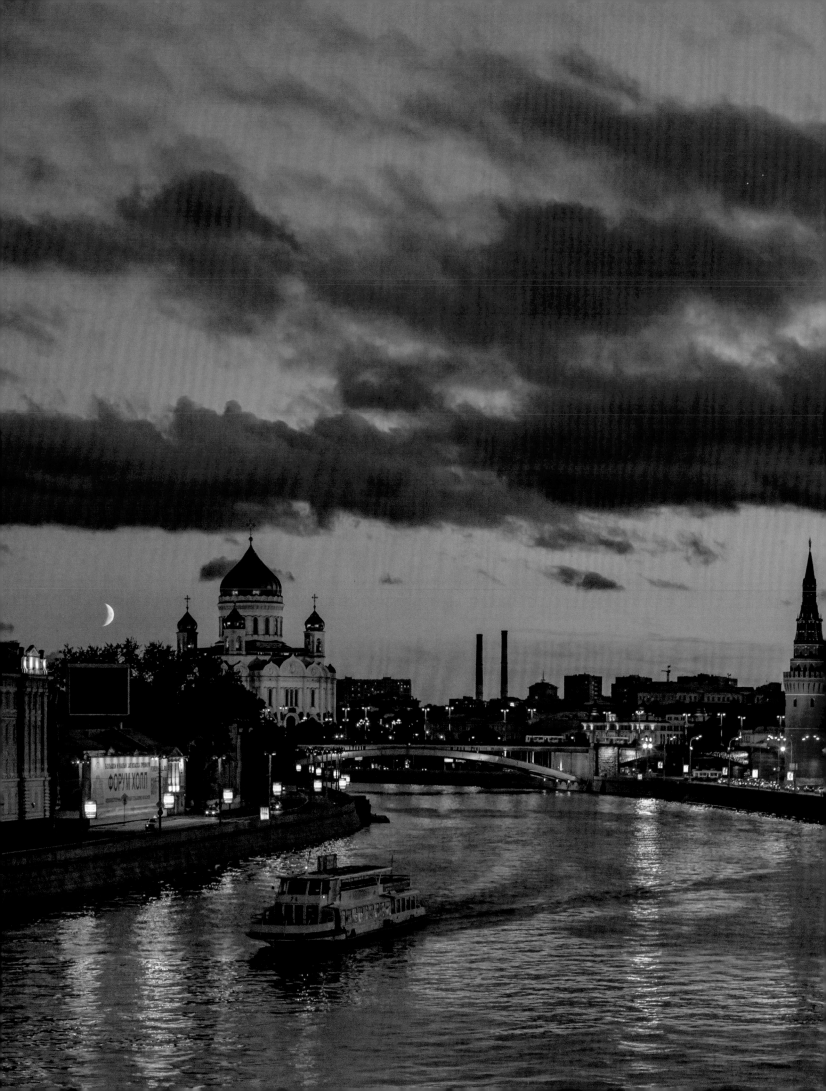

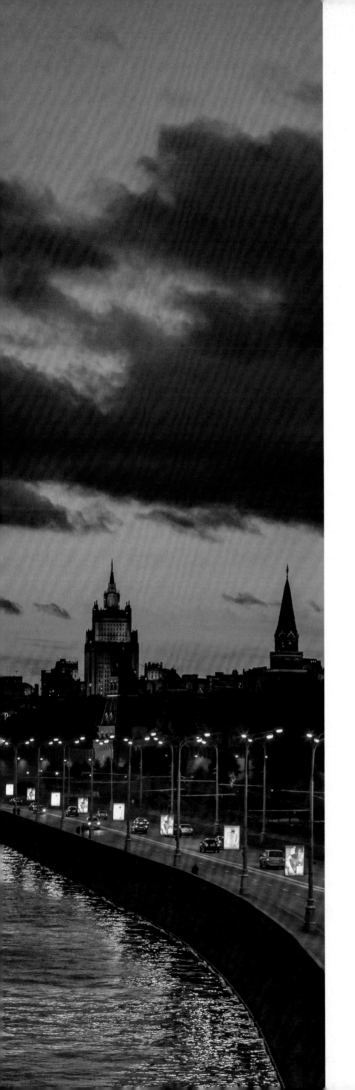

World Heritages

THE NIGHT SKY IS A TIME MACHINE AND SO IS ARCHAEOLOGY. THE NIGHT SKY STAYS ETERNAL ABOVE OUR FLASHING CIVILIZATIONS.

More than 1,000 sites are protected under the UNESCO World Heritage programme, the large majority of them dating back thousands of years. Some are far enough away from light pollution that today's onlookers can experience much the same vision of the natural night sky as that seen by our ancestors when they built these magnificent landmarks. That is the common theme for a number of the photographs in this chapter – just as the monuments speak to history, to ancient learning and much more, these captured skies allow us to contemplate the ancient 'landmarks' of the night sky. The skies above these iconic and important heritage sites resonate with the viewer on an instinctive level – they spark the imagination. Not only do they reveal the true beauty of the night sky within a protected environment, but they showcase some of the world's most familiar, iconic sites in a less familiar light.

In a world in which the lights of urbanization have, for many, overwhelmed the natural light of our skies, The World at Night programme provides viewers with more meaningful experiences of these heritage sites. Bringing the stars and the ancient monuments together within single frames, these carefully curated photographs reconnect us with the importance of the night sky to early civilization. It is in this context that we start to see the night sky as being blended with archaeology. Through stargazing and capturing vistas at historic sites, a bond is created between these ancient stars and sacred grounds. Just as archaeology acts as a time machine, digging into the buried practices and geography of our history, the night sky, too, is a living time machine. Due to light speed and cosmic distances, celestial objects visible to the naked eye take us back in time anywhere from one second (the moon) to 2.5 million years ago (the Andromeda Galaxy), when the first human ancestors appeared in Africa.

The first few pages of this chapter consider World Heritage sites with links to archaeoastronomy, a young science that studies sites in relation to the sky. Stonehenge in the United Kingdom, Mexico's Chichén Itzá and the Mesopotamian ziggurats of the Middle East are lasting evidence of places where ancient stargazers used celestial figures and solar and lunar motion to keep track of time for both ritual and agricultural purposes. While they bear no resemblance to the observatories of today's science practices, these ancient calendar-keeping monuments represent the birth of astronomy. Such monuments exist on all of the world's inhabited continents, conceived by every major civilization as a means of tracking time. In North America, Chaco Canyon in New Mexico is one such destination, at one time inhabited by the Ancient Pueblos. Now a national park, the site is home to a hand-moon-star pictograph that could well represent the configuration of the new moon and a supernova recorded in the year 1054 – this

was the explosion of a star much bigger than the sun, far in our galaxy, which glowed like a bright new star in the Earth's sky for around two years.

From a high desert in New Mexico to a green valley of giant natural rock pillars in Europe: perched atop a series of tall and delicately thin rocks in Metéora, Greece, are ancient monasteries. Incredibly isolated, these are truly unique places from which to appreciate the stars, exactly as they have appeared to the thousands of monks who have lived here since the eleventh century. A little further south of Metéora sits one of the most impressive symbols of Western civilization, on a steep rocky hill overlooking Athens. The Acropolis witnessed the emergence of classical Greek thought and art, a time when Socrates' philosophy was formed and when the first Academy was founded by Plato in 387 [BCE].

More than 13,000 km (8,000 miles) away, at the heart of Australia, Uluru – an immense monolith – towers 348 m (1,142 ft) above the surrounding desert and extends some ten times further underground. It has been home to settlements for more than 10,000 years. Uluru National Park is peppered with ancient rock art recounting stories of the creation of the land and skies. Many celestial stories can be found in ancient petroglyphs and pictographs around the world – the exhibits of open-air galleries, often far from city lights, beneath an ocean of stars on moonless nights.

Journeying from the deserts of Australia and across the waters of the Indian Ocean, some 8,000 km (4,900 miles) west, almost half of an island near Madagascar is protected by the World Heritage programme. This is Réunion, a land of erupting volcanoes, subtropical rainforests and truly dark skies that appear almost to rest on the mountains above the cloud forests.

Although the foreground is an important element in all of these images, to a nightscape photographer, the sky always forms the main story. This chapter is, perhaps, the most unique in the essential planning that is necessary for the capture of these images – sometimes many months in advance. A good knowledge of the night sky and practical astronomy is critical, to ensure the photographer is 'in the right place, at the right time'. While ideal weather and moonlight conditions are the primary focuses of that planning, other factors include geographic location, altitude and temperature, local topography and light pollution. In the case of many World Heritage sites, there is the added complication of limited access – rightly so, given the protected status of these historic landmarks. These various elements combine to provide more resonance to the unique story each photograph has to convey – the story of the eternal night sky above our flashing civilizations.

[previous]

Moscow RUSSIA

The moon hangs low in the sky next to the Cathedral of Christ the Saviour in this summer evening twilight overlooking the Moskva River and the Kremlin (right) near Red Square.

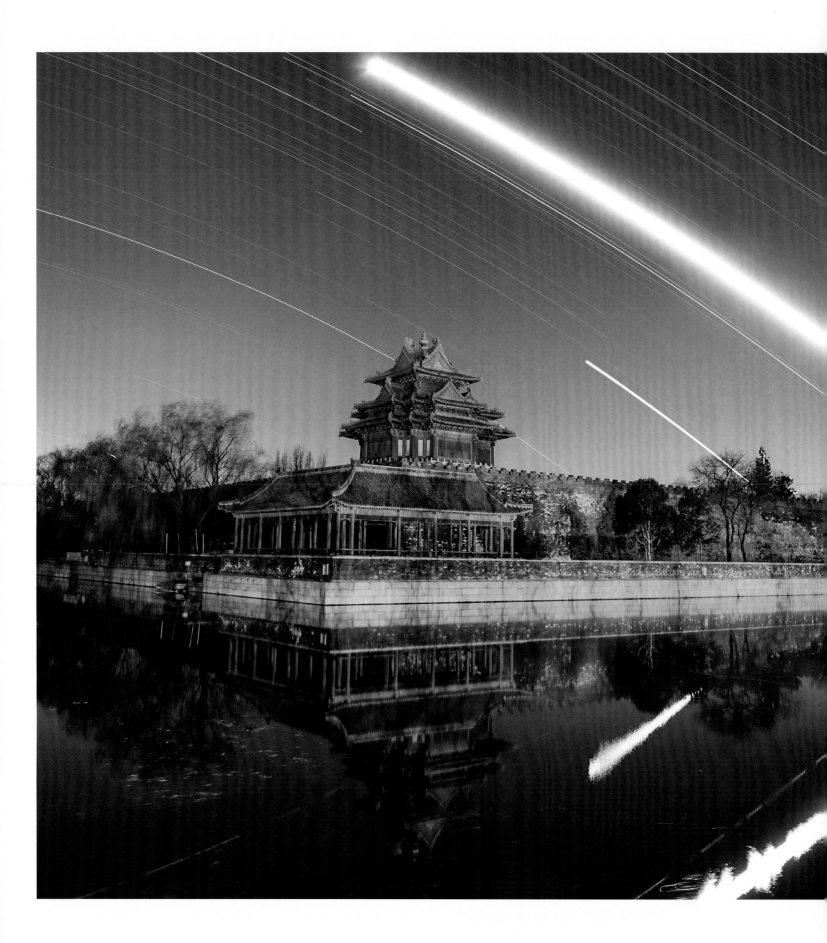

ASTRONOMY

UNESCO's Heritage of Astronomy initiative has listed around 100 historic or ancient sites as having notable connections to practical astronomy. Some are those observatories in which groundbreaking discoveries have been made during the last few centuries, such as Mount Wilson in Los Angeles, California, where Edwin Hubble proved the existence of galaxies beyond the Milky Way and later discovered the expansion of the universe. Other sites are pre-telescopic observatories, where early astronomers used massive angular-measurement devices to track the movement of the stars more accurately than could be achieved with the naked eye. These include the Maragheh and Ulugh Beg observatories of the medieval Islamic world, in modern-day Iran and Uzbekistan respectively; the Beijing Ancient Observatory, China; and Tycho Brahe's Uraniborg observatory in Denmark. More primitive sites take us back to the very dawn of science, when astronomy was used to create calendars for farming and social rituals. Some of the rock art in Lascaux Cave in France, now 17,000 years old, shows abstract designs associated with seasonal animals that may relate to astronomical calendars. It is thought that some examples here show the earliest known constellation and asterism figures. Above an aurochs, a cluster of dots resembles the the Pleiades (Seven Sisters), while the animal's eye and surrounding dots resemble bright star Aldebaran and the Hyades star cluster, both part of Taurus (the Bull) constellation.

Prehistoric stone circles are known across the globe. There are as many as 1,000 sites in total, the oldest of which dates back 10,000 years. Reasons for their construction vary. Some served as burial grounds for notable members of society, others as centres for ceremonial gatherings. In many cases, the positions of the stones relate to specific celestial observations, marking events in the lunar and solar calendar, such as equinoxes and summer solstices. One of the most spectacular examples of this is Stonehenge, just 100 km (60 miles) west of London, in the United Kingdom. Astronomical alignments are found in many other monuments of the ancient world, from pre-Columbian Mayan temples, such as those at Chichén Itzá in Mexico, to the Pyramids of Giza in Egypt and the Taosi archaeological site in China's Shanxi province.

Beijing CHINA

Beijing shows its stars on an exceptionally clear evening. A long combined exposure captures the journey made by the moon, Mars, Venus and other stars as they cross from the night sky above Jiao Lou tower in the Forbidden City, and trail down to the western horizon. This site served as the home of emperors for almost 500 years. The colour of the moon shifts to yellow as it approaches the hazy horizon.

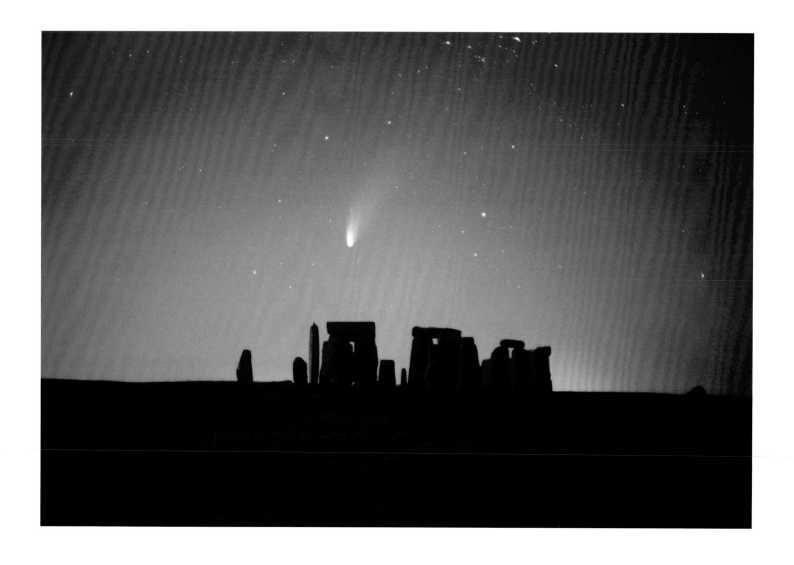

Stonehenge, Wiltshire ENGLAND

The most architecturally sophisticated prehistoric stone circle in the world, Stonehenge is a testament to the skills of ancient peoples. It has long been recognized as a site of astronomical significance. Most notably, it is aligned along the midwinter sunset–midsummer sunrise solstitial axis. The main construction started 5–6,000 years ago and saw some 2,000 years of continuous monument building from 3700 to 1600 [BCE]. This photograph, taken in April 1997, captures the moment at which Comet Hale-Bopp, one of the greatest comets of our time, flew above this historic landmark. Intriguingly, it is thought that the comet's last appearance above Earth coincided with an early development phase of Stonehenge, some 4,200 years earlier. The comet is expected to return to the inner solar system around the year 4385. As such, this celestial phenomenon is inextricably linked to our ancient past, but also to our far distant future.

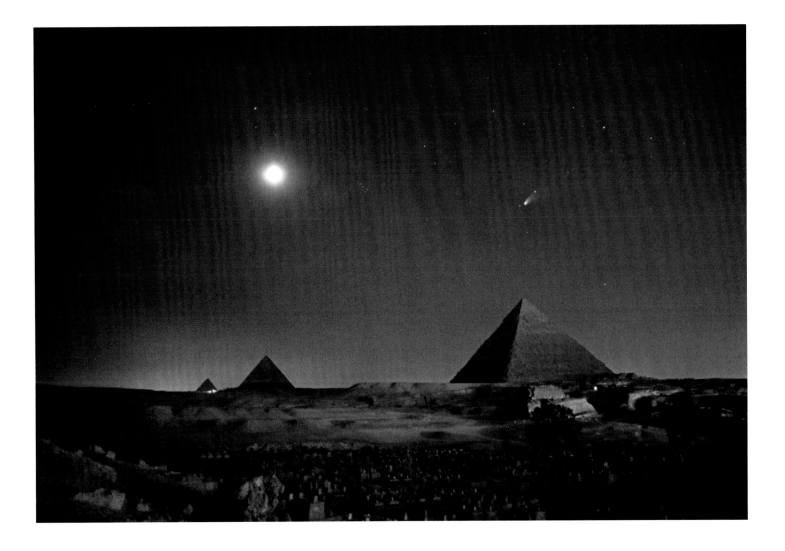

Pyramids of Giza, Cairo EGYPT

Above the Pyramids of Giza, the moon and stars of constellations Taurus and Perseus share the night sky with Comet Hale-Bopp as it travels past Earth. Photographed on the outskirts of Cairo in April 1997, this was one of the brightest comets of our time – so bright, that it was easily visible from metropolitan areas in spite of city light pollution. The comet's previous encounter with Earth coincided with the completion of these pyramids, built on the Nile River between 2589 and 2530 [BCE]. The three main pyramids are orientated to the cardinal directions with remarkable precision. For such monumental structures, this could only have been achieved through astronomical observation. What an extraordinary sight the appearance of this bright comet must have been for those ancient astronomers of Giza.

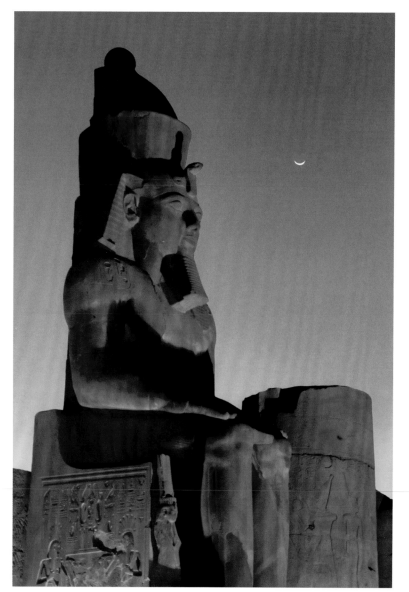

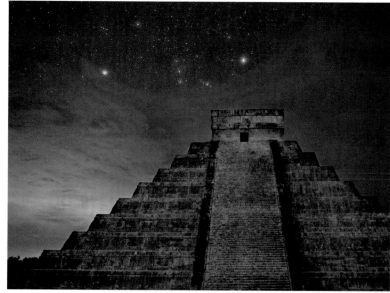

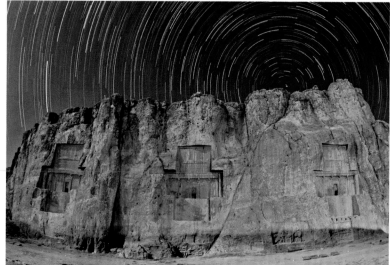

Luxor Temple, Luxor EGYPT

The new moon at dusk, above a colossal, 3400-year-old seated statue of Ramesses II at Luxor Temple in the ancient Egyptian city of Thebes. Now modern-day Luxor, the city lies on the east bank of the Nile River, some 500 km (300 miles) south of Cairo. Across the river are the Valley of Kings and the Valley of Queens, the burial sites of ancient pharaohs and their wives. Nearby, in the Deir el-Bahri temple complex, lies the tomb of Senenmut, where a masterpiece of ancient art and astronomy appears on the ceiling and depicts circumpolar constellations such as the Big Dipper alongside lunar cycles and sacred deities.

Chichén Itzá, Yucatán MEXICO

Orion (the Hunter) rises above the central pyramid at Chichén Itzá, a grand Mayan centre on the Yucatán Peninsula. Known as the Temple of Kukulkan, it stands 30 m (100 ft) tall and was built between the ninth and twelfth centuries. Noted for various astronomical alignments, it is thought that the Mayas – accomplished astronomers and mathematicians – used the cyclic motions of celestial bodies to measure time. They regarded the constellation of Orion as 'heart of heaven', representing it as a turtle.

Persepolis, Fars Province IRAN

One of the world's most remarkable archaeological sites is Persepolis and the 2,500-year-old tombs of ancient Persian kings in Naqsh-e Rustam, both some 100 km (60 miles) northeast of Shiraz in modern-day Iran. This time-lapse exposure captures the rotation of sky around Polaris above the 60 m (200 ft) tall cliff with its massive cross-shaped tombs.

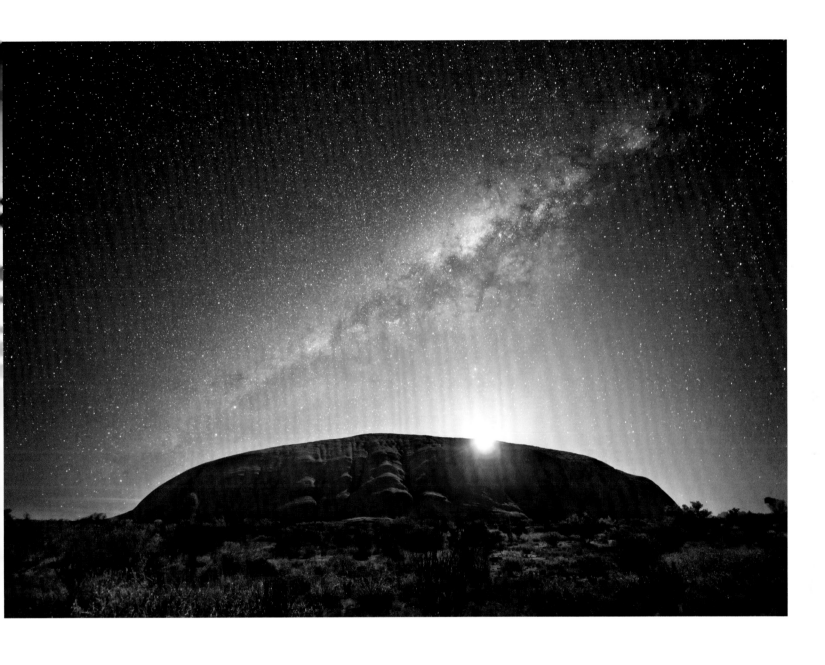

Uluru (Ayers Rock), Northern Territory
AUSTRALIA

With the first-quarter moon setting in the west, the Milky Way appears prominently in the starry sky above Australia's most recognizable landform. Uluru is a World Heritage site at the very heart of Australia – a single massive rock formation 348 m (1140 ft) above the plain. This monolith actually extends much further beneath the desert plain. The most sacred site to Aboriginal culture, it is home to ancient rock art depicting stories relating to the creation of the land and skies.

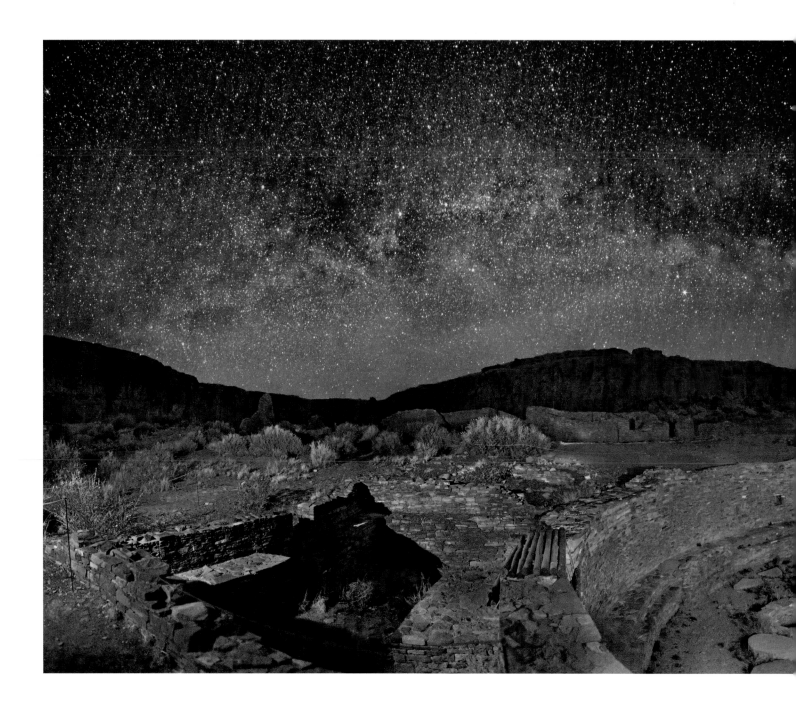

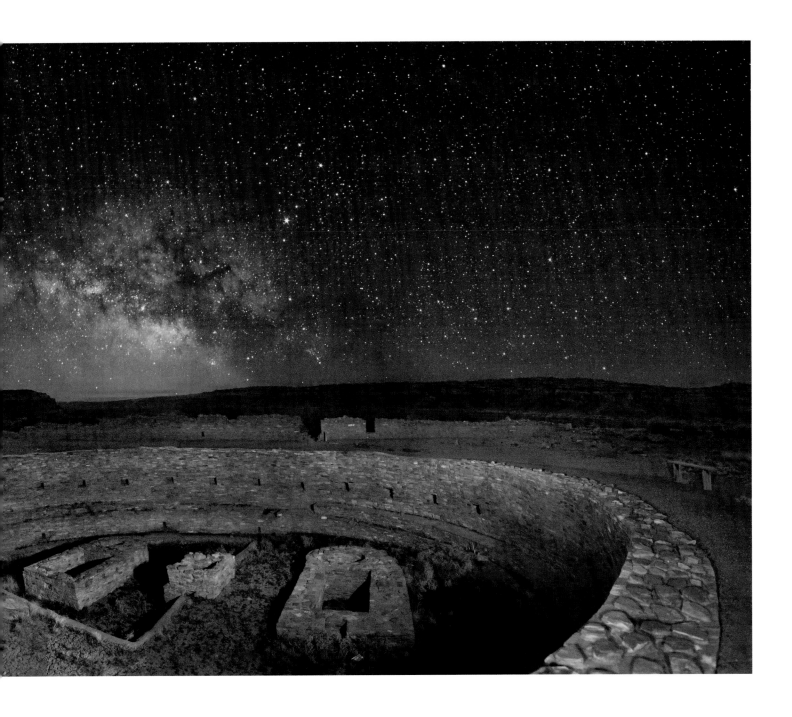

**Chaco Canyon,
New Mexico** USA

The entire Chaco Culture National Historical Park is an International Dark Sky Park, a natural darkness zone with no permanent outdoor lighting. The night sky is deeply connected to the Native American Pueblo culture that has been handed down through the generations from the Ancestral Puebloans who inhabited the canyon from 900 to 1150 [CE]. Pictured here is the Casa Rinconada kiva, beneath a rising Milky Way. It is thought that certain alignments of this circular ceremonial gathering place relate to astronomical observations, allowing the Ancient Puebloans to use the site as a lunar or solar calendar.

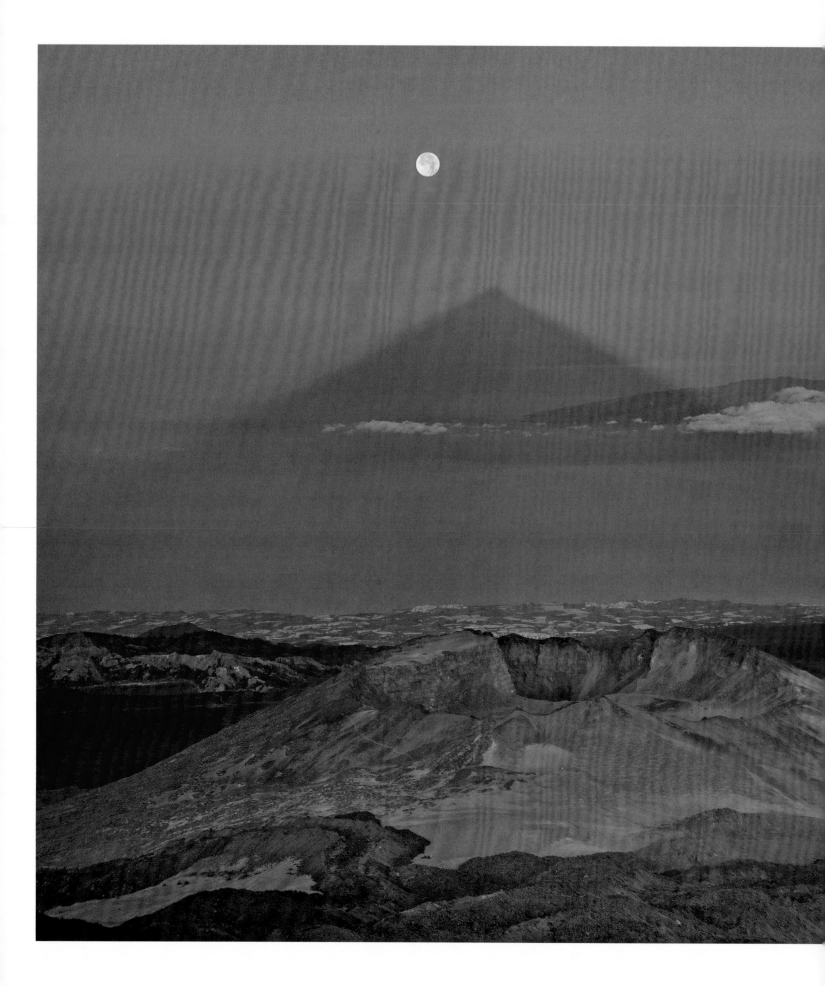

NATURAL

In order to qualify for UNESCO's elite World Heritage List, a natural location must meet some or all of the following criteria: it must be a superlative example of a natural phenomenon or an area of exceptional aesthetic importance; an outstanding representation of a major stage of Earth's history, or of an ongoing geological process in the development of landforms; it must be an important natural habitat for the conservation of biological diversity. Given the nature of these requirements, it follows that most natural heritage sites are also far enough from major developments to benefit from dark night skies. Images in this category show how the natural beauty of the night-time environment is preserved in these protected sites. Sitting under an ocean of stars in the Grand Canyon or at the foot of Patagonia's rugged Torres del Paine Mountains, it's easy to imagine how the past generations in these locations enjoyed the beauty of the night sky above some of Earth's most stunning landforms.

Tenerife, Canary Islands SPAIN

This exceptional capture of the full moon setting above Tenerife just at the start of sunrise was planned months in advance. The photograph was taken shortly after a total lunar eclipse in mid-June 2011, with the photographer standing on the top of Mount Teide. The island's tallest peak, Teide is a magnificent volcano that reaches 3,718 m (12,198 ft) above sea level and some 7,500 m (24,600 ft) above the floor of the Atlantic Ocean. In the foreground is the crater of Pico Viejo, the island's second-tallest peak and, beyond that, the shadow of Teide itself. There is an optical illusion at play here, specifically in the way that the shadow of this great mountain forms a perfect triangle. Teide does not have a strictly pyramidal shape – in fact, around 200,000 years ago, the cone-shaped summit of the volcano collapsed, creating a caldera. Still, the shadow persists, and is common to the shadows of other large mountains and volcanoes. A key reason for its shape is that the observer is looking down the long corridor of a sunset (or sunrise) shadow that extends to the horizon. As such, the edges of the mountain taper towards the vanishing point, just as parallel train tracks do.

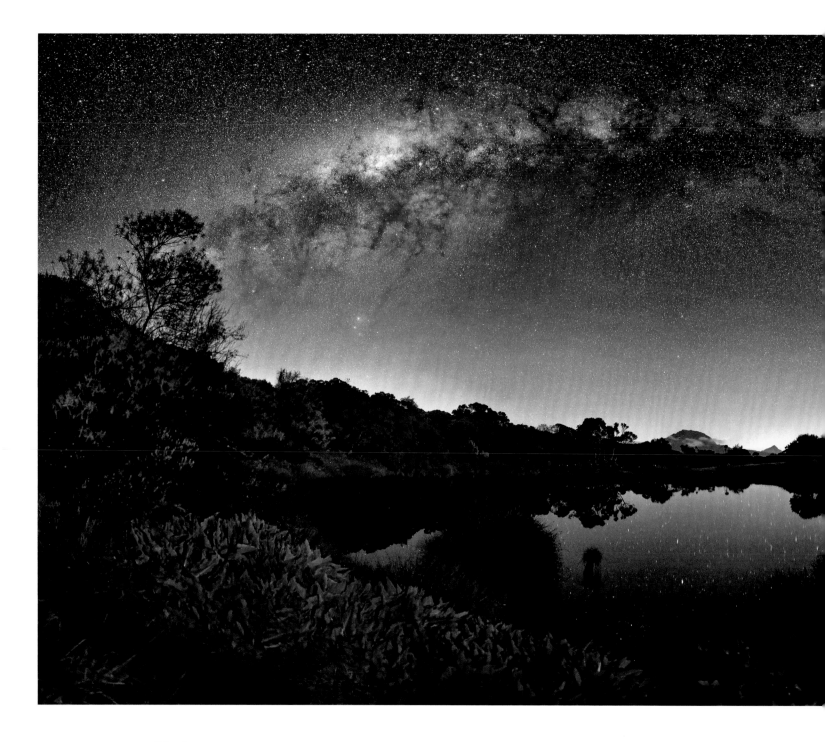

Réunion SOUTH INDIAN OCEAN

The dreamlike scene depicts one of the most beautiful places on Réunion, a 70 km (43 mile) wide island, some 700 km (435 miles) east of Madagascar. The Piton de l'Eau is a crater filled with water and surrounded by arum lilies from July to September. Here, the setting Milky Way occupies the greater part of the sky, forming an arch over the Piton des Neiges volcano in the distance – the highest point in the Indian Ocean at 3,070 m (10,070 ft). Almost half of this French territory paradise island is protected as a natural World Heritage site, taking shape as La Réunion National Park with massive volcanic plugs (pitons), cliff-rimmed cirques, forested gorges and basins. At a latitude of 20 degrees south, the island's well-preserved dark skies showcase the best of the southern sky wonders.

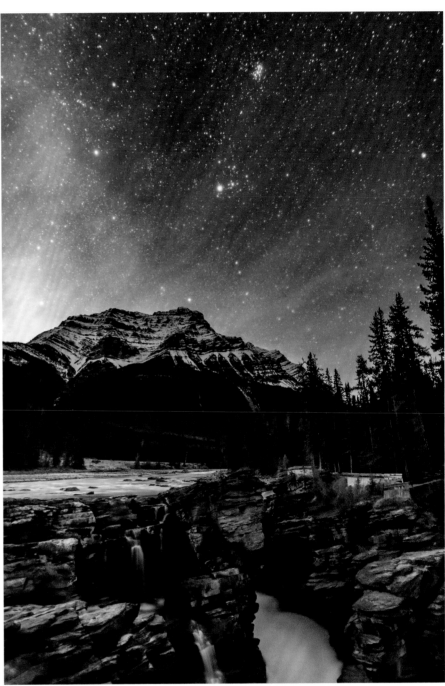

Jasper NP, Alberta CANADA

Above Athabasca Falls, amid high cirrus clouds, Pleiades star cluster (top) and the rest of the Taurus constellation with its bright-orange star, Aldebaran, appear in this October night at Jasper, the largest national park in the Canadian Rockies, north of Banff National Park. The two parks, known for their glaciers, hot springs, lakes, waterfalls and rugged mountains, are popular stargazing destinations.

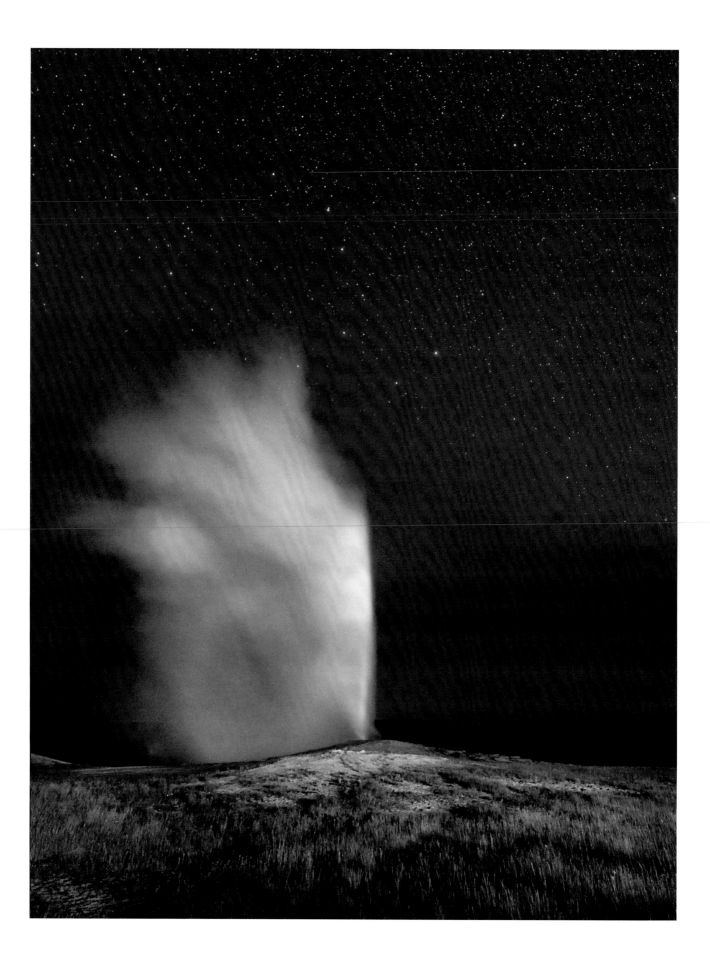

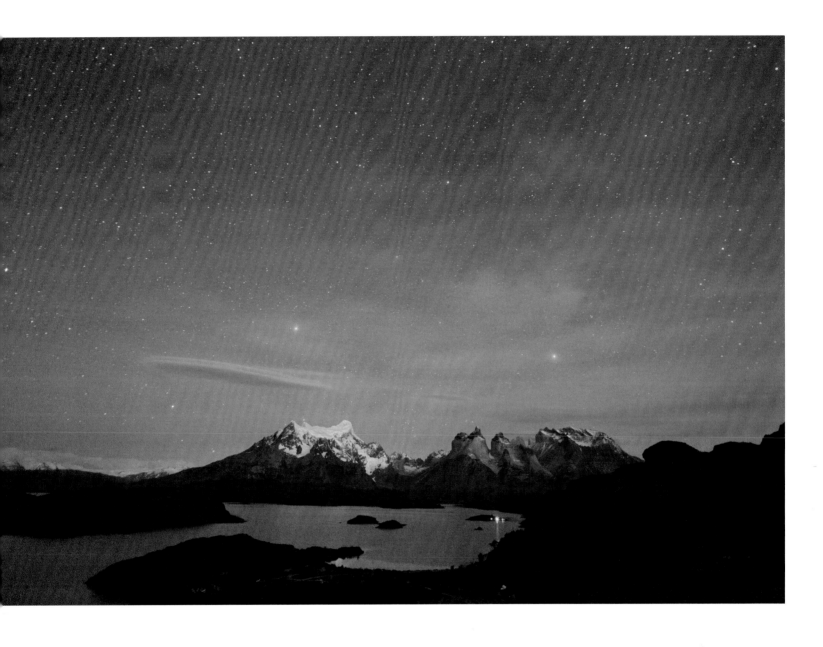

[opposite]

Yellowstone National Park, Wyoming USA

Old Faithful geyser erupts under the stars on a summer's night at Yellowstone, the first national park established in the United States (and worldwide), in 1872. This geyser erupts at intervals of between 60 and 110 minutes and can shoot 14,000 to 32,000 litres (3,000 to 7,000 gallons) of boiling water to a height of 30–55 m (100–180 ft). Here, stars of Ursa Major (the Big Bear) are right above the eruption. Wandering around Yellowstone at night, a photographer should also be aware of the big bears on the ground! The park is home to many grizzly bears.

[above]

Torres del Paine National Park CHILE

At a latitude of 51 degrees south, some 2,000 km (1,245 miles) south of Santiago, near the southernmost tip of the Americas, rests a small group of rugged mountains in Patagonia. These gigantic granite monoliths, the tallest reaching 2,884 m (9,460 ft) high, were shaped by the forces of glacial ice. On this February morning, planet Saturn (left) and bright star Arcturus (right) shine in twilight above the Paine Cuernos Mountains and Lake Pehoé in Torres del Paine National Park.

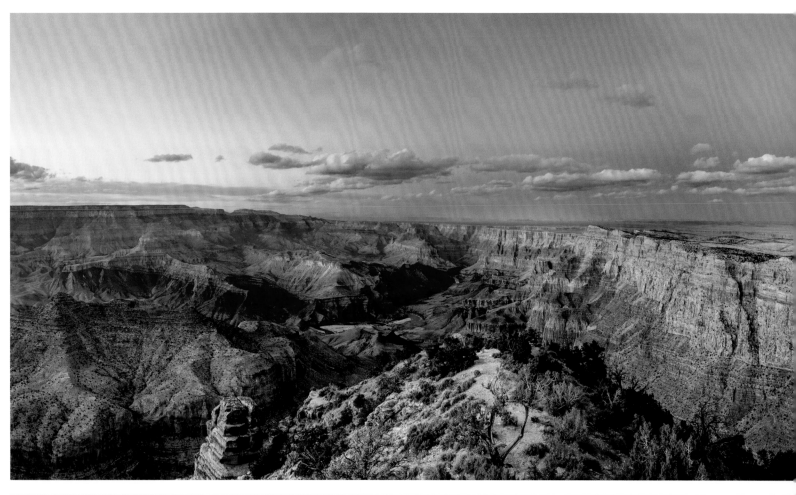

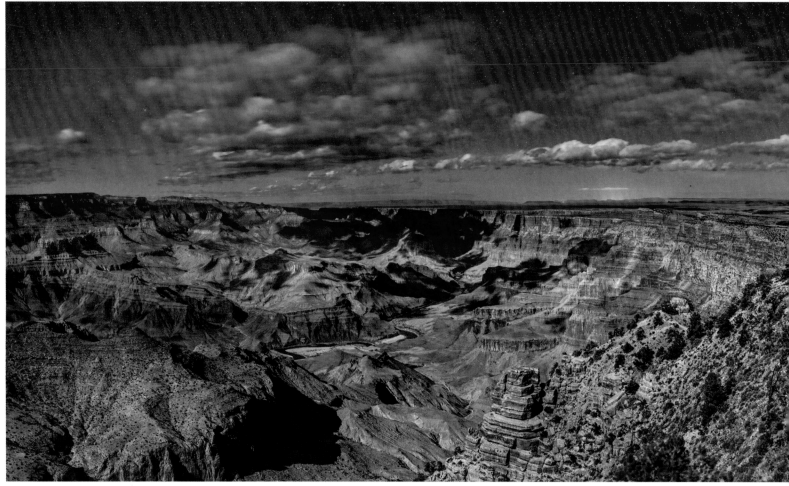

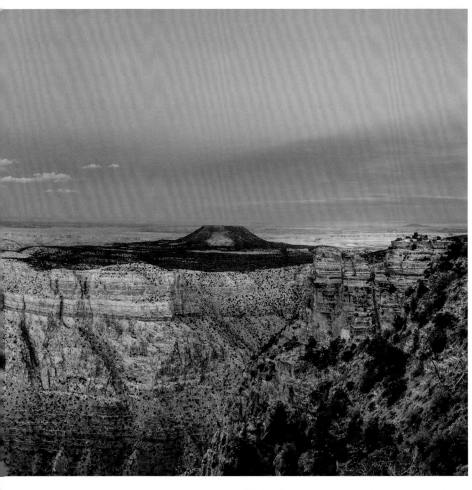

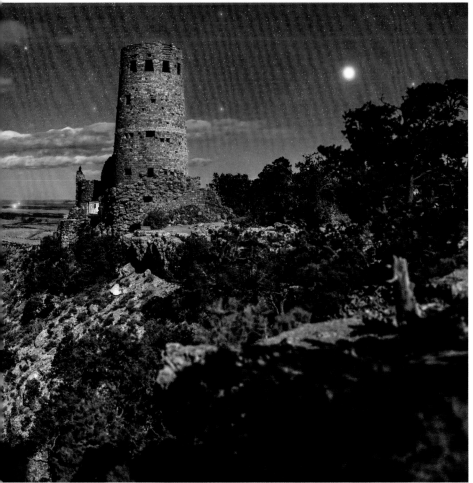

Grand Canyon National Park, Arizona USA

The Grand Canyon offers extremely dramatic scenes when caught at the right time and in the right light. The upper panoramic image ranges from west (left) to east, and captures the yellow-red light of early twilight a few minutes after the sunset, illuminating the canyon and the blue-purple colour of the rising Earth shadow on the right, at the opposite horizon (east). This is the shadow that Earth itself casts onto its atmosphere and into outer space. Above the Earth shadow, another atmospheric phenomenon forms – anticrepuscular rays directly above an extinct volcano that sits near the edge of the world's longest canyon. This steep-sided gorge has been carved by the Colorado River over an approximately 17-million-year timespan. It is 446 km (277 miles) long and attains a depth of more than 1.6 km (1 mile). More than 1 million people spend a night in the Grand Canyon every year, with the sky spread out above them. The lower panorama shows a moonlit night in the park, with the stars glowing over the Desert View Watchtower. Planet Jupiter is the dazzling 'star' on the right.

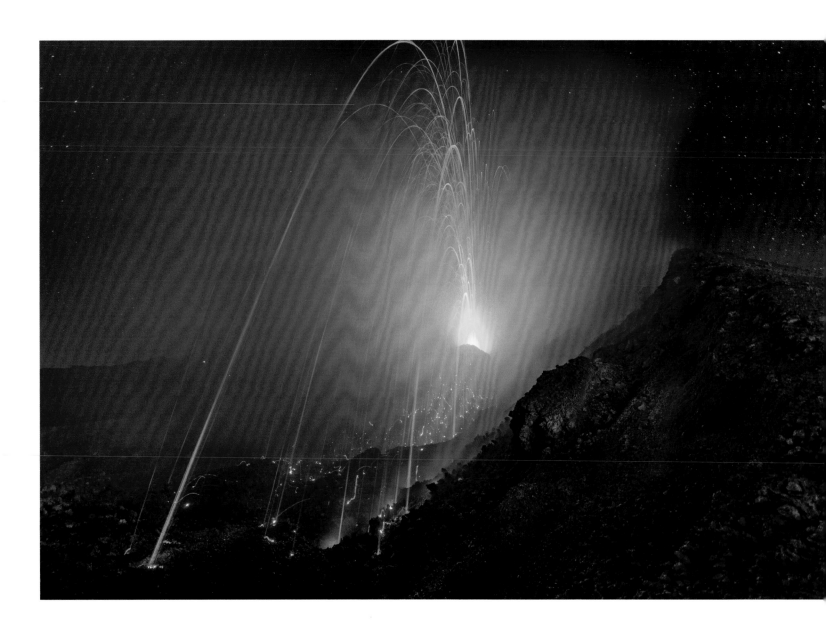

Réunion SOUTH INDIAN OCEAN

The eruption of Piton de la Fournaise, a shield volcano
on the eastern side of the island. With more than 150
recorded eruptions since the seventeenth century, this
is one of the world's most active volcanoes, along with
Kīlauea on the island of Hawaii (pictured opposite).

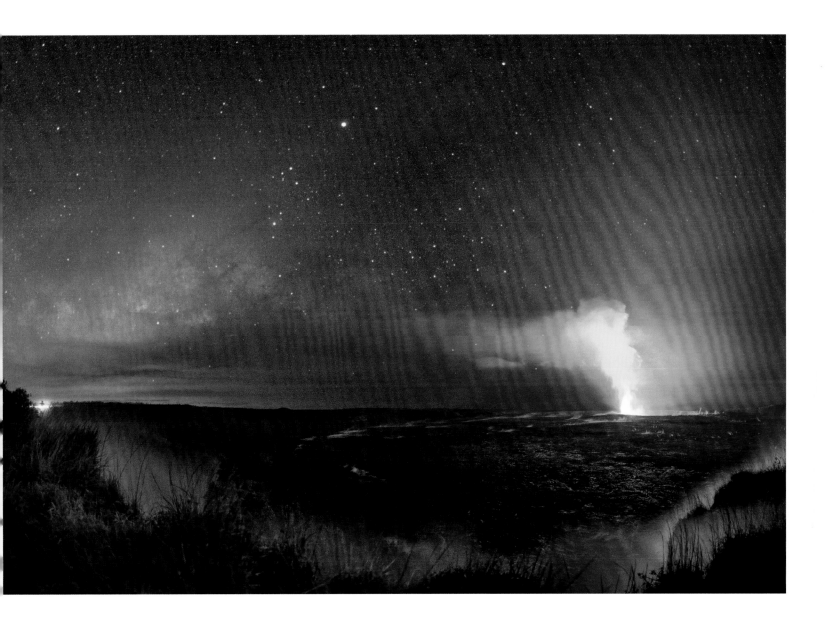

Hawaii Volcanoes National Park USA

The night sky over Kīlauea, a shield volcano on the island of Hawaii, also known as Big Island. On this late-January morning, a short window of totally dark sky between moonset and the onset of morning twilight allowed the photographer to capture the rising Milky Way above Halema'uma'u Crater, from a distance of 2 km (1.2 miles) away. Illuminated by the lava, the steam and smoke rising from the lava lake cause part of the sky to vanish.

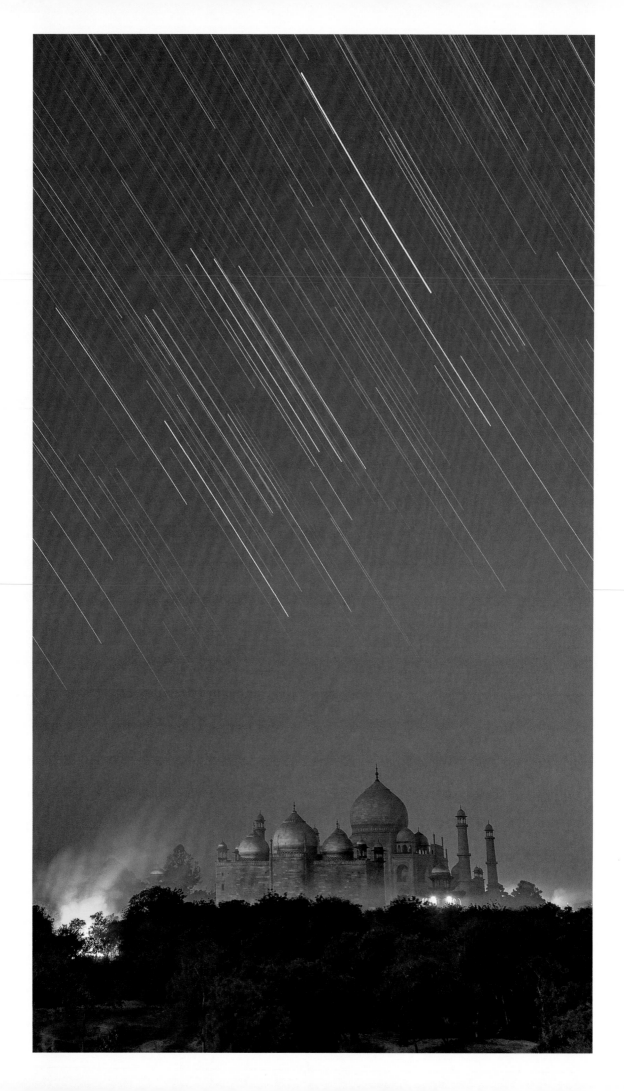

HISTORIC

There are around 1,000 cultural and historic sites on UNESCO's World Heritage List. Many of them are located within large cities, but there are a number to be found in more remote areas with minor light pollution. Preserving the common cultural heritage of humanity, these sites represent masterpieces of creative genius and exhibit the interchange of human values over centuries of time. Among the sites included in the list are those that display remarkable architecture, such as India's Taj Mahal, often described as the most extravagant monument ever built for love. Others are selected for their unique contribution to a living or past civilization. The Belém Tower in Lisbon is an example of this, having played a significant role in the Portuguese maritime explorations of the sixteenth century. Venice is another fine example – also with a maritime connection – an entire living city where humankind has long had a precarious interaction with a most fragile natural environment. Remnants of a civilization's cultural past also qualify, as in the curious monolithic stone heads on Easter Island or the Great Wall of China, built out of the necessity to defend Chinese territory for many centuries. Such examples can be found on all of Earth's inhabited continents, spanning thousands of years of human civilization. It is every nation's desire to add a cultural site to this prestigious list. Such an honour brings an increasing number of remarkable sites to the attention of the wider public, generating income for the host country, but also raising public awareness and sharing in humankind's growing desire to preserve the irreplaceable.

Taj Mahal, Agra INDIA

Stars of Orion (the Hunter) set above the Taj Mahal, with the three 'belt' stars visible near the centre of the image. The combined photo sequence captures Earth's rotation during the course of an hour. The skies of populated cities like Agra are light polluted and often dusty, but this sequence was shot after a cleaning rain and strong winds had cleared the air, leaving an exceptionally clear night. Still, for bright urban skies, it is much more practical to record them using a stacked sequence of short-exposure photos, instead of one single over-exposed image.

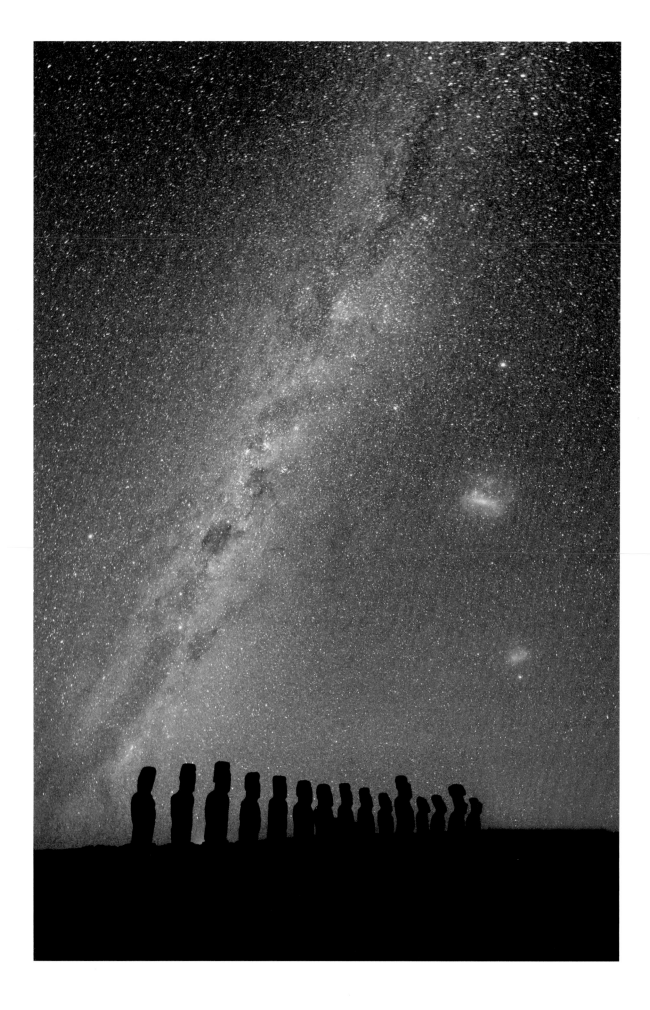

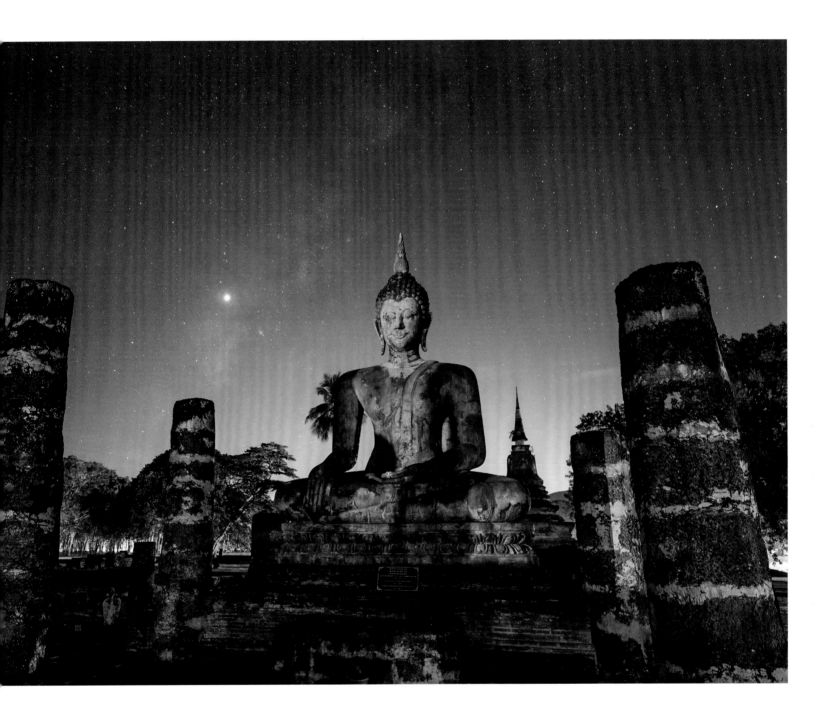

[opposite]

Rapa Nui National Park, Easter Island CHILE

On this isolated island in the Pacific Ocean, large statues called Moais stand silhouetted against the southern Milky Way. Dating from the thirteenth to the fifteenth centuries, these monolithic stone heads were made in their hundreds. The pictured set is known as Ahu Tongariki in the Rapa Nui (Easter Island) National Park. The patchy clouds to the right are neighbouring satellite galaxies, the Large and Small Magellanic Clouds, each several billion times the mass of our sun. The smaller of the two is the furthest object visible in this view at 200,000 light years away. Its light belongs to a time when there was no civilization on our planet.

[above]

Wat Mahathat, Sukhothai THAILAND

The Milky Way and Venus hang high above a large Buddha statue at the temples of Sukhothai in Thailand. Dazzling Venus resembles a supernova explosion in our galaxy, a phenomenon that has not been observed for more than four centuries. The ancient tropical site of Sukhothai, meaning 'dawn of happiness', was the capital of a kingdom of the same name during the thirteenth and fourteenth centuries. Pictured here is Wat Mahathat, the 'Temple of the Great Relic'. This most significant part of Sukhothai was built on the concept of the mandala, an ancient Hindu symbol representing the universe.

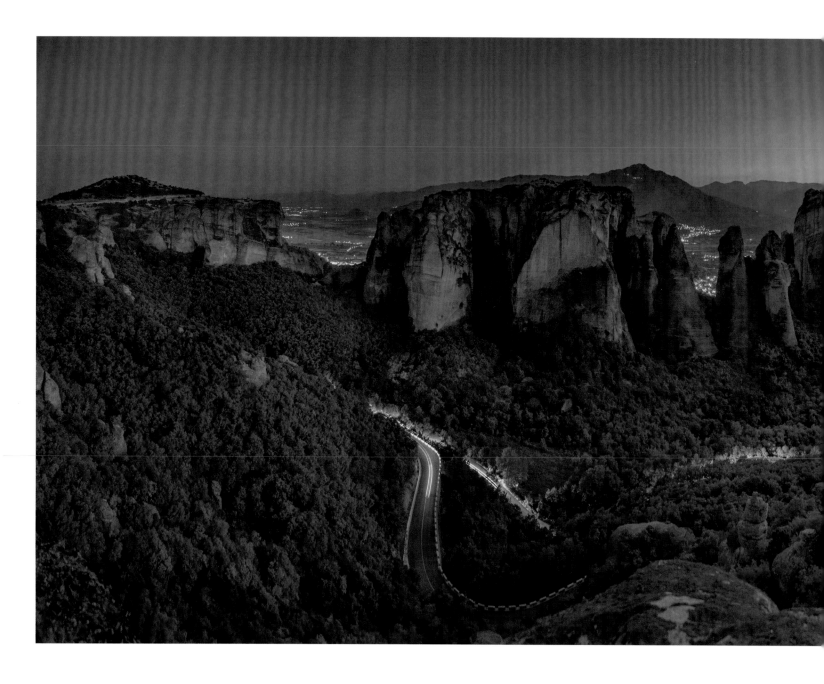

Metéora GREECE

Located near the town of Kalambáka in central Greece,
Metéora is the scene of a cluster of monasteries, precipitously
built on (or inside) pillars of natural sandstone. With a name
that derives from a contraction of the Greek for 'suspended
in air', this extremely isolated complex is one of the world's
largest Eastern Orthodox monasteries. Some are around
1,000 years old. Here, at the centre of the image, Venus shines
elegantly in a colourful dusk on the western horizon, an hour
before the star-filled sky embraces this otherworldly site.

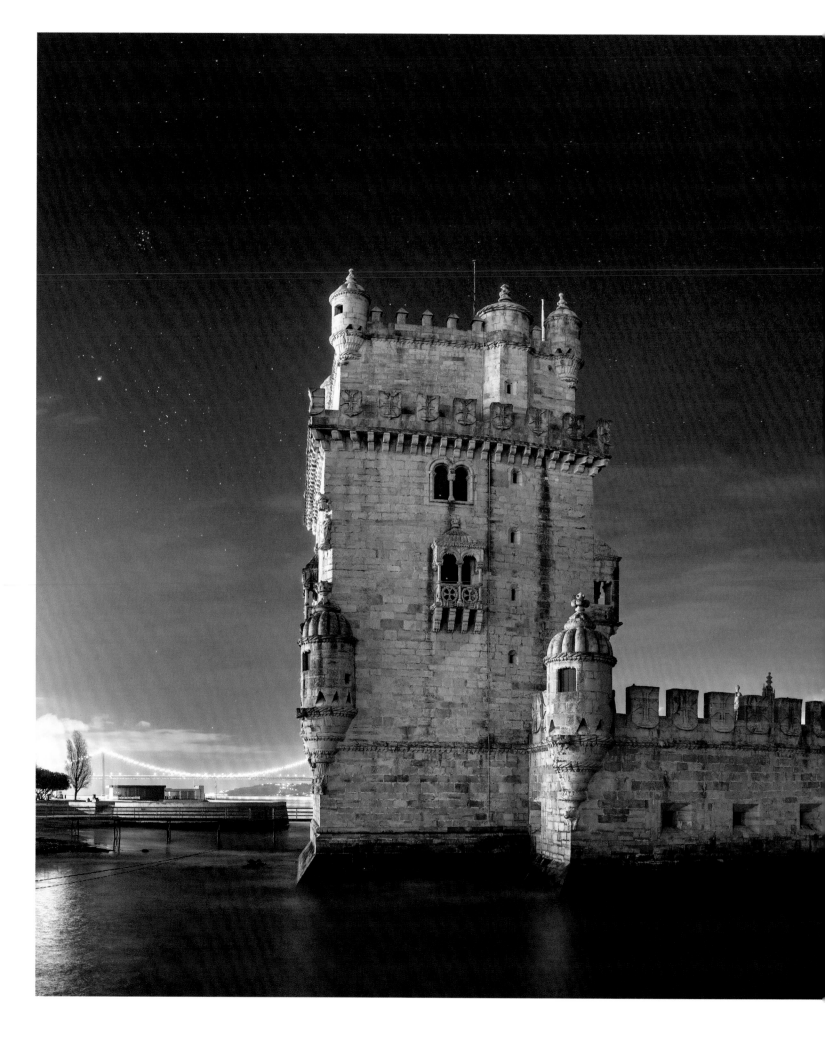

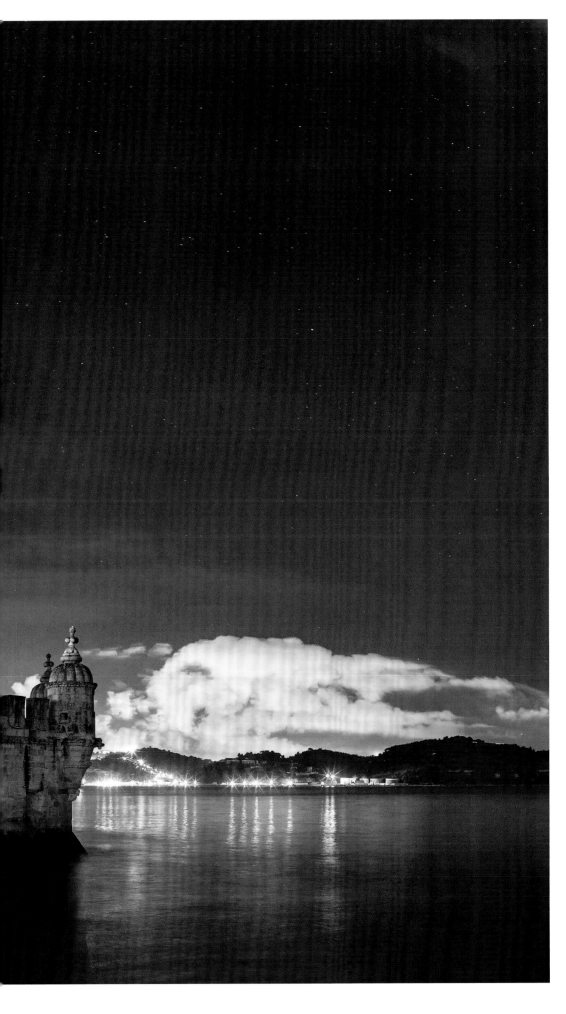

Belém Tower, Lisbon
PORTUGAL

This photograph of the iconic
landmark of Lisbon, the Belém
Tower, takes advantage of a rare
occasion on which its security
floodlights were turned off.
Otherwise, capturing stars above
this strongly lit monument is not
possible in the dynamic range of a
single-exposure image. Constellation
Taurus (the Bull) with the Pleiades
star cluster and Jupiter (brightest
point) appear to the left of the
image, above the 25 de Abril Bridge.
The tower is a fortified structure,
a defence system at the mouth of
the Tagus River and a ceremonial
gateway to Lisbon.

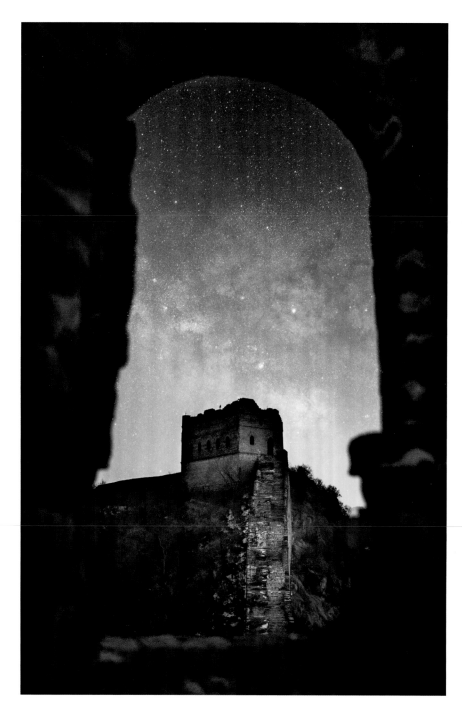

Great Wall, Hebei Province CHINA

The central region of the Milky Way and planet Saturn (brightest point) are framed through a window of the Jinshanling section of the Great Wall of China, Hebei province. The wall was built and rebuilt in periods from the seventh century [BCE] to the sixteenth century [CE]. Its purpose was to protect the Chinese states and empires against the raids and invasions of nomadic groups, primarily from Mongolia. This wall is the world's largest military structure with a total length of more than 20,000 km (12,500 miles) and runs along an east-to-west line across the historical northern borders of China.

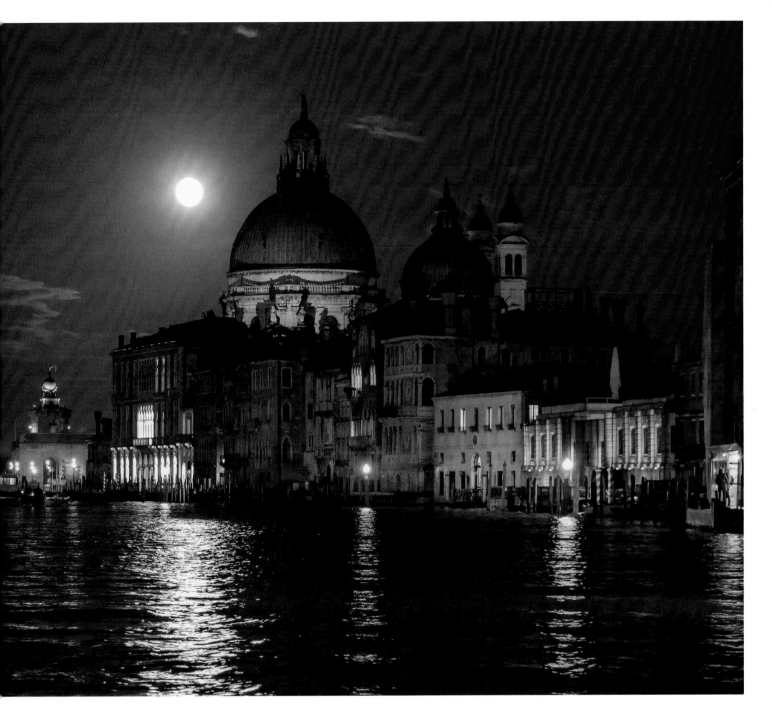

Venice ITALY

Gondolas float at night as the full moon shines on the
Canal Grande and Santa Maria della Salute church in Venice.
While the incredible, dynamic range of the human eye can
detect very faint and very bright lights at the same time,
revealing stars, landscape and details of the lunar disc in
one glance, it is impossible for camera technology to replicate
this in a single exposure after dark. Attempts to do so can
lead to overexposure, resulting in an intensely bright full
moon, as here.

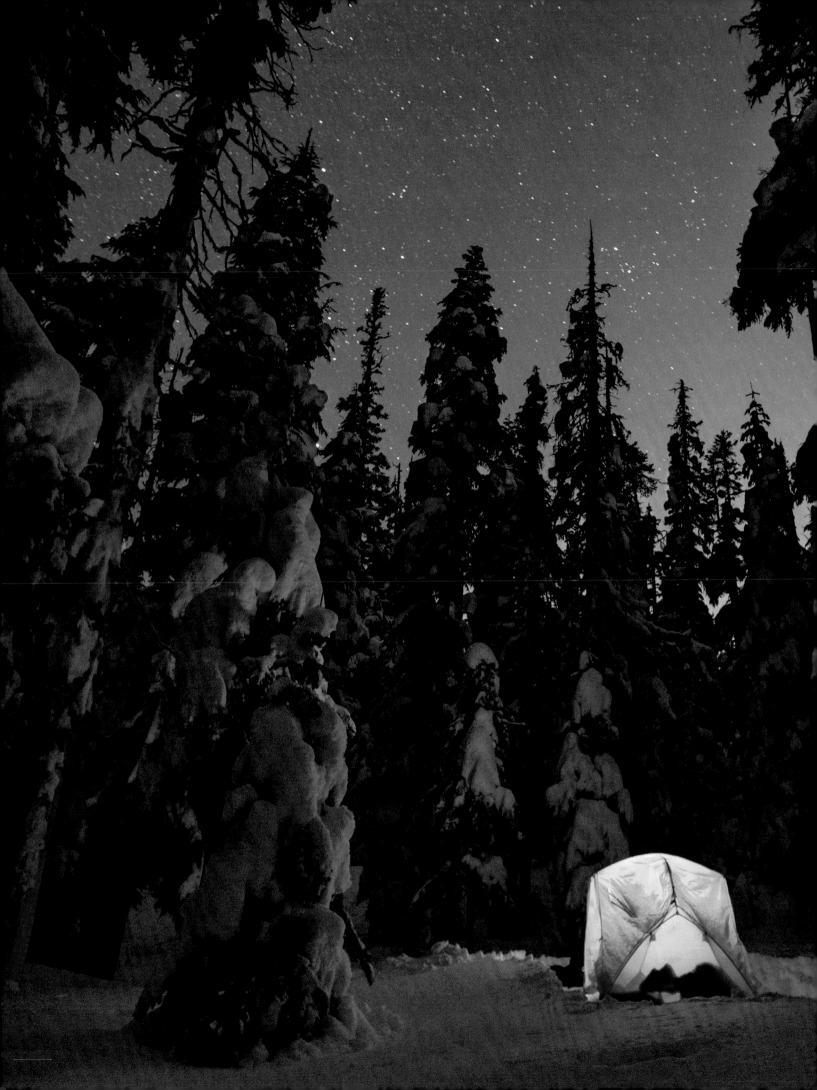

Hidden Universe

NIGHT HIDES A WORLD BUT REVEALS A UNIVERSE.

Naturally, we are not a nocturnal species. Throughout our ancient history, the outdoors at night-time is often presented as unsafe and mysterious – a colourless, eerie world. Yet once you begin to explore it, you will become seduced by its charms. Nightscape images show the hidden beauties of the world at night and offer a means of connecting the viewer to other cultures, to art and to science. For the photographer, this genre is not only about recording parts of outer space, it is about leading the life of adventure and exploring new worlds filled with unique experiences and untold stories for sharing with others.

In many ways, exploring the night sky is similar to discovering an unseen cave or reaching the top of a mountain from which only a few climbers have experienced the amazing vista. Imagine the boundless darkness of a remote island beach, with the summer Milky Way setting above the glittering blue glow of bioluminescent plankton. Picture the shimmering beauty of rugged, snow-covered Alpine peaks beneath a full moon, or heavenly curtains of dancing aurorae in all colours over an Icelandic landscape, or the crystal-clear skies of the Himalayas as the bright stars of a winter sky rise above Mount Everest. For the nightscape photographer, such stunning scenes forever engrave moments into memories.

The farmer, the nature trekker and the urban skygazer who enjoys the twilight view of the crescent moon and Venus above their cityscape – each enjoys turning their gaze to the night sky from time to time. Those wishing to delve deeper will find important principles of stargazing are better understood through well-planned photos – for example, those that showcase such phenomena as the phases of the moon, revealing ways in which our celestial companion interacts with our planet and all living species. It is this interaction that has so inspired artists and writers throughout history.

Once hooked on observing the night sky, you will discover the incredible number of constellations and asterisms, from prominent northern hemisphere figures such as the Big Dipper (part of Ursa Major; the Big Bear) and the Little Dipper (part of Ursa Minor; the Little Bear) to those on the celestial equator, their position making them easily visible from both hemispheres. Stargazers in the southern hemisphere

will recognize the constellation Crux. Also known as the Southern Cross, it features on a number of national flags, including those of Australia, New Zealand and Brazil.

Some images in this chapter reveal the celestial motions, while others highlight star colours and their brightness diversity, known as magnitude. The Milky Way does not always appear the same in these images. As our planet revolves around the sun our night-time window opens to different regions of the galaxy. In northern hemisphere summers, for example, we look towards the galactic centre, where the Milky Way in constellations Scorpius (the Scorpion) and Sagittarius (the Archer) is magnificently bright. In winter nights we look outwards, to the galactic suburbs. Skies of the tropics and southern hemisphere are often regarded as the most impressive. The Milky Way appears prominently here, with the galactic core stretching directly overhead. Also visible in the southern sky are our neighbouring satellite galaxies, the Magellanic Clouds, which circle the 'empty' South Celestial Pole as the Earth rotates. The skies of the far north have wonders of their own. In these geographical zones, Polaris stands very high and the aurora borealis, or Northern Lights, often dominate the entire sky.

There are various other elusive phenomena, such as the atmospheric distortion that occurs as celestial objects approach the horizon; the shadow of the Earth darkening the atmosphere; crepuscular rays; haloes around the moon and the sun, created when ice crystals hang in the air; lunar rainbows formed by mist and, higher up, near the edge of space, night-shining clouds. Known as NLCs (noctilucent clouds), these are commonly viewed on bright summer nights of polar latitudes. All of these incredible scenes almost resemble works of art – colours and patterns that elsewhere only exist in our imagination.

On an instinctive level, the nightscapes in this chapter connect us to an essential part of our natural world. In the pure, peaceful dark, a patchy glowing band of visible light gradually moves above the trees – the billions of stars that make up our home galaxy as it rises above the horizon of our planet. There are few scenes in nature as profoundly moving as the rise of the Milky Way in a place unspoiled by light pollution.

[previous]

Oregon USA

Camping at night in early spring on the shoulders of Mount Hood, Oregon-based TWAN photographer Ben Canales had just one thing to say: 'The silence was deafening.'

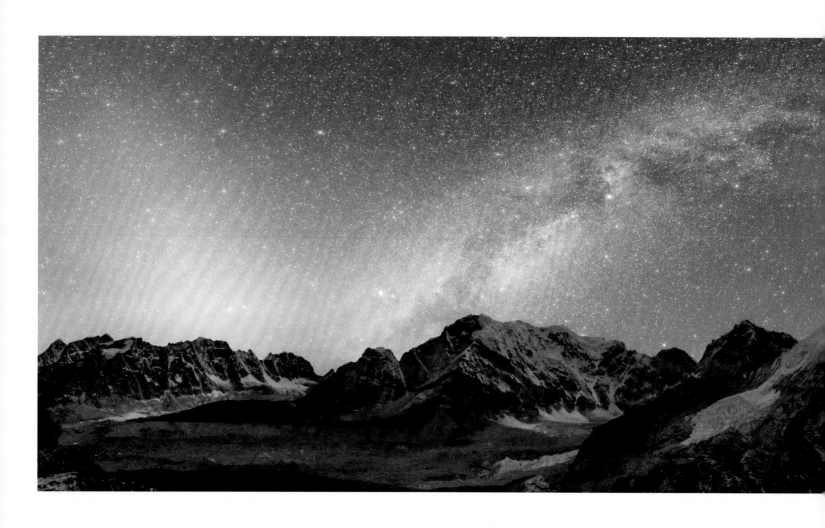

NIGHT REVEALS

Natural night environments and truly dark skies ignite our curiosity, the lens of exploration, but they can also be humbling, reminding us exactly where – and who – we are in this massive universe. It is impossible not to feel a deep-rooted connection to the Earth beneath your feet when standing under a vast galactic ocean. The very darkest skies allow us to witness a range of phenomena that are lost to stargazers in urban areas, where light pollution obscures all but the very brightest stars. These include zodiacal light, caused by sunlight reflecting on the billions of particles of asteroid dust scattered across our solar system. There are also larger particles of dust, which burn up as they zip through Earth's upper atmosphere. These 'shooting stars' leave a fiery wake behind them as they go.

Some of the most dramatic experiences can be found in lofty places, such as the Himalayas of Nepal, where the high altitude allows for stunningly transparent, crystal-clear skies, or in remote ocean locations, such as Easter Island in the southeastern Pacific Ocean. It is in such places that shooting stars and zodiacal light are frequent night-sky occurences.

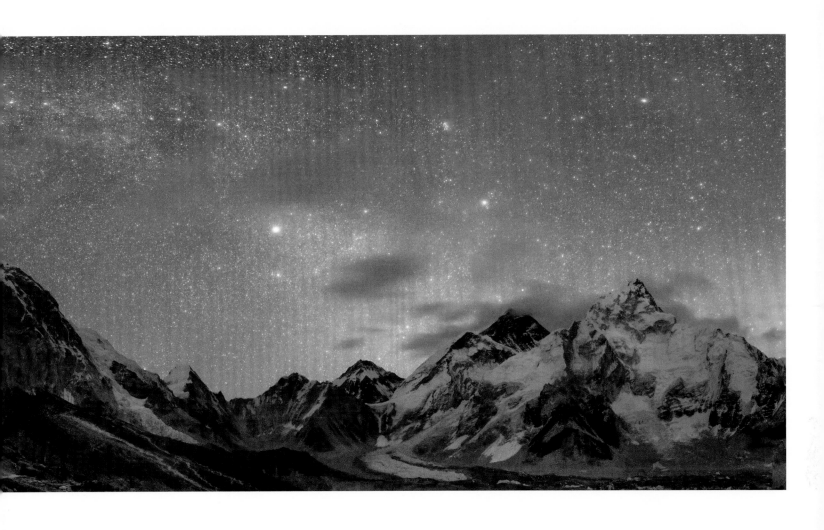

Sagarmatha National Park NEPAL

The World Heritage Sagarmatha National Park is home to Mount Everest and several other spectacular peaks, including Lhotse and Ama Dablam. In order to capture this image, the photographer climbed to an altitude of 5,550 m (18,000 ft) on Kala Patthar to view Everest from its base camp to its peak – no mean feat, since working in the dark night, at high altitude and in perishing temperatures can be extremely dangerous. Recorded on a surreal evening in December, this long panorama opens on the left with a diagonal band of zodiacal light, followed by the Milky Way in the constellation of Cygnus (the Swan). Beside the red cloud, the North America Nebula, the bright star Deneb (centre left) marks the tail of the celestial swan. A massive star, some 100,000 times more luminous than our sun, Deneb shines brightly in the Earth sky from around 2,600 light years distance, with a light that comes from the time when the ancient Kirati people created the first Himalayan kingdom. Further along the faint Milky Way band, the constellations of Cepheus and Cassiopeia (top), stand above Pumori (7,161 m/23,500 ft), the closest peak in the view. The panorama ends on the right with the rising winter stars Capella and Aldebaran, just where clouds are forming above Nuptse and the Khumbu Glacier, the world's highest. To the right of the glacier is the tallest point on our planet, the 8,848 m (29,000 ft) summit of Everest.

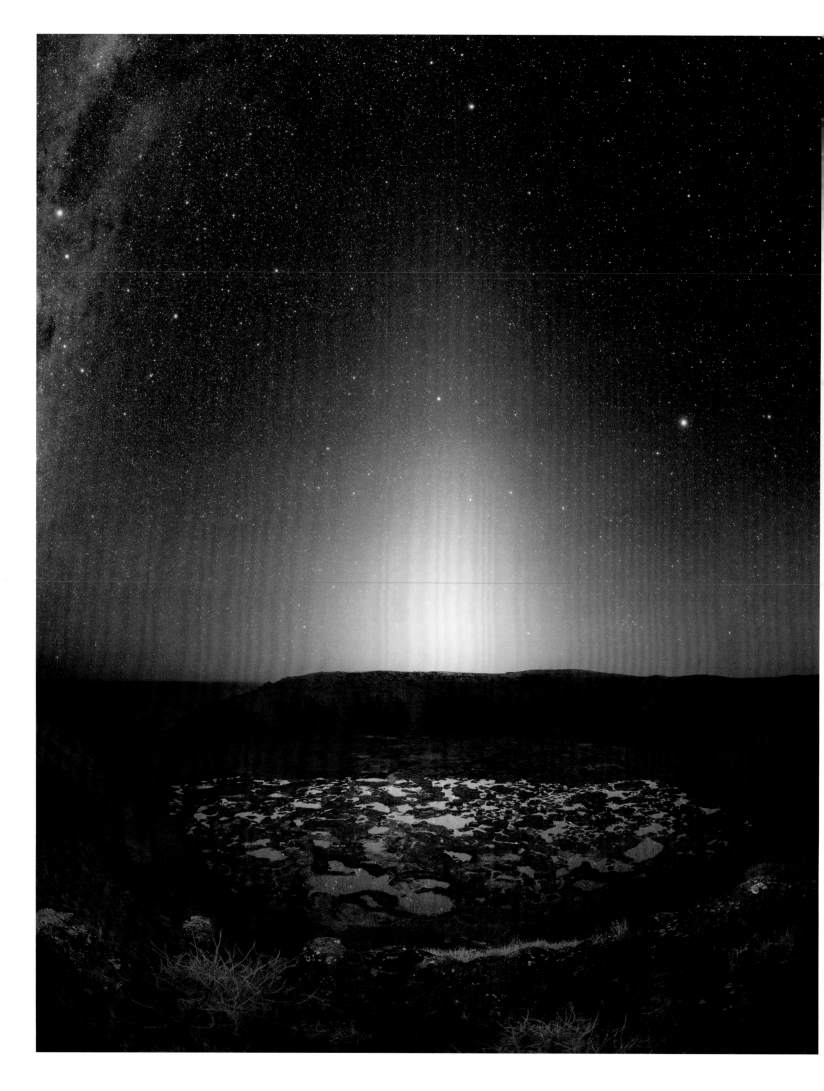

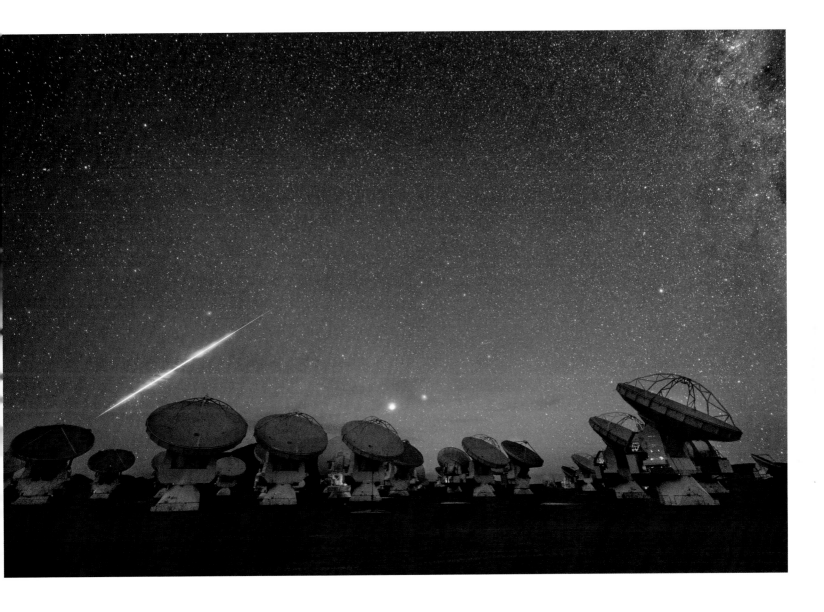

[opposite]

Easter Island CHILE

Zodiacal light shines above Rano Kau's volcanic crater lake on this remote Pacific island, best known for its mysterious moai statues. The unusual triangle of light, sometimes referred to as a 'false dawn', is visible before dawn and after dusk, but only under dark skies. While such light is visible all year round in tropical areas, in mid- and high latitudes it appears better in the pre-dawn of late summer and after dusk of early spring, because the orientation of the dust band at these times is near vertical and not dimmed or blocked by the horizon.

[above]

San Pedro de Atacama CHILE

High above the Chilean Andes, a shooting star zooms past the sixty-six, high-precision antennas of a desert space observatory, perched some 5,000 m (16,400 ft) above sea level. Beneath the meteor, some of the antennas of the Atacama Large Millimeter/submillimeter Array (ALMA), which can operate together as a single giant telescope, keep an eye on far more distant space phenomena. Just above the antennas, at the centre of the image, Mars and the star Spica, the brightest star in the constellation Virgo, burn brightly in the night sky.

Gulf of Oman IRAN

This November nightscape is notable for its 'glow'. The foreground surf glimmers blue with the light of bioluminescent plankton. Across the water, Earth's atmosphere dims the horizon, creating opaque clouds. Above them, the planet Venus glows bright at the centre of the image. There is a diagonal beam of zodiacal light crossing behind Venus, while, much further away, also rising diagonally and forming a 'V' with the zodiacal light, is the central band of the Milky Way. Most of the billions of Milky Way stars and dark clouds are thousands of light years away.

MOON

The moon plays an essential role for life on our planet – not just as a light source, but as a bodyguard, protecting Earth's surface from space debris. Since the dawn of time, the moon has obstructed some of the deadliest asteroid impacts. Being one of the largest moons in the solar system and in a close distance to us, it is also the main reason for Earth's tidal patterns. The lunar gravitational force pulls our oceans in and out from 400,000 km (250,000 miles) away. Without these tidal forces, the evolutionary path of life on Earth may have developed very differently. Even then, our ancestors would not have benefitted from the practical and simple time-keeping offered by the lunar cycles, that was so critical to the farming that advanced human societies.

The enduring influence of Earth's celestial neighbour is also widely evident in art, culture and science and spans cultures across the globe from ancient history to the present day. We are so used to the moon that we often forget its cosmic identity; it naturally fits with our surrounding environment. Yet, for a car travelling nonstop at 100 kmh (60 mph) it would take six months to travel the same distance as the reflected moonlight that reaches Earth. Next time you see a full moon rising at dusk, remember this, and it will become an unusual sight.

Cape Sounion GREECE

In this photo sequence, each shot just one minute apart, a summer solstice full moon rises above the 2,400-year-old Temple of Poseidon, which sits atop a 60 m (200 ft) tall hill facing the Mediterranean Sea on the southernmost tip of the Attica peninsula. This incredible effect is captured using a telescope or long telephoto lens and achieved through precise planning to ensure the distance from the monument enables the moon to appear in similar scale to the landmark. The primary task in such an exercise is to calculate the moon's physical azimuth – that is, its angle to the horizon – and altitude in relation to the monument, so that the two are seen in perspective from the viewpoint of the photographer. For this set of images, the photographer was approximately 1,280 m (3,200 ft) northwest of the foreground.

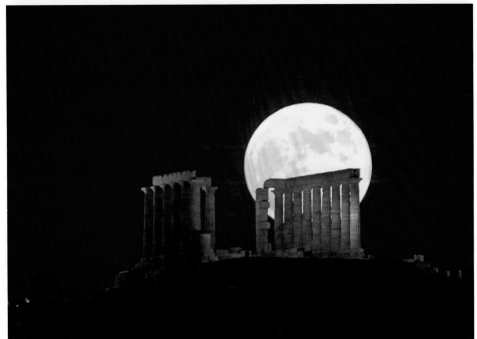

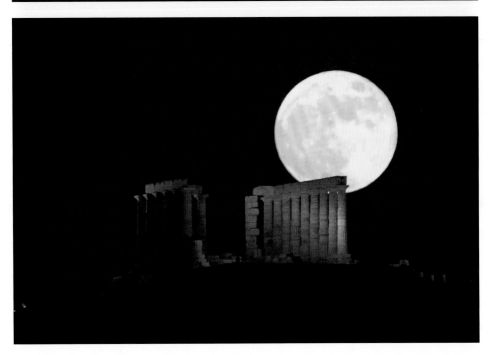

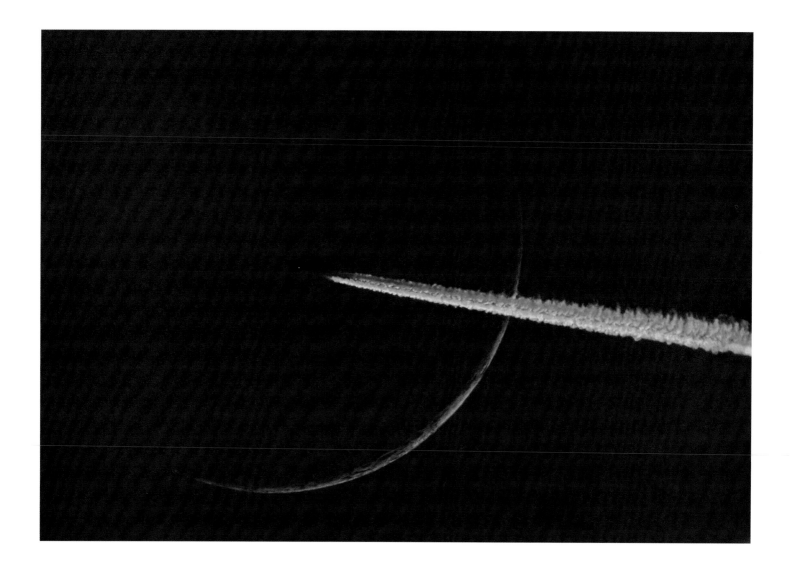

Stuttgart GERMANY

Just thirty-four hours into a new moon, this unique image was captured using a telescope. When calculating the lunar phase age, the time frame begins with solar conjunction – when the Earth, moon and sun, in that order, are approximately in a straight line – or the closest approach of the moon to the sun in the Earth sky. This is called the 'new moon moment' and the moon remains invisible in the sun's glow for a day or so. Though the slim crescent is relatively faint, it is visible low in the west as the sky grows dark after sunset. At the time of this lucky capture, the moon was already 12 degrees above the horizon and the sun was just setting below it, its rays hitting the jet stream of the high-altitude aeroplane.

Réunion SOUTH INDIAN OCEAN

One of the most active volcanoes on the planet, Piton de la Fournaise on Réunion Island is photographed erupting at dusk, with a full moon rising. There has been much research as to whether or not the moon's tidal force can trigger volcanic eruptions on Earth. In fact, the moon plays a minor role in increasing seismicity and volcanic activity – up to 1 per cent during full and new moons, when tidal forces on our planet are combined with the sun. However, some researchers discovered that volcanic activity becomes increasingly sensitive to tidal forces when magma pressure reaches critical levels.

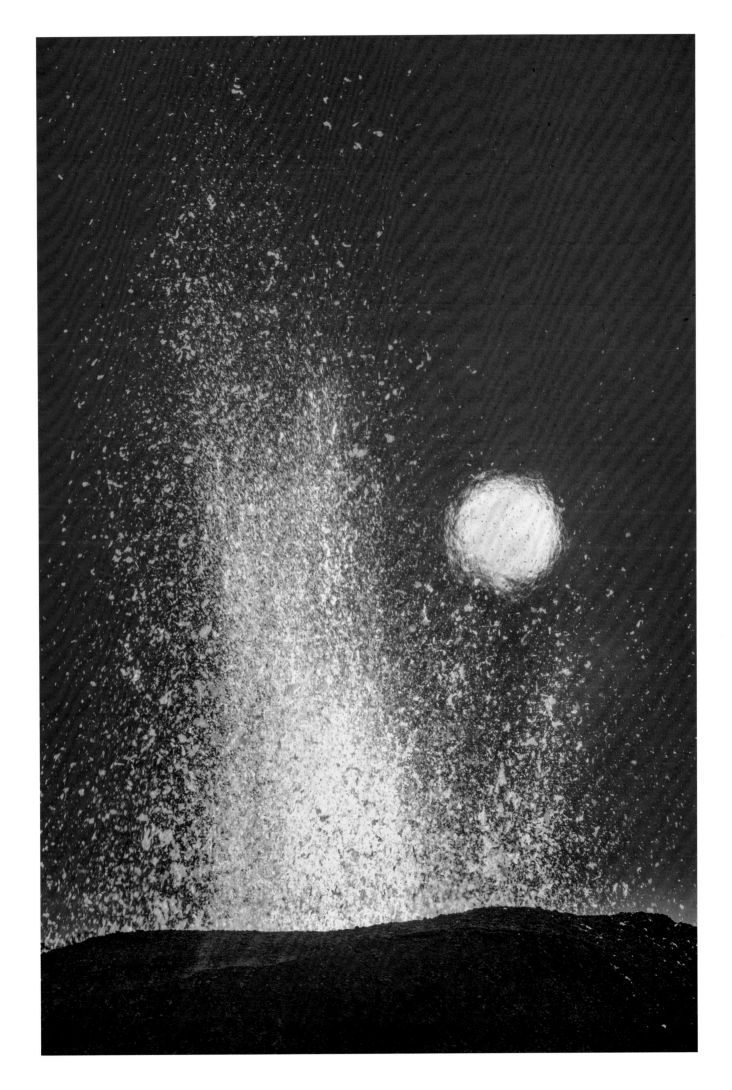

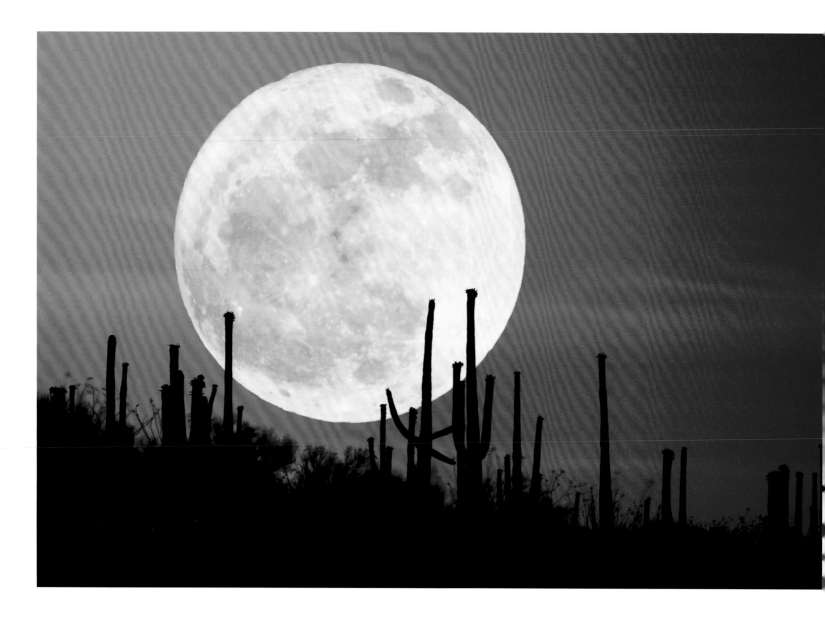

Saguaro National Park, Arizona USA

Using a telescope from a distance, this single-exposure photograph captures the full moon rising in a colourful desert dusk above the endless plains of Saguaro cactuses near Tucson. It is the moon's close angle to the horizon that causes its yellow colour, much in the way that the rising or setting sun reddens. In both cases, the result is due to atmospheric scattering. At the horizon, the light of celestial objects passes through a thicker layer of air to reach the observer and the light becomes weaker and more scattered.

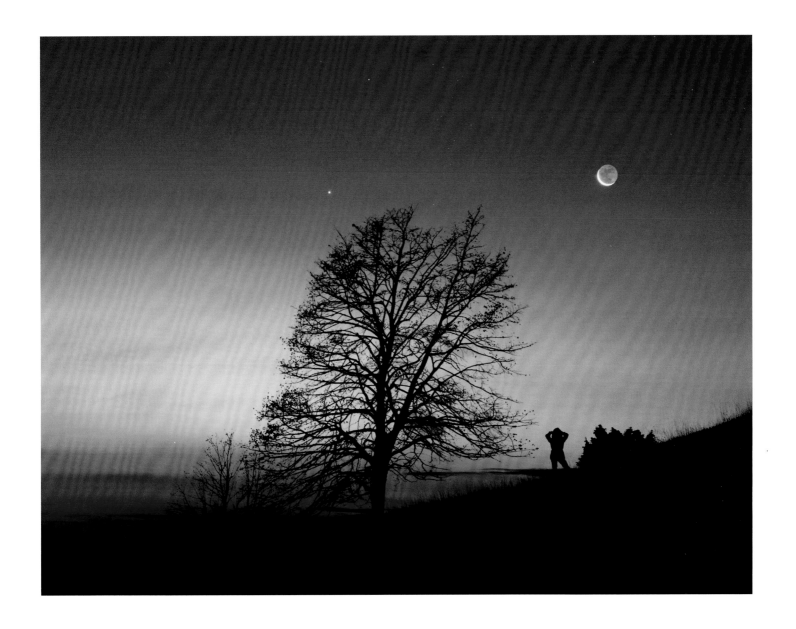

Nördlingen GERMANY

A celestial gathering of three bright planets – Mercury (lowest), Venus (middle) and Saturn (top) – as they join the moon in the morning sky. This beautiful phenomenon was captured at Nördlingen, a town in Bavaria that, amazingly, is located in the middle of a giant 24 km (15 mile) wide meteorite crater, called the Nördlinger Ries. The 15-million-year-old crater is mostly eroded now.

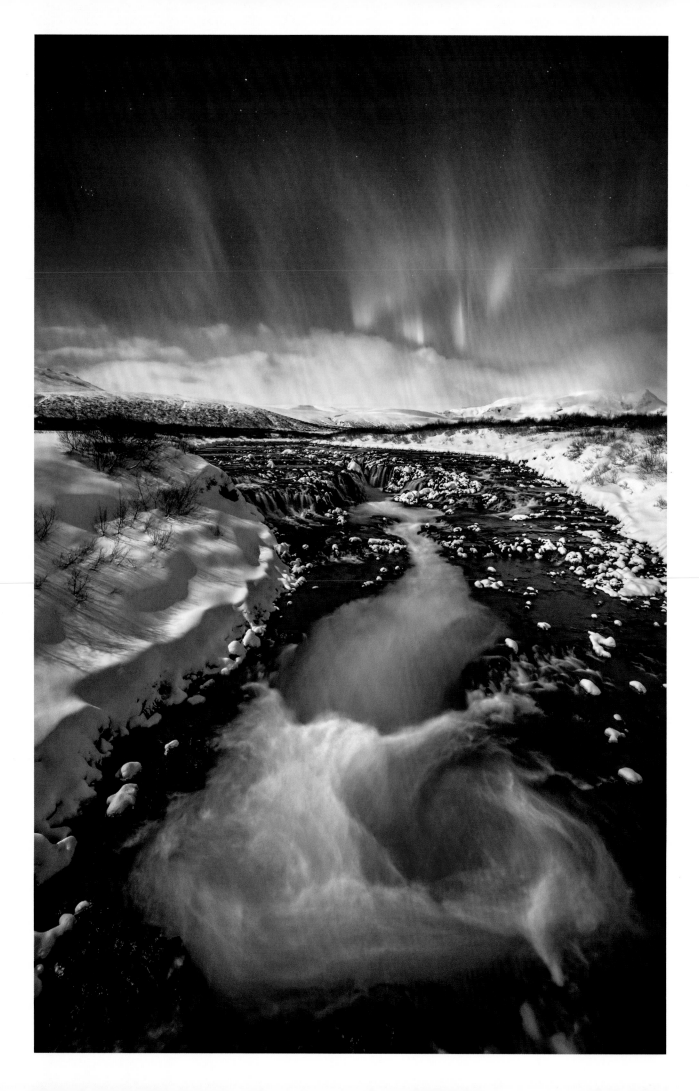

AURORA

The dancing lights of the aurora borealis and aurora australis are better known as the Northern and Southern Lights. They occur when high-energy, charged solar particles collide with the Earth's upper atmosphere, typically at an altitude range of 90–150 km (55–95 miles). A giant oval ring forms around each of the magnetic poles, extending some 4,000 km (2,500 miles) on average, with light shows increasing in frequency further away from the centre. In the highest altitudes, the lights are red, changing to blue and green in lower altitudes. Earth's magnetic poles are in slightly different locations to the geographical ones. For example, the North Geomagnetic Pole is currently in the Canadian Arctic at a latitude of 80 degrees north and a longitude of 73 degrees west, and is shifting half a degree higher per decade. This means that places with similar longitudes to the magnetic pole have higher magnetic latitudes, and therefore see more aurorae because these places are closer to the magnetic pole and the auroral oval, compared to similar latitudes on the other opposite side of the world. For instance, both Montreal and Milan have a latitude of 45, but their geomagnetic latitudes are 55 and 48 respectively because North America sits under the geomagnetic pole and as we move eastward we move away from the aurora oval. This is reverse in the southern hemisphere.

In the northern hemisphere, the lights are particularly prevalent in North America – especially in the eastern half – the North Atlantic and Scandinavia. In the southern hemisphere, they are frequently visible in southern New Zealand and Tasmania, although not as magnificent and frequent as Northern Lights in the Arctic due to the vast Southern Ocean separating the mainlands from Antarctica and the South Geomagnetic Pole. There is a particularly deep connection between people of the far north and these majestic dancing lights. The Sami people in Lapland, which encompasses northern Norway, Sweden, Finland and northeast Russia, traditionally believed that the Northern Lights were the energies of departed souls.

Brúarfoss Waterfall ICELAND

Green aurora borealis streak the sky in the bright light of a gibbous moon, above fresh blue glacier water. Although a bright aurora is visible in full moonlight, most aurora chasers look for moonless nights. There are more than 10,000 waterfalls in Iceland, ranging from the strikingly massive Gullfoss and the immensely powerful Dettifoss. But the small Brúarfoss Waterfall photographed here has something else. This less visited, 'hidden' waterfall, is an amazing natural wonder with bright blue water, unlike any other.

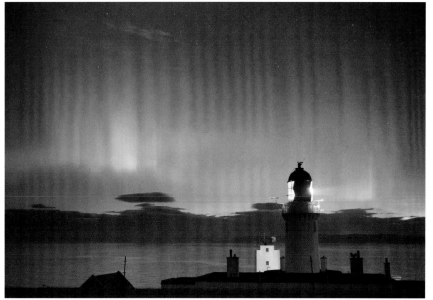

Caithness SCOTLAND

On a clear evening in late August, the Northern Lights put on a show over Dunnet Head, the most northerly point of the British mainland, at a latitude of 58.7 degrees. Aurorae can appear on any dark night in the polar latitudes, except on nights close to the summer solstice, when the sky does not grow dark enough. Close to the Arctic Circle, at a latitude of 66 degrees, the night sky is too bright from mid-April to early September. In lower latitudes, such as those of northern Scotland or southern Canada, there is enough darkness, even in the summer, especially close to midnight.

Tasmania
AUSTRALIA

The lights of the aurora australis burst in the sky above Tasmania's Southern Ocean coastline. This is one of the best places in the southern hemisphere to see the lights during strong activity. The moon is on the upper right in this fisheye wide-angle image.

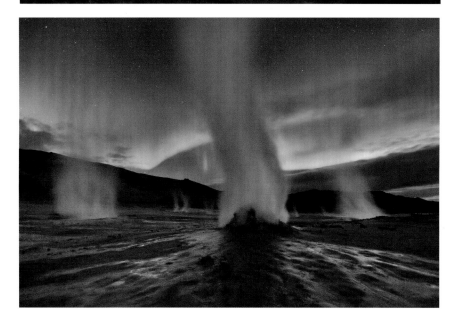

Mývatn
ICELAND

The unearthly landscape of Iceland in this dark night resembles a science-fiction scene from another planet. On a geomagnetic storm night in September, in the country's northeastern volcanic landscape, the ghostly towers of steam and gas venting from fumaroles in the geothermal area of Hverir are seen against the eerie greenish aurora light.

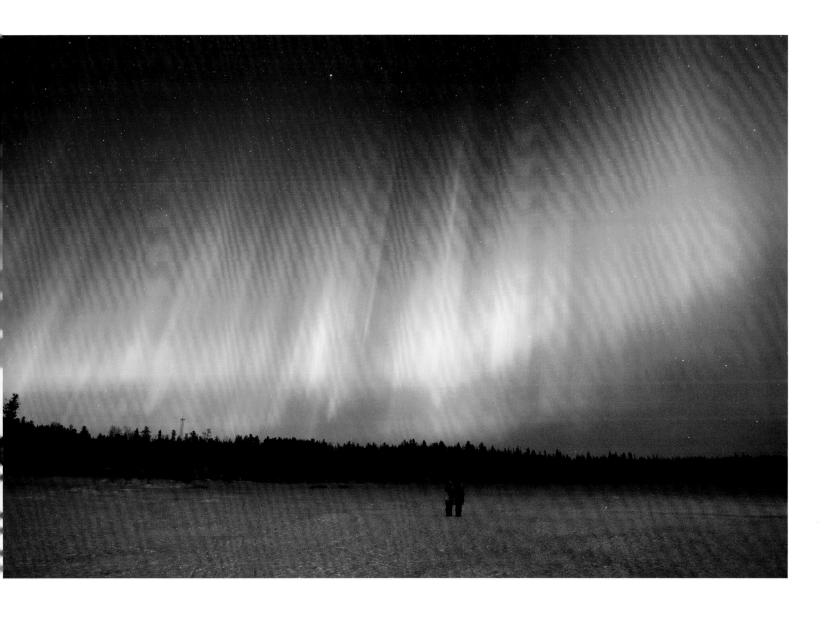

Northwest Territories CANADA

A solar storm creates an aurora-filled sky on reaching Earth near the town of Yellowknife, Canada. On this night, the aurora oval around the North Geomagnetic Pole was so enlarged that it passed through Yellowknife to reach lower latitudes. The photographer's northern horizon was empty of lights for some time and he could only see the red upper edge of the aurora above the southern horizon. In such an intense aurora display, the lights activate our eyes' colour-reading cone cells, making it possible to see the incredible light display unaided.

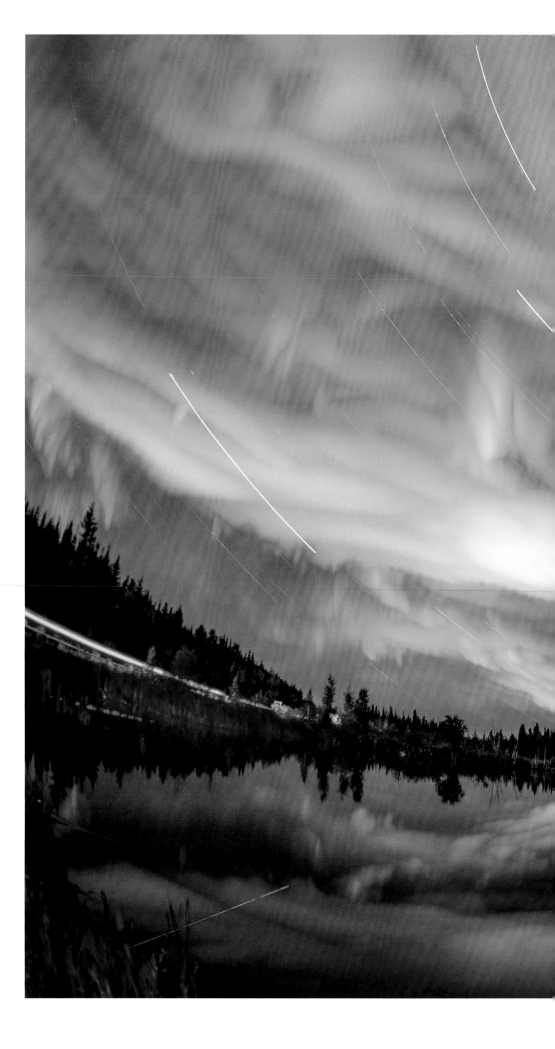

Northwest Territories

CANADA

Reminiscent of the postimpressionist
works of Vincent van Gogh, which
feature twisted celestial forms, this
long-exposure image – actually
a combined photo sequence –
demonstrates how actively dancing
aurora ribbons fill the sky during the
course of an hour. Photographed
from Yellowknife on a clear, windless,
moonlit night of September, the calm
lake reflects the aurorae. Bright star
trails peer through the mesmerizing
Northern Lights, adding to the
incredible scene.

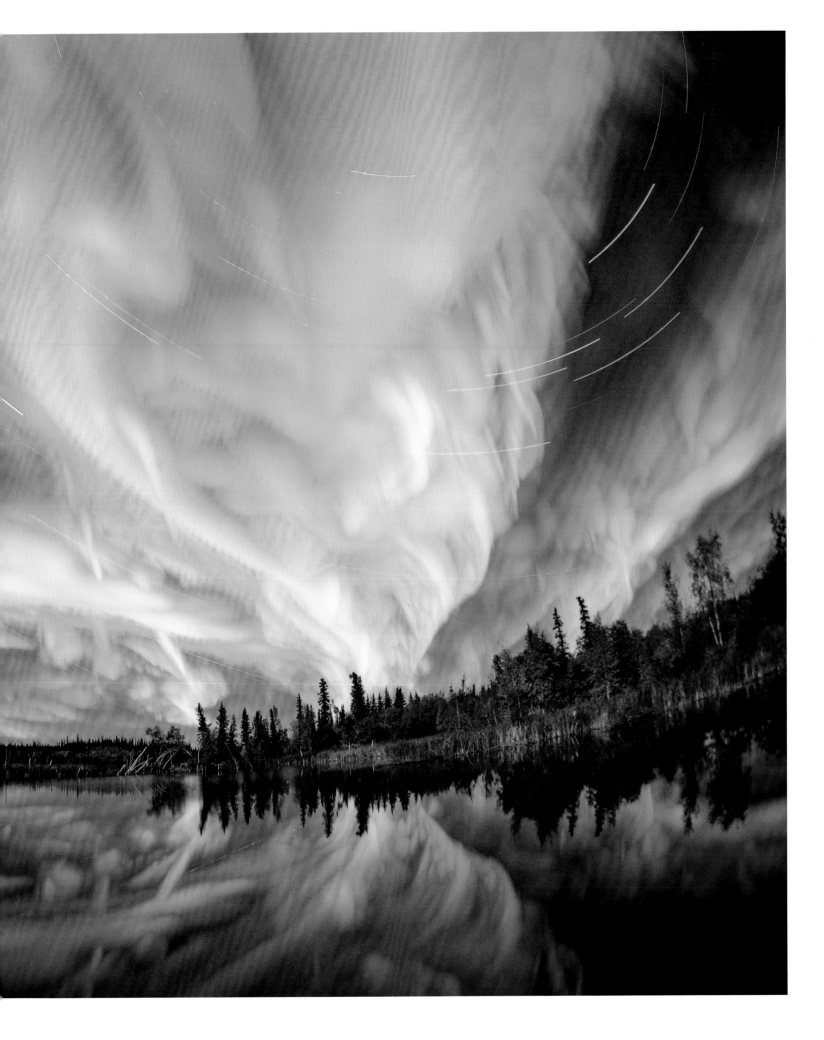

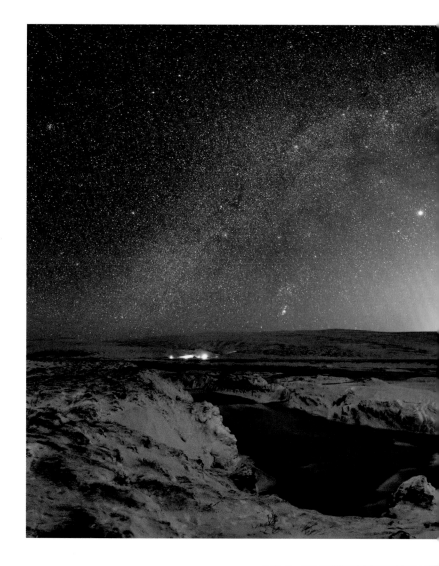

Goðafoss ICELAND

In this panorama, above the Icelandic boreal
landscape, the arc of the Milky Way and
shimmering aurorae flow through the night.
Echoing their forms, below them lies the
spectacular Goðafoss, the Waterfall of the Gods.
In the year 1000, the leader of Iceland made
Christianity the official religion of the country
and symbolically threw his statues of the Norse
gods into this waterfall.

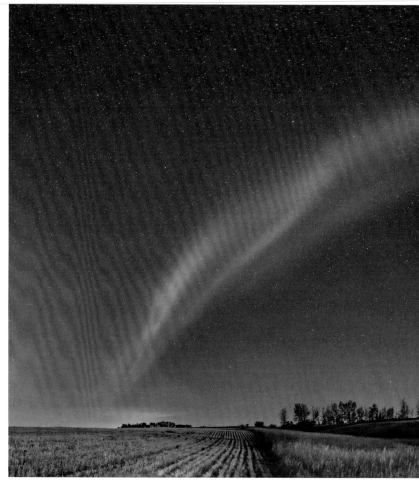

Alberta CANADA

A phenomenon known as STEVE (Strong Thermal
Emission Velocity Enhancement) crosses the full
sky horizon, with the setting moon and late
summer Milky Way as a backdrop. The isolated
arc always defines the most southerly extent of
an aurora, more frequently visible further away
from the polar circle in latitudes between 50 and
60 degrees. For the few minutes that it lasts, it
usually sits motionless, featureless and colourless
to the eye, though the camera can pick up
magenta and green tints.

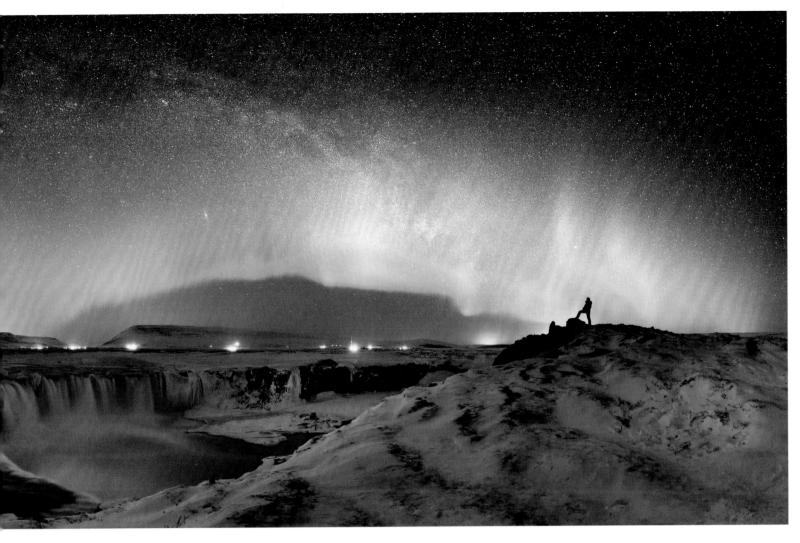

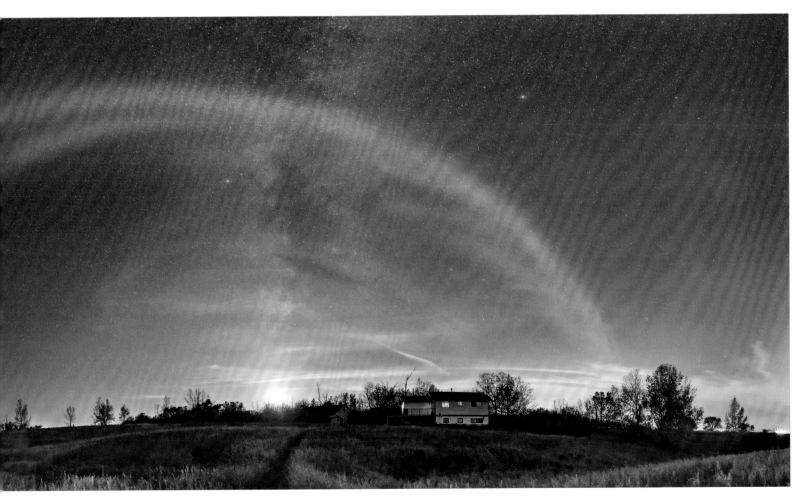

Northwest Territories CANADA [opposite]

The Northern Lights take on a spooky form above the frozen winter landscape of the far north. Aurorae appear in various forms – extended arcs that reach from the northwestern horizon to the southeast; colourful rays and curtains coming out of an aurora arc; vertical pillars; and faint pulsating patches. The most majestic form is a corona. Appearing overhead, the crowns appear to melt in colour and shape by the second and can become bright enough to illuminate the surrounding landscape. This dazzling appearance is often followed by an all-sky colourless aurora veil, faint enough to be mistaken for high cloud.

Lapland SWEDEN [above]

Like a snow-globe celebration of winter, the Northern Lights are captured in this full-circle image using an 8 mm fisheye lens. In this village between Kiruna and Abisko National Park, at a latitude of 68 degrees north inside the Arctic Circle, the little trees hold frozen ice after a snowburst.

SEASONAL SKY

As Earth travels around the sun, our night window onto the galaxy changes where the sunlight obscures a different part of the night sky. Earth's constant motion moves every single one of us at the incredible speed of 30 km/s (18.5 mp/s), travelling 2.5 million km (1.5 million miles) every day. This shifts the Earth 1 degree in its orbit, which causes every star in the sky to shift 1 degree each night, when viewed at the same time and from the same place on the planet. It means that stars appear to rise, cross the sky, and set four minutes earlier each night. This equates to one hour earlier in fifteen days and two hours earlier in one month and accounts for us seeing a different constellation each season.

At night in a northern hemisphere summer, the Earth faces the bright central bulge of the galaxy. In winter, the night window is to the outer suburbs of the galaxy, making the Milky Way band appear faint and sparse. However, this is the time of the year when the brightest stars appear. Sirius, just eight light years distance from the sun, is a symbol of the northern winter sky. Five other bright stars in the constellations of Orion (the Hunter), Taurus (the Bull), Auriga (the Charioteer), Gemini (the Twins) and Canis Minor (the Little Dog), complete the Winter Hexagon, the giant asterism that summarizes the shimmering celestial beauty of the northern hemisphere winter sky.

Sichua CHINA

A starry sky above Mount Jampayang at the break of dawn includes bright star Sirius on the left, prominent constellation Orion (the Hunter) in the middle and Aldebaran at the top right of the image. Marking a shoulder of Orion is bright star Betelgeuse (top). This red giant, 1,000 times larger in diameter than the sun, is at the very end of its life, waiting to stun the galaxy with its supernova explosion. At about 600 light years away, it's one of our closest supernova candidates. When that happens, anytime in the next several thousand years, it may outshine the full moon in the Earth sky.

Gunma JAPAN

Bright stars Vega, Deneb and Altair form a large triangle known as the Summer Triangle, which can be seen rising during the morning in early spring in the northern hemisphere, and setting during the evening in the northern autumn. In summer months, the triangle is almost overhead close to midnight. Taken in April, this photograph features a triangular shape of its own – of a blossoming 500-year-old cherry tree.

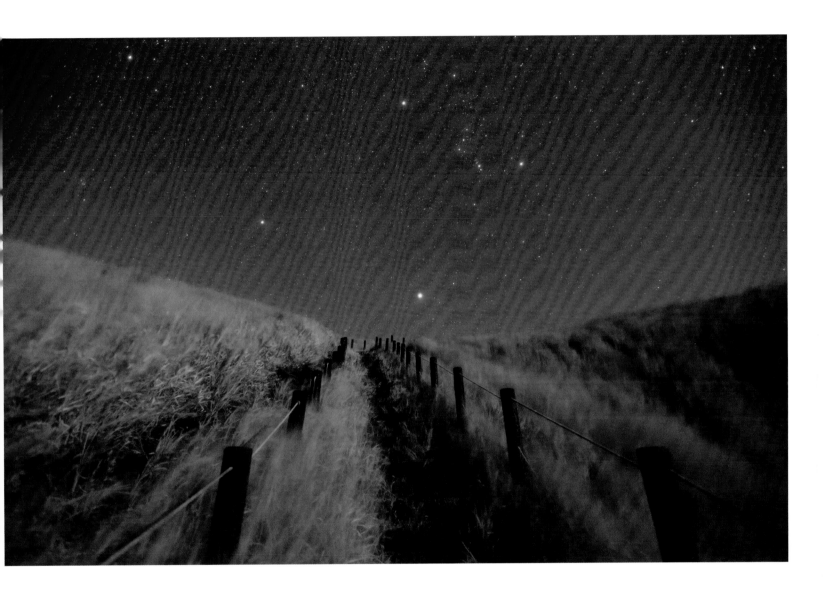

Shizuoka JAPAN

In this February night on Izu Peninsula, on the eastern coast of Japan, prominent northern hemisphere winter stars appear in a gentle moonlight. Sirius is in the middle, with Procyon in Canis Minor to the left.

SOUTHERN SKY

The true beauty of the Milky Way is best showcased in a dark southern sky. In the northern latitudes, the bright galactic core stays low on the southern horizon, but from the tropics and the southern hemisphere, this most impressive element of the night sky reaches overhead. It is from here that you can sense being in the suburbs of this gigantic galaxy, an 'island universe' as German philosopher Immanuel Kant put it in 1755.

To the Australian Aboriginals, the band and the dark dust lanes in the Milky Way, together with the galactic bulge at zenith represents 'emu in the sky', a constellation defined not by stars but by the dark nebulae, opaque clouds of dust and gas in outer space that are visible against the Milky Way background. The emu's head is the very dark Coalsack Nebula, next to the Crux (Southern Cross) constellation; the body and legs are other dark clouds trailing out along the Milky Way to the constellation of Scorpius (the Scorpion).

Other southern sky icons are the Large and Small Magellanic Clouds, satellite galaxies of the Milky Way near the outer edge of our galaxy at 160,000 and 200,000 light years away. The first known scientific mention of the Large Magellanic Cloud was in 964 [CE] by the Persian astronomer Sufi, in his night sky guide *Book of Fixed Stars*. The cloud is not visible from Iran, but was observed on a visit to the tropical latitudes in Yemen, where it's just visible on the southern horizon. It was not seen by Europeans until Ferdinand Magellan's voyage in the sixteenth century – both galaxies now bear his name.

Tongariro National Park
NEW ZEALAND

A starry southern night at Lake Rotoaira in the World Heritage site of Tongariro National Park, the oldest protected area in New Zealand. The Milky Way spans the southern sky in all its beauty. Captured moments before a midnight moonrise, there is a slight tint of blue moonlight across the sky and bands of red airglow. The 360 panoramic image is projected in a circular format that represents a fisheye view of the entire sky.

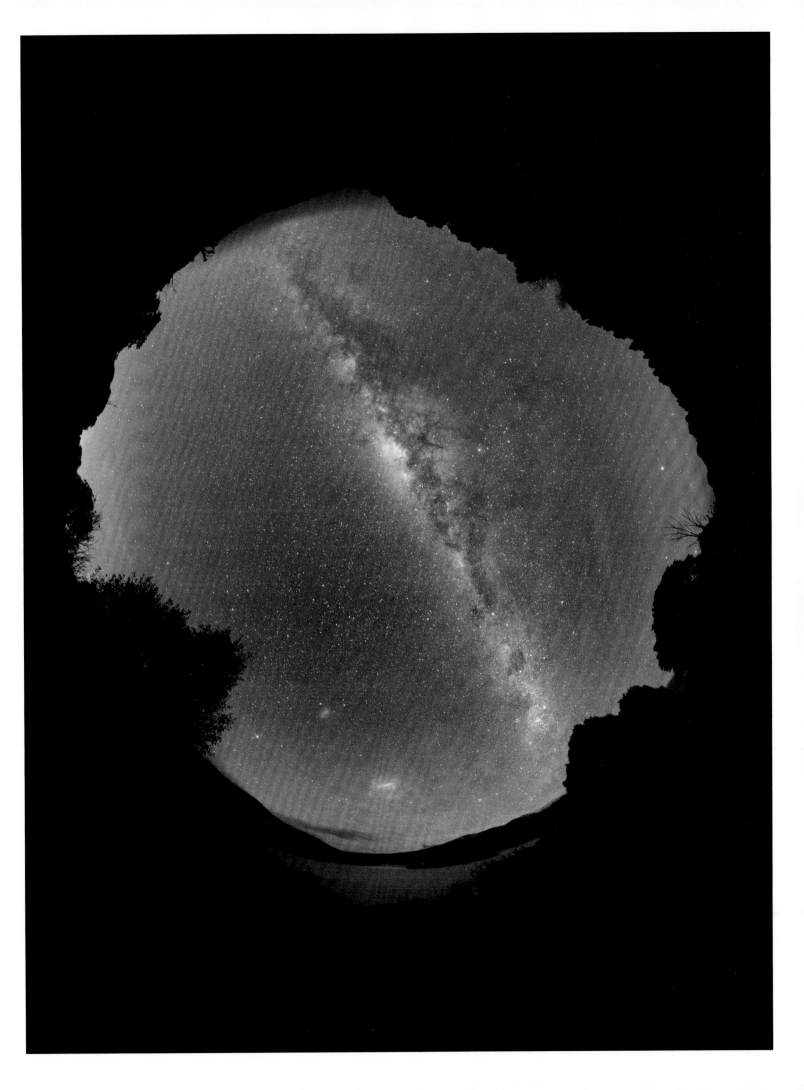

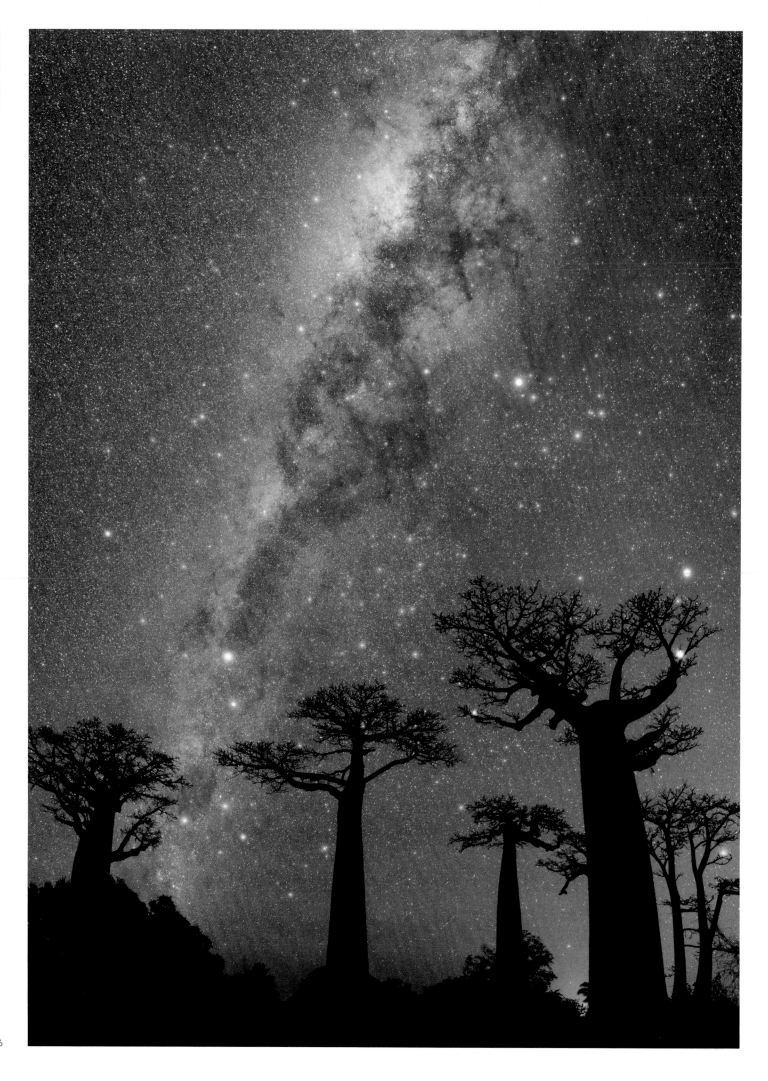

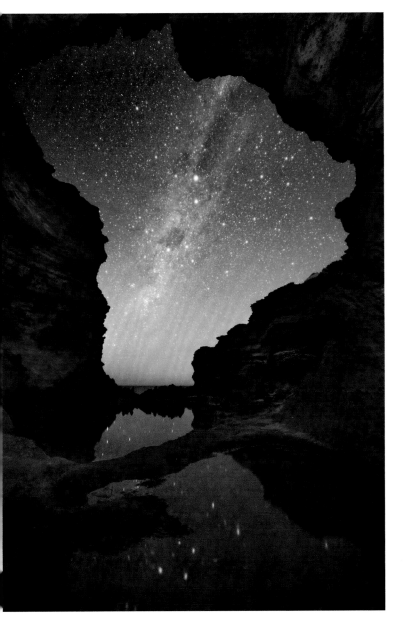

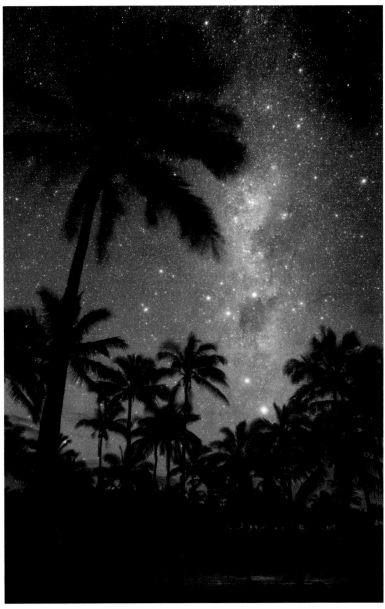

[opposite]

Menabe MADAGASCAR

The iconic Avenue of the Baobabs features trees that are up to 2,800 years old. They are a legacy of the dense tropical forests that once thrived on Madagascar. The core of the galaxy is reaching high in this crystal-clear night, with the bright-orange star Antares at top-right.

[above left]

Victoria AUSTRALIA

The southern Milky Way framed by a grotto on the Great Ocean Road near Melbourne. Alpha Centauri is the brightest star in this view. It is also the closest star system to the sun at 4.37 light years away. The colourful stars of Crux (the Southern Cross) are in the middle of this image.

[above right]

Easter Island CHILE

Appearing at the centre of this image is Crux (the Southern Cross), the smallest constellation in the sky. It is one of the most iconic constellations of the southern hemisphere, having been adopted as a symbol on a number of national flags.

ATMOSPHERIC

Nightscape photography not only reveals the beauty of the night illuminated by the stars and the moon, but also presents an opportunity to record the glowing colours of the air itself. As such, this photography can contribute to the work of atmospheric scientists in helping to understand how the atmosphere above Earth works and reacts to space weather. Observational astronomers study the atmosphere, too. In order to minimize the diffusing effect of air turbulence on the stars they wish to observe, they need to understand how the various layers of Earth's atmosphere work in refracting the incoming starlight. Giant telescopes of today would be useless placed in sites with constantly turbulent air, and so astronomers seek places with steady air, along with dark, clear and transparent skies.

At their brightest, atmospheric night displays are seen as clearly as aurorae. At their faintest, green and orange-red ripples and waves occur, 100 km (62 miles) high, at the very top of Earth's atmosphere. Even in a totally dark sky, this natural emission – known as airglow – may brighten the sky and will be more evident near the horizon. Although colourless to the naked eye, such phenomena can be captured in colour using a digital camera. At much lower altitudes, ice crystals, water droplets and even pollen grains produce their own spectacular effects, hinting at the wide variety of ways in which Earth's atmosphere interacts with light.

Portillo CHILE

Captured here is a highly unusual display of atmospheric airglow. The smooth red gradient in the sky transformed into bizarre shapes at the moment of capture. This is the natural emission from Earth's upper atmosphere, especially strong above South America due to a phenomenon called the South Atlantic Anomaly. This is where the protective Van Allen radiation belt around our planet comes closest to the Earth's surface, releasing more energetic particles into the atmosphere, so creating stronger airglow. Airglow is always visible in night photos of Earth from space, as a very thin green-orange layer just above the planet. Unlike aurorae, which are powered by collisions with charged particles and seen at high latitudes, airglow is due to chemiluminescence – the production of light in a chemical reaction, and found around the globe. Like aurorae, however, the greenish hue of airglow originates at altitudes of 100 km (62 miles) or so, dominated by emission from excited oxygen atoms. The (usually weaker) red light, which is exceptionally bright in this image, is from oxygen and sodium atoms further up.

Gotland SWEDEN

A summer's evening at the World Heritage site of Visby, on the island of Gotland in the Baltic Sea, is painted in electric-blue night-shining clouds known as noctilucent clouds (NLCs). They lie near the edge of space, reflecting sunlight from around 80 km (50 miles) above Earth's surface. They are so high that they still reflect the sunshine deep into the night. NLCs are usually spotted above the polar regions in summer, but occasionally are viewed from lower latitudes with a rare record in Turkey from a latitude of just 40 degrees north.

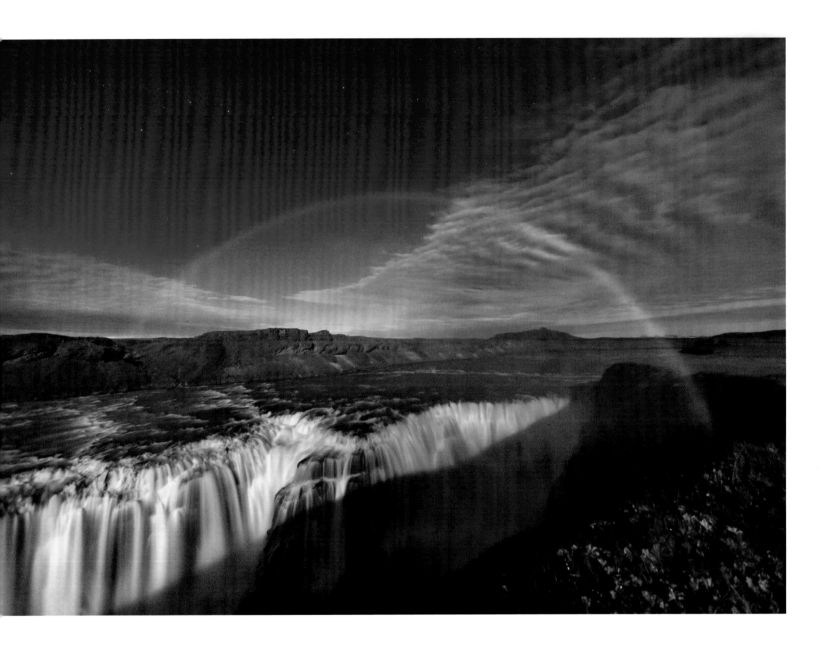

Gullfoss ICELAND

A fantastic view of a moonbow above the massive Gullfoss
Waterfall. A rainbow produced by moonlight is usually
faint, due to the smaller amount of light, and appears in the
opposite part of the sky from the moon. Although it is difficult
for the human eye to discern colours, they show clearly in long-
exposure photographs. This view resembles a paradise, but
the reality is one of extreme wind and ice-cold water spray.

Tenerife SPAIN

The strong anti-crepuscular rays dominate this colourful dusk on the Canary Islands. The panorama is taken from a 3,270 m (10,725 ft) high refuge on the way to Mount Teide's volcano summit. These rays are similar to crepuscular rays at sunrise or sunset, but appear opposite the sun in the sky, converging on the horizon.

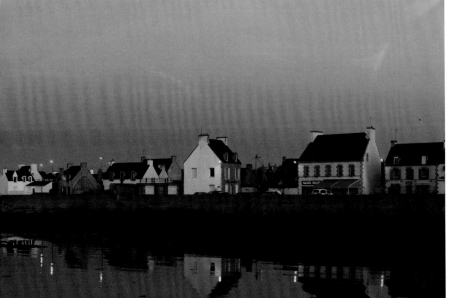

Brittany FRANCE

This long panorama frames a setting full moon in the morning twilight, just as our planet's shadow appears on the Earth's atmosphere itself. The shadow is visible with every clear sunset or sunrise, on the opposite horizon from the sun. Most people miss it, however, owing to haze, closed horizon or simply being unfamiliar with the phenomenon. The pink-red band above the blue Earth shadow is called the Belt of Venus. Beside the moon, the contrail (condensation trail) of an aeroplane casts a shadow in the background sky.

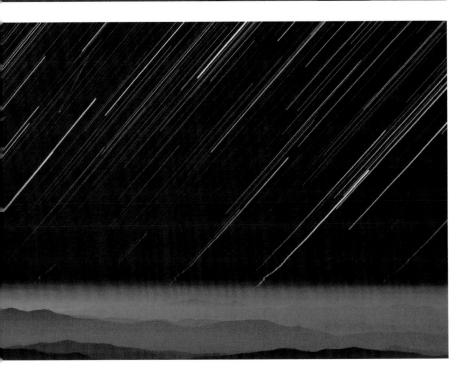

Atacama Desert CHILE

The inversion layer about these mountains in the southern outskirts of the Atacama Desert is lit by the moon and revealed in this telephoto long-exposure, combined-photo-sequence image. A close look at the setting stars reveals that the trails are notably distorted at the horizon. Caused by atmospheric refraction, this is an optical phenomenon in which light rays are refracted and bent in the atmosphere to produce distorted or multiple images of star trails. The light on the horizon also passes through thicker air to reach us, which becomes dimmer and reddened, as recorded here, from the top of La Silla Observatory in this exceptionally open and transparent view.

Himalayas CHINA

In April 2014, this remote plateau at the foot of the Himalayas saw an incredibly rare skyscape produced through atmospheric gravity waves. The waves are revealed due to the layer of airglow. Normally hard to see, a disturbance such as an approaching storm can cause noticeable rippling in the atmosphere. The gravity waves visible in this image are oscillations in air similar to those created when a rock is thrown into calm water. The colours of the airglow, invisible to the naked eye, but captured through photography, include orange from excited hydroxyl radicals and green from oxygen light emissions.

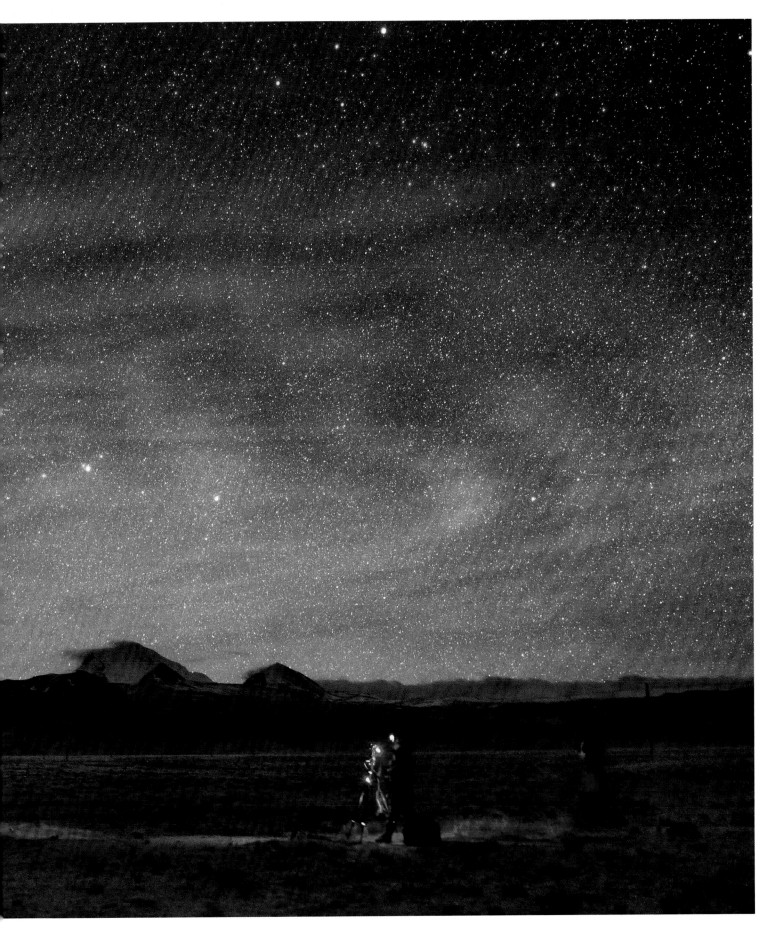

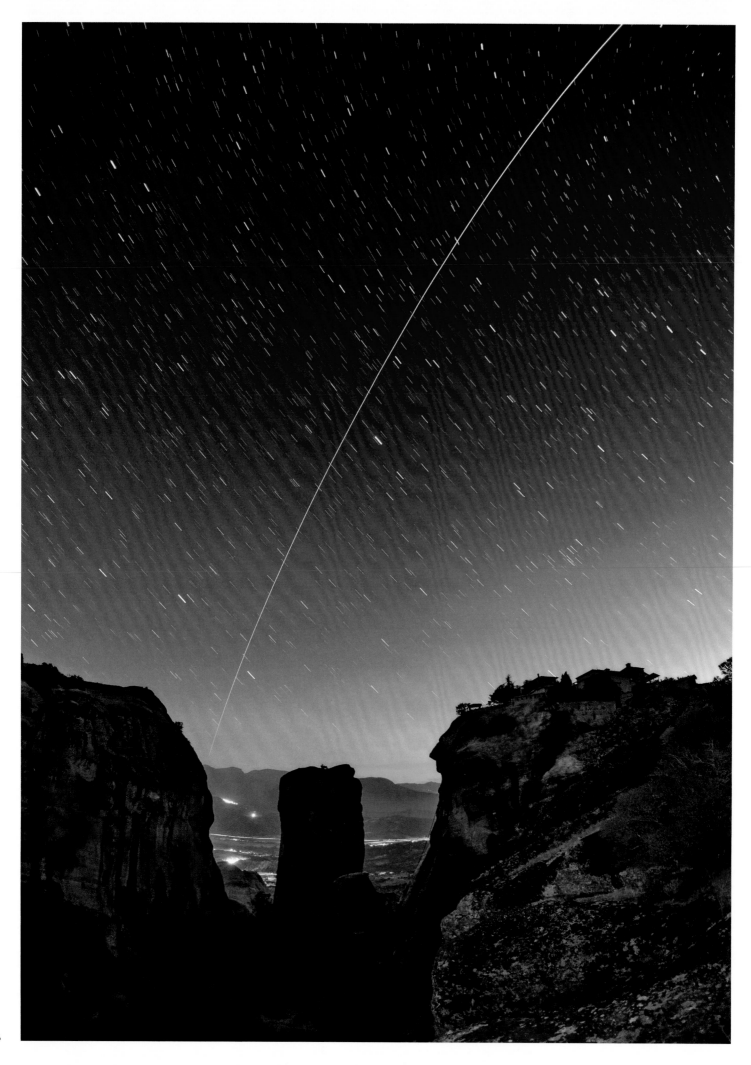

SATELLITES

We have come a long way since the beginning of the space age in 1957, when the little Sputnik was the only artificial satellite above Earth. Today, our planet is encircled by more than 8,000 satellites from around forty countries. Fewer than one-quarter of them are actively operational – the rest have become space debris. But all of them can be observed from the ground. Some need radars and large telescopes, but hundreds of satellites are visible to the naked eye, especially at the beginning or the end of the night, when the objects are in low orbits, are outside of the Earth shadow and, therefore, reflect sunlight. The most prominent satellite in low Earth orbit (LEO) is the International Space Station (ISS). At roughly 400 km (250 miles) altitude, the ISS circles Earth in ninety minutes, completing fifteen orbits per day. Not all of these orbits pass above each one of us and some will pass through Earth's shadow, but you can frequently see the space station if you know exactly when it will be passing over your specific location.

The ISS can be astonishing to watch. It often shines brighter than any star, but can also rival the brightness of Jupiter and Venus when passing overhead. At 108 m (355 ft) wide, it is the size of a football field, thanks to its enormous solar panels. With a good pair of binoculars, it can actually be seen as a moving disc, and not just a point, especially when it is near zenith.

Also in LEO, but higher than the ISS, is the Iridium constellation of sixty-six active satellites providing global satellite phone coverage. Due to their small size they are naturally dim, but can briefly outshine Venus and illuminate a dark night landscape for a few seconds. These so-called Iridium Flares happen due to the highly reflective aluminium flat plates on the satellites' main antenna. As the satellite rotates around itself and moves in the orbit, each observer may see a flare of a few seconds at various times.

Meteora GREECE

The International Space Station passes overhead in this three-minute exposure. Favourable passes like this – that is, unobscured by other objects or the Earth's shadow – can be seen crossing the sky from horizon to horizon.

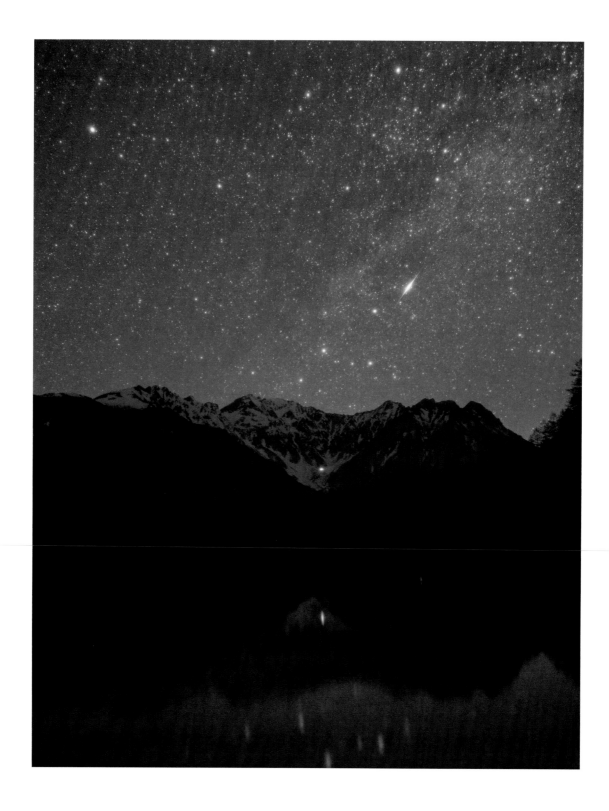

Nagano JAPAN [above]

A star-filled spring night at Lake Taishō in Kamikōchi with Polaris (upper left), Cassiopeia (centre) and a streaking light. The streak resembles a meteor, but is created by a satellite reflecting sunlight while rotating around itself. This remote mountainous highland valley has been preserved in its natural state within Chubu-Sangaku National Park and designated as one of Japan's National Cultural Assets.

Munich GERMANY [opposite]

Marienplatz, the central square of Munich, captured using a fisheye view. The time-exposure image, made up of a photo sequence of shorter exposures, presents the rotating sky in the form of star trails and the International Space Station. The short trail near zenith is a flaring Iridium satellite.

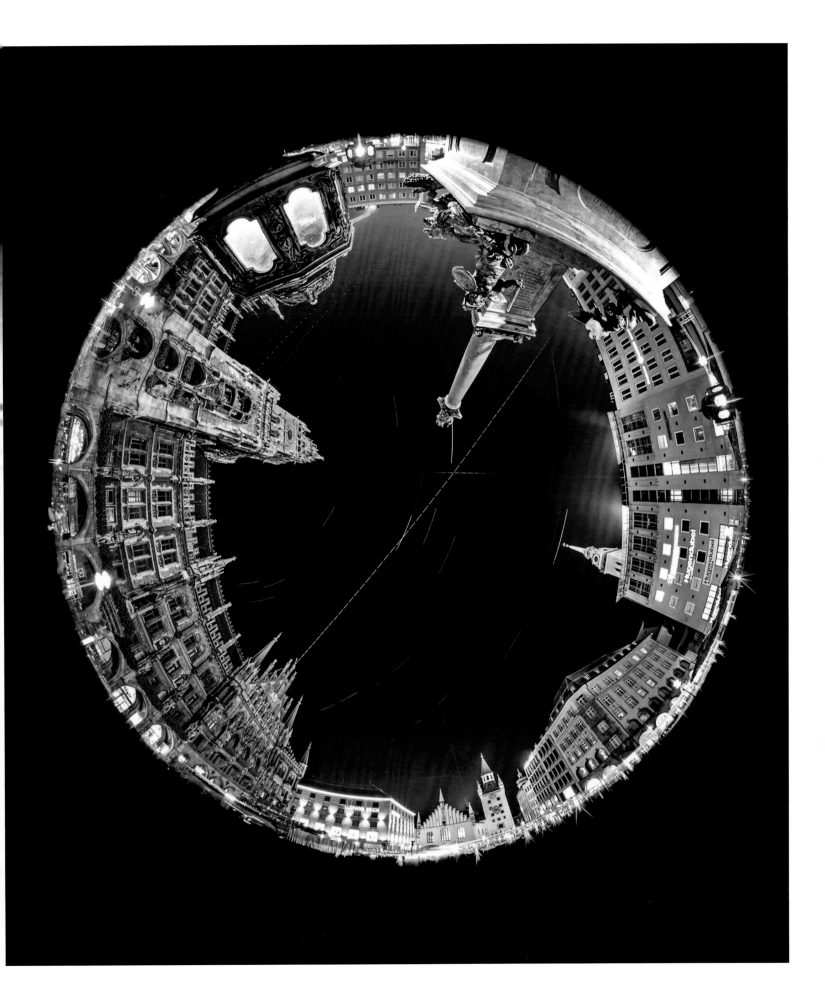

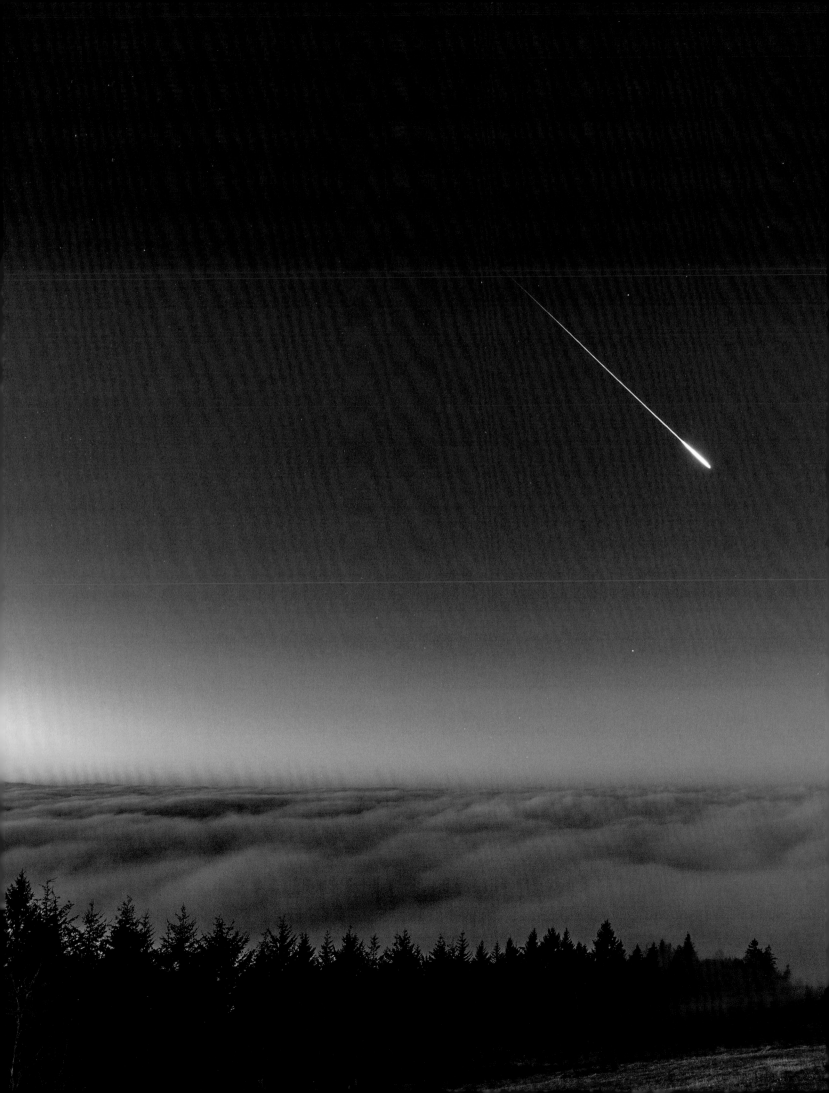

Events That Shook the World

THE NIGHT SKY IS AN EVER-CHANGING DISPLAY OF MOST IMPRESSIVE NATURAL PHENOMENA.

In our day-to-day existence, few of us take the time to contemplate the very dynamic nature of the night sky, or to consider that this natural theatre might be screening more than one film over and over again. To many of us, the naked-eye view of our galaxy does not seem to change at all in the lifetime of a human being but, in fact, countless celestial events are happening within our solar system all of the time.

These are the events that draw stargazers across the world to gather and bear witness. Every time there is a total solar eclipse, thousands of people travel to where the moon shadow travels across the Earth's surface. Something deep inside of us is touched during these brief moments of totality. We understand the physics and geometry of the phenomenon, but when viewed for the first time it can stir almost primeval instincts within us, leaving us in awe of the natural takeover of this event. It can be an incredibly emotional experience. While this phenomenon appears to be repeating in the same shape, each one of its daytime nights is utterly unique, depending on how the immediate environment reacts to the mysterious darkness of totality that can last anywhere from one second to seven minutes. Beyond their dramatic day-to-night shift and scientific importance, eclipses have also made a cultural impact in their time, seen by past civilizations as a warning from the gods. Even today, these irregular events remain a powerful and connecting experience. Eclipse-chasers from a multitude of cultures and beliefs come together under the lunar shadow and are united through a common passion.

One of the most spectacular scenes in a dark night sky – one that rivals the beauty of the Milky Way, even – is the appearance of a great comet. Seeing its extended tailburn across the sky makes for a truly memorable experience. The most impressive in recent history was the incredibly vivid Comet Hale-Bopp in 1997, visible even from metropolitan areas. In more rural locations, it was the most unusual sight, with both the dust and ion tails distinctively visible, and appearing many times larger than the moon. The comet's icy nucleus measured roughly 50 km (30 miles) in diameter and had a lower light density than water, but the comet's tail, although consisting of very little mass, extended further than 100 million km (62 million miles) into the solar system – two-thirds of the distance from Earth to the sun. This made it visible from almost 200 million km (124 million miles) away during its closest approach to our planet. In 2007 and 2011, Comets McNaught and Lovejoy made history with their extraordinary appearances in

the southern hemisphere sky. On average one great comet appears in the Earth sky per decade, when one of these small icy visitors from the outer solar system makes a close approach to the sun and the Earth. Not all sightings are as bright as the great comets, and so many are not visible to the naked eye. Thankfully, they can be captured using long-exposure photographs, such as a few of the images in this chapter, which also illustrates majestic comets seen in both hemispheres.

The celestial world does provide some known quantities. Comet debris around the sun generates meteor showers when the Earth passes through its streams. These repeat throughout the year, almost always at the same times. Casual stargazers have a few favourites among them, in particular the Geminids in mid-December and the Perseids in August. The most amazing are the occasional meteor storms of Leonids in November. About every three decades, when the parent comet of this stream returns to the sun, this usually poor meteor shower becomes a roaring monster, with thousands of meteors in just a few hours of peak activity. In recent decades, some of the most memorable Leonid storms occurred from 1998 to 2002. During this time, countless fireballs (bright meteors) and thousands of meteors would burst into the sky in a single night with a sharp peak lasting one or two hours. The next Leonid storm is expected in early 2030s.

Other notable sky events include massive aurora storms, especially during periods of maximum solar activity, which make the lights easily visible in latitudes far from the polar regions. In October 2003, a massive solar eruption occurred directly facing Earth. Our planet experienced a geomagnetic storm that caused spacecrafts and satellites to malfunction and red aurorae were observed over the northern horizon as far south as Greece, Southern California, Texas and even Florida.

Close conjunction of the moon and planets or between the planets themselves also makes the news. A very close conjunction of Venus and Jupiter in the year 2 [BCE] is possibly the origin for the Star of Bethlehem, with the two dazzling planets being so close that they appeared to merge into a single object. Seeing such close alignment today, on a clear and bright night sky, almost allows you to imagine how the great 'star' was seen.

As the photographs in this chapter will testify, the night sky is an ever-changing display of the most impressive natural phenomena.

[previous]

Black Forest GERMANY

This bright streak is a fireball from a Leonid meteor shower, flashing through a clear predawn November sky and seen from a high-altitude vista above an ocean of low cloud. Sirius and stars of constellation Orion (the Hunter) are about to disappear on the western horizon.

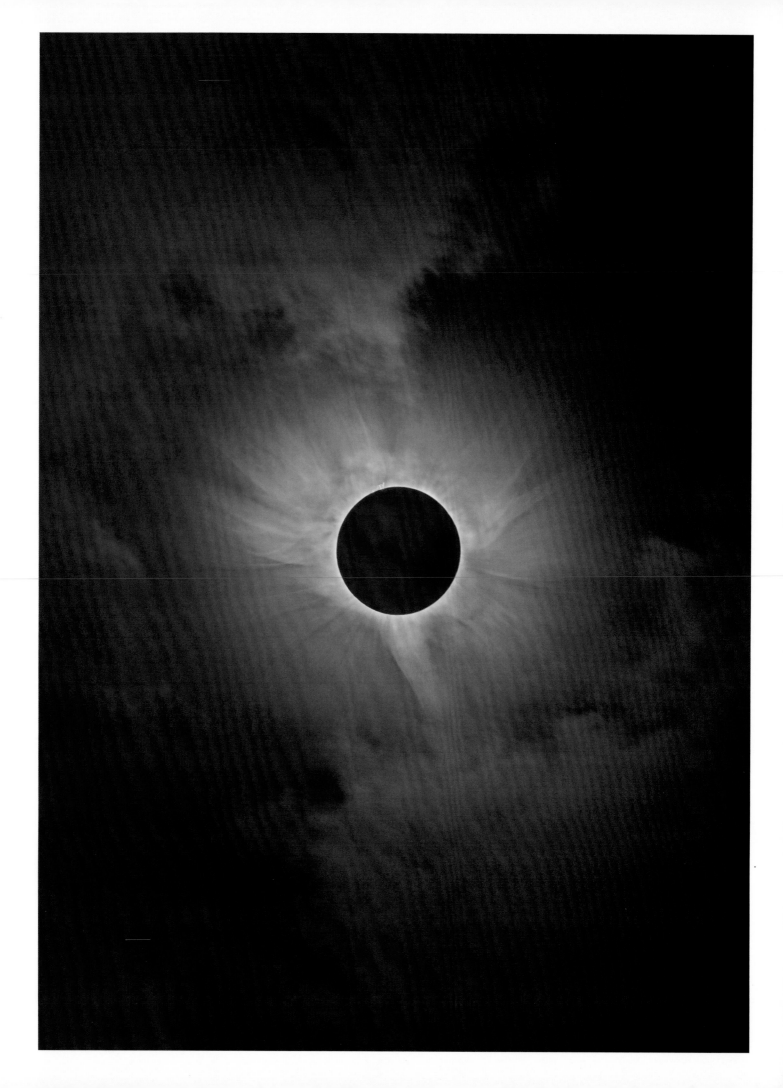

ECLIPSES

Creating the most beautiful 'diamond ring' – when the faint glow of the sun's corona begins to appear around the black disc of the moon, with a bright sparkle in just one spot – the last rays of the sun disappear to leave a sudden midday darkness. Birds fly to their nests, insects jump out to celebrate the brief night and bizarre twilight colours and shades shift along the horizon. These tantalizing moments can hook anyone – eclipse-chasers are often referred to as addicts – and it makes for a unique form of travel to head to the place where the moon's shadow touches the Earth during a total solar eclipse.

The moon's shadow is typically more than 15,000 km (9,300 miles) long and around 100–200 km (60–125 miles) wide. It covers less than 1 per cent of Earth's surface and usually falls across more sea than land. Outside of the area – and up to 3,000 km (1,900 miles) – people will still be able to witness a partial eclipse in the moon's penumbral shadow. Only during a full eclipse, when it is totally safe to remove any solar protection and enjoy the scene with the naked eye, do the solar corona and red prominences become easily visible, forming the 'diamond ring' that marks the beginning and end of totality. The brightest stars and planets become visible at this time, the temperature drops and a sudden wind manifests, and all of nature reacts to this most spectacular natural phenomenon. During a total lunar eclipse (when Earth passes between the sun and the moon), people in the half of the planet that faces the moon will see it dim to a red colour as it falls within Earth's shadow.

Solar eclipses occur more frequently than lunar eclipses. On average a total solar eclipse takes place somewhere on Earth every one and a half years, while lunar eclipses are slightly less frequent. But for those who don't travel, totality is a once in a lifetime experience. On average, a single location will experience a total solar eclipse once every 375 years.

Ternate INDONESIA

An eclipsed sun hangs in a clearing sky over Ternate, Indonesia, during the total solar eclipse of 9 March 2016. In this close-up image, the sun's elusive outermost layers – known collectively as its corona – illuminate the clouds. At this stage of the eclipse, with the solar disc blacked out, the brightness of the corona is similar to that of a full moon.

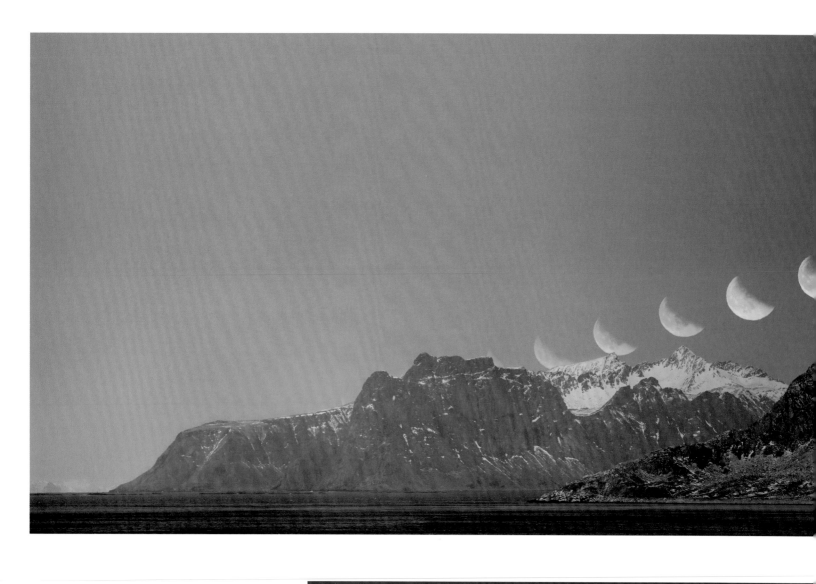

Isfahan IRAN

The lunar eclipse of 10 December 2011 is captured here at total phase, with the moon rising at dusk over the Zagros Mountains. The moon does not completely disappear as it passes through Earth's shadow because the Earth's atmosphere refracts the sunlight, allowing some indirect light to reach the moon. If the Earth had no atmosphere, the moon would go completely dark.

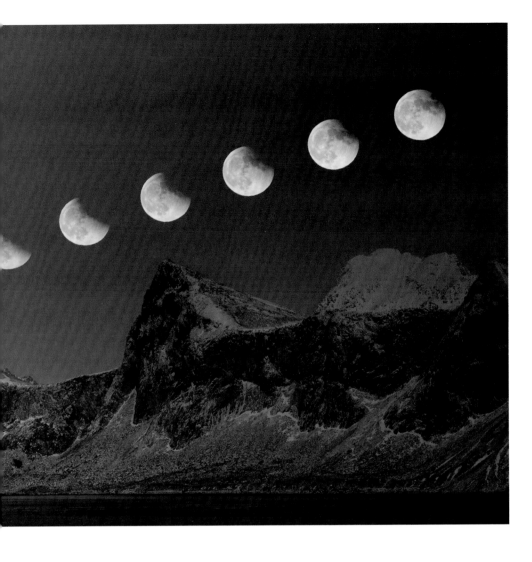

Lofoten Islands NORWAY

This composite image shows various phases of the partial lunar eclipse of 31 January 2018, each shot taken using a telephoto lens and about five minutes apart. The camera setting was fixed during the sequence, and captures the changing light during the eclipse. In the foreground are the coastal mountains of Myrland, in the central area of the Lofoten Islands, inside the Arctic Circle at 68 degrees north.

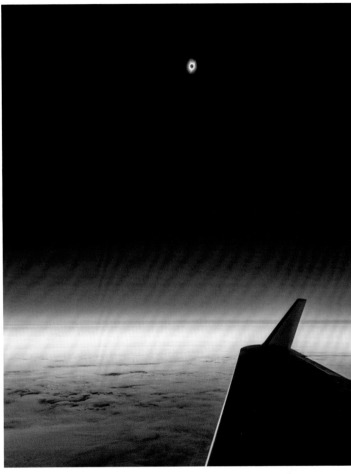

[opposite]

Wyoming USA

The Great American Eclipse of 21 August 2017 is so-called because it was visible in a band that spanned the United States from the Pacific to the Atlantic. Here it is captured above a twisted pine, in a shot taken from a high-altitude vantage point. The wide-angle view shows the full extent of the solar corona, only visible when the much brighter solar surface is masked and the background sky is darkened. It would seem logical for the sun's outer layers to cool down in space, but in fact the opposite is true. While the temperature is around 6,000°C (10,800°F) on the solar surface, it rises sharply to a few million degrees in the corona and astronomers have not yet discovered why.

[above left]

Antalya TURKEY

An analemma image involves photographing the sun from exactly the same location, and at exactly the same time of day, twice a month. The shots are then assembled in a composite image, to show how the sun's position in the sky changes as the year progresses. The image here is thought to be the world's first analemma image that also includes a total solar eclipse. This particular composite image shows the sun's motion in one frame, with photos taken every ten to fourteen days, including the eclipse of 29 March 2006. The eclipsed sun appears brighter because it is the only shot taken without a solar filter and for a longer exposure time. The photograph is dubbed 'Tutulemma' – a play on the Turkish word for eclipse (*tutulma*), and 'analemma'.

[above right]

PACIFIC OCEAN

The 21 August 2017 totality, captured while flying 13,700 m (45,000 ft) above the cloud-covered Pacific Ocean, on the edge of the stratosphere, some 400 km (250 miles) off the west coast of Oregon, USA. Taken from onboard a small jet aeroplane, this was the first image of the Great American Eclipse to be taken before it hit the coast and travelled across the United States. The horizon colours are surreal, but more notable at such a high altitude is the pitch-black sky that almost conjures the feeling of flying in space.

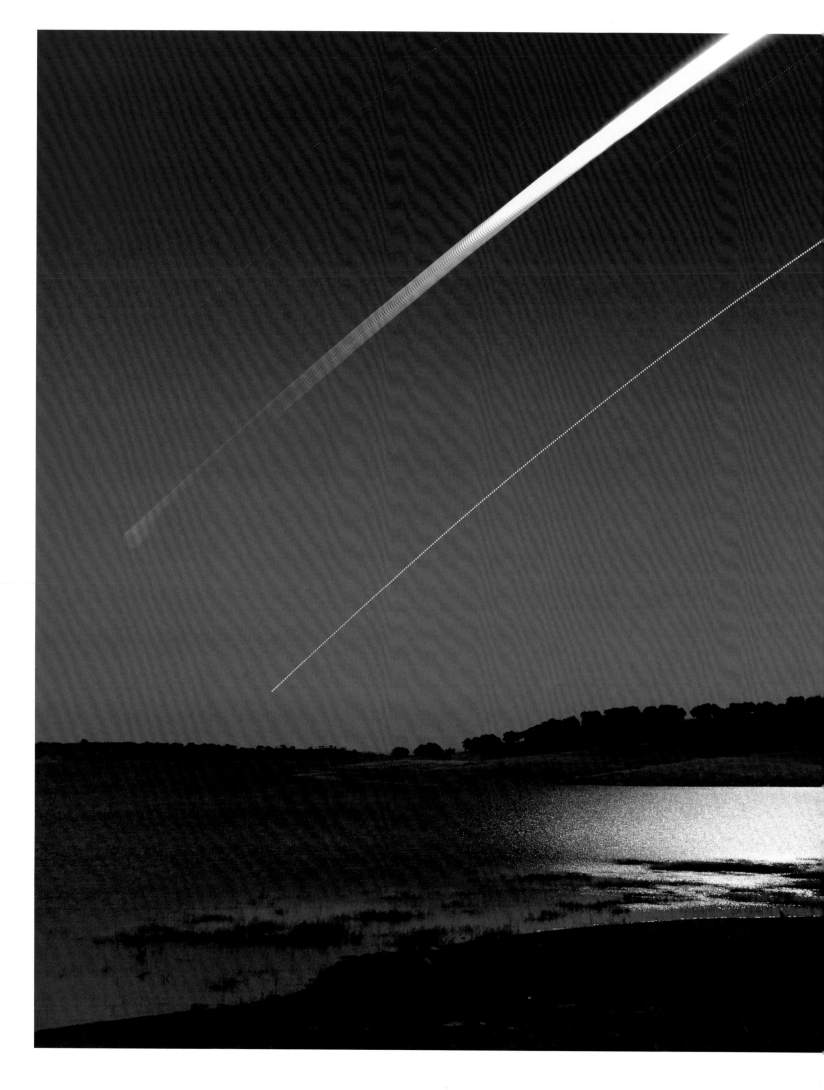

[left]

Alqueva PORTUGAL

Mars (lower trajectory) appears close to the moon in this time-lapse sequence of the longest total lunar eclipse of the century, which occured on 27 July 2018. The sequence begins close to moonrise, with the moon in total eclipse phase, and progresses from dark red to bright orange. As time passes, the sequence then continues through partial eclipse phases until the return of brilliant silver moonlight. Sunlight, refracted by Earth's atmosphere, is the source of the dim red light on the moon during lunar eclipses. Dust and gases in the atmosphere scatter blue wavelengths from sunlight, leaving the remaining light reddened.

[overleaf top]

Tehran IRAN

During one of the darkest lunar eclipses of our time, the red eclipsed moon is captured against the galactic centre – the heart of the Milky Way – in a single-exposure photograph of just forty seconds. The photograph was taken from the Alborz Mountains near Tehran, on 15 June 2011. The moon lies just above the bowl of the dark Pipe Nebula, to the right of the glowing Lagoon and Trifid nebulae and the central Milky Way dust clouds. To the far right, the wide field is anchored by yellow Antares in the constellation of Scorpius (the Scorpion) and the colourful clouds of the star system Rho Ophiuchi.

[overleaf bottom]

Las Campanas CHILE

This panoramic view shows the setting Milky Way band and neighbouring satellite galaxies, the Magellanic Clouds (left), in the southern sky, hanging over the twin Magellan Telescopes at Las Campanas Observatory, during the total lunar eclipse of 27 September 2015. What had been a bright, star-free, full-moon sky just hours before this scene, has changed dramatically into a totally dark night that lasts a full hour during the total eclipse. The image is a high-dynamic-range (HDR) composite that uses two exposures – a shorter one to reveal the eclipsed moon details and a longer one to capture the much darker background sky.

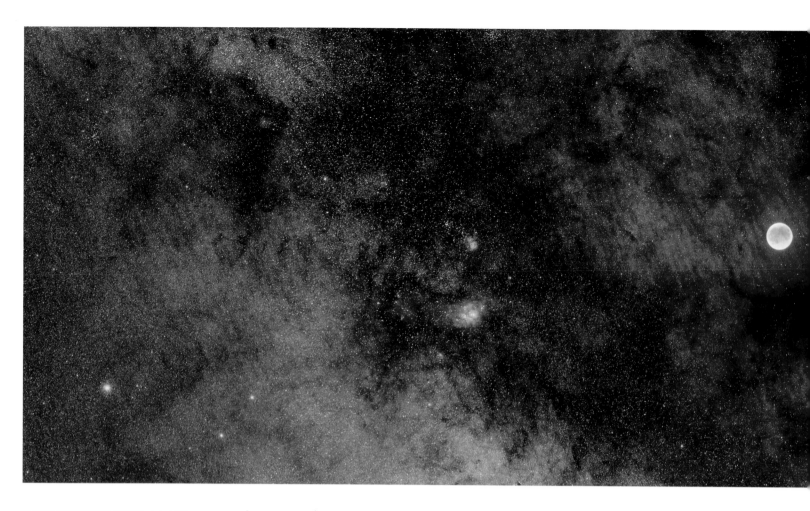
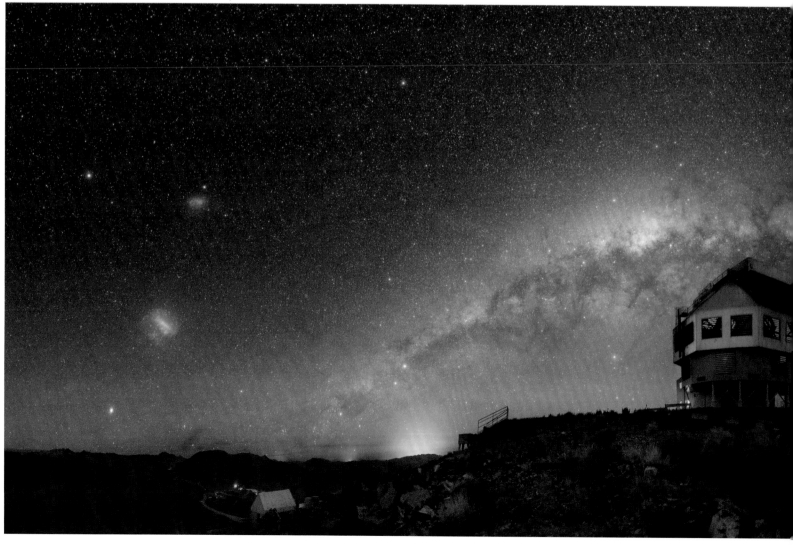

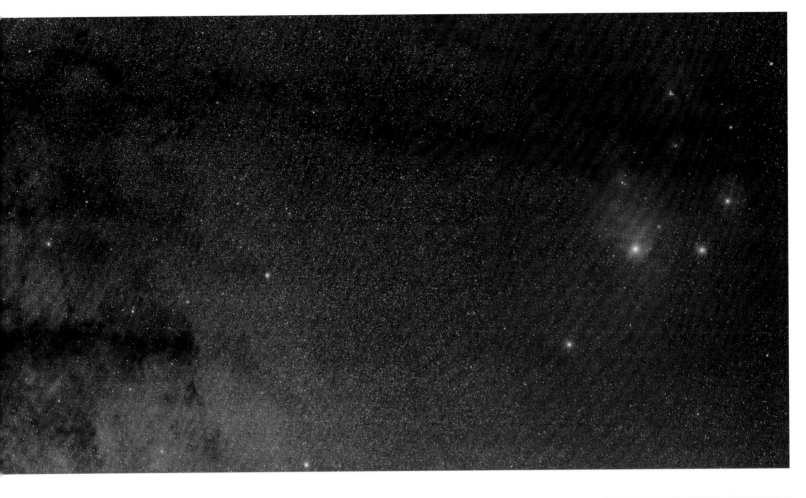

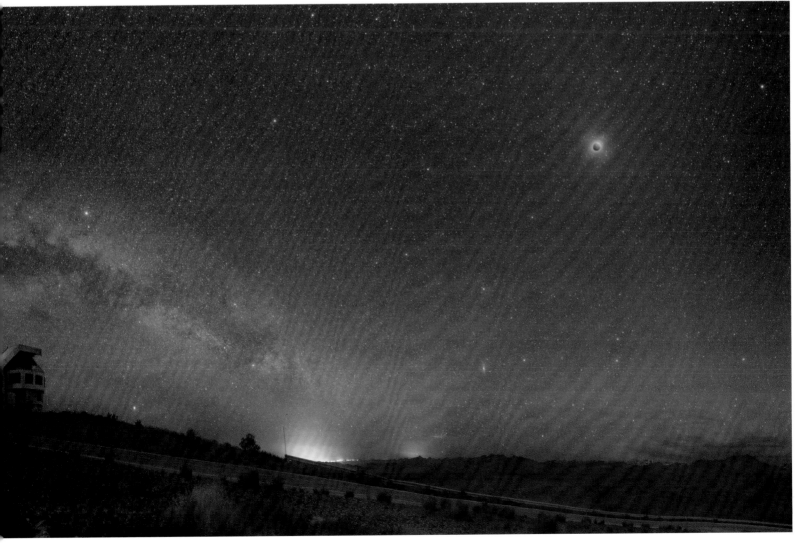

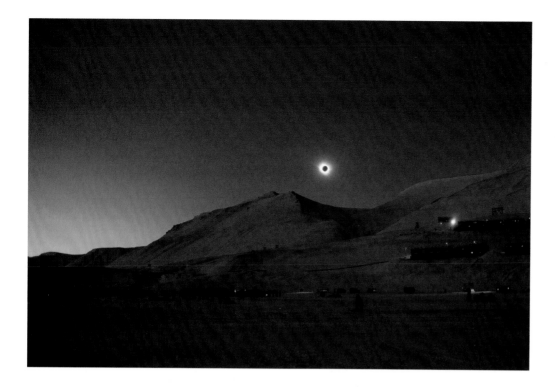

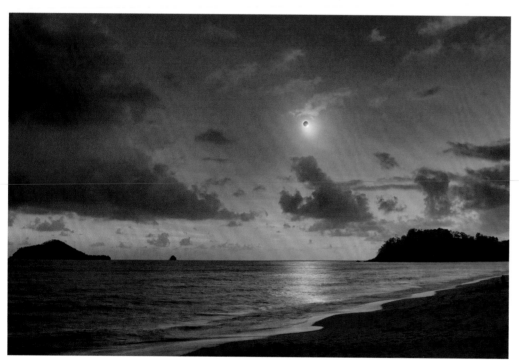

Svalbard NORWAY [top left]

The Arctic total solar eclipse of 20 March 2015 occurred on the vernal equinox that marks the beginning of spring. This image was taken just 1,000 km (600 miles) from the North Pole, at 78 degrees north, in Svalbard, with the eclipse hanging low on the southern horizon over the high hills that hug the settlement of Longyearbyen. The daytime temperature was –20°C (–4°F) and dropped lower during the totality.

Queensland AUSTRALIA [above]

Photographed above Australia's northern coastline on the morning of 14 November 2012, storm clouds threatened to spoil the view of this eclipse, but the clouds parted minutes before totality. The area was plunged into darkness for two minutes as the moon's shadow swept offshore towards the Great Barrier Reef and out into the South Pacific Ocean. Streaming past the moon's edge, the last direct rays of sunlight produced a gorgeous diamond-ring effect. Ranging from 1/4000 to 1/15 seconds long, five exposures were blended to create a presentation similar to the breathtaking visual experience of the eclipse.

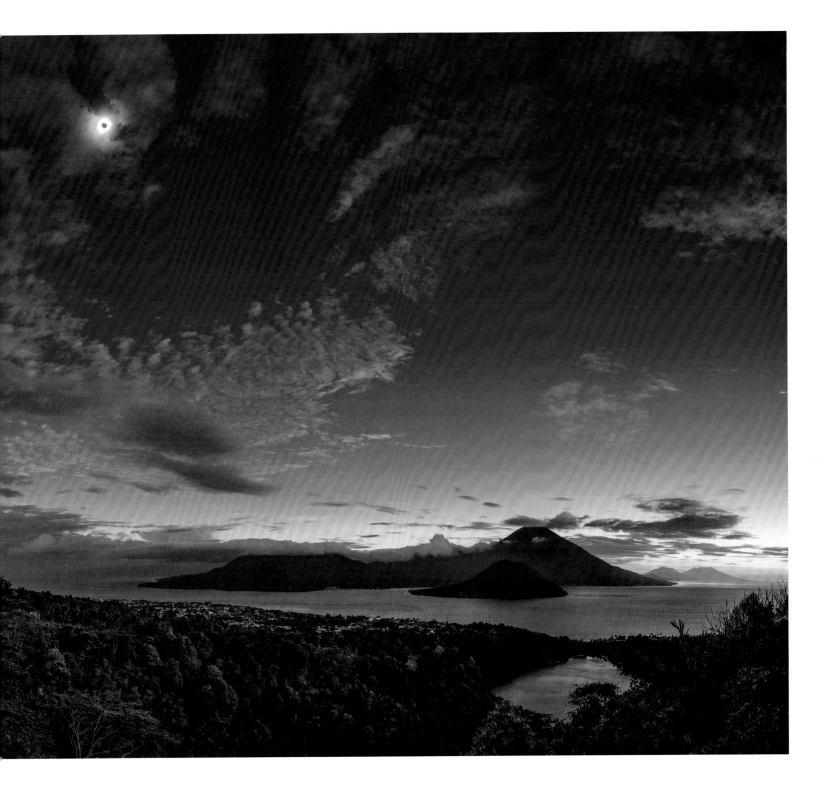

Ternate

INDONESIA

A dark sun hangs in a clearing sky in this sea- and skyscape, during the total solar eclipse of 9 March 2016, somewhere along the narrow path of totality where the moon shadow touches the Earth's surface. Ternate and a chain of other volcanic islands in North Maluku lie in the foreground. The sky is still bright near the eastern horizon, outside the moon's umbral shadow. In fact, near the equator the dark lunar umbra rushes eastward across Earth's surface at about 1,700 km (1,100 miles) per hour – faster than it travels at high latitudes because of the larger circular diameter of the Earth surface in the tropics and hence more rapid surface rotation. Shining through the thin clouds, around the sun's silhouette is the alluring glow of the solar corona.

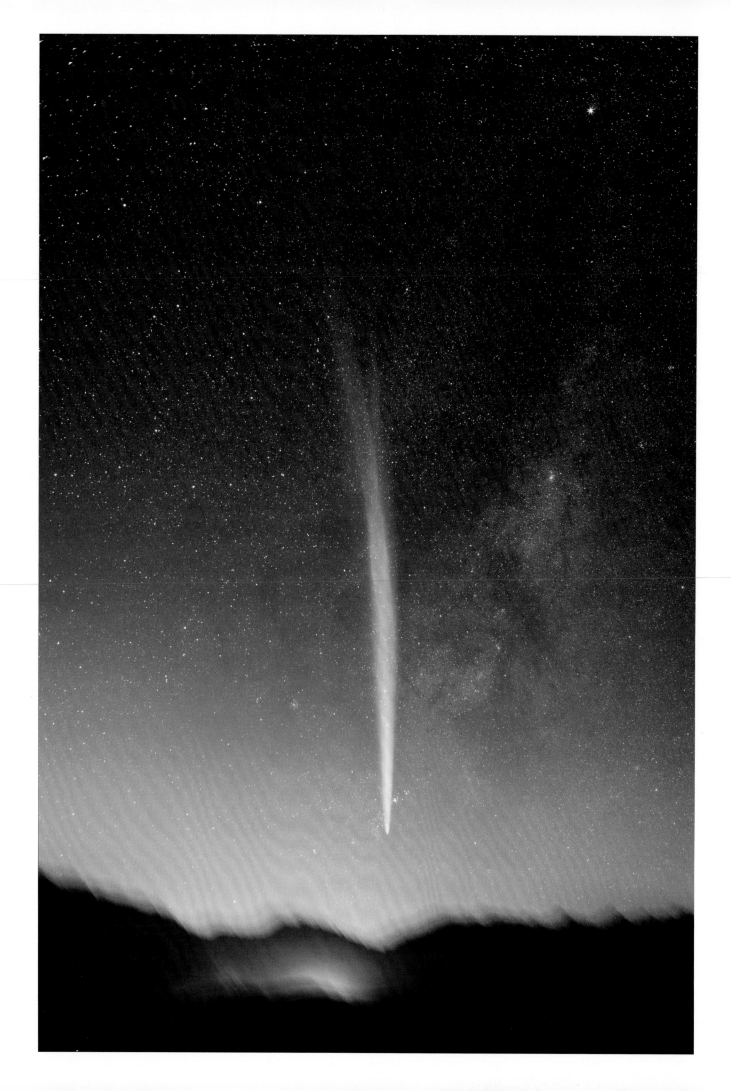

COMETS

Many millions of comets exist in the outer solar system – beyond Neptune in the Kuiper Belt, for example, and in a spherical cloud of icy bodies known as the Oort Cloud, which extends out from the Kuiper Belt to an incredible distance of almost two light years away – halfway to the next star in the galaxy. Comets travel on elongated elliptical orbits. When one approaches close enough to the sun and Earth, it becomes a magnificent sight. Moving slowly across the sky over a succession of nights, a comet develops a tail and sudden eruptions burst out from the icy nucleus, changing the brightness of the comet's coma – the nebulous layer that surrounds the nucleus. Today we know that these wandering icebergs are fossils of the solar system's formation some 4.5 billion years ago. Like rocky asteroids, they became some of the first solid bodies to orbit the newborn sun, and are mainly formed of dusty ice, not only containing frozen water, but also frozen carbon dioxide, carbon monoxide, methane and ammonia. At that time, comets and asteroids were not confined to certain zones. During the years of the chaotic young solar system, comets and asteroids constantly battered the newly formed planets; some studies suggest that this is how Earth's oceans formed.

Today, one or two naked-eye comets appear in Earth's sky per year on average, reaching magnitudes of 4 to 5. Usually barely visible to inexperienced eyes, these are often majestic in long-exposure telescopic images. Sometimes, an eruption at the comet nucleus exposes otherwise concealed ice to sunlight, suddenly increasing the comet's brightness with a larger coma or longer tail. If a comet passes a magnitude scale of 2 to 3, it could be considered a Great Comet as it approaches Earth and the sun.

Before the eighteenth century, little was known about the nature of comets and they were often considered bad omens – forewarnings of death, catastrophe or an attack from heavenly beings. Most astronomers considered them to be atmospheric phenomena. It was in the late sixteenth century that Danish pre-telescope astronomer Tycho Brahe proved comets must exist in outer space, by measuring the parallax of the Great Comet of 1577 from observations collected by geographically separated observers. In 1705, British astronomer Edmond Halley was the first to prove that some comets return periodically, and he predicted Comet Halley's return to the inner solar system to be every seventy-five to seventy-six years. We now know that this comet has been observed since at least 240 [BCE], its presence having been recorded by Chinese and Babylonian astronomers. Comet Halley's next return will be in 2061, but we don't have to wait until then to witness the next great comet in Earth's sky. On average, a bright comet hits our skies every decade and some of the most recent and majestic appearances are showcased in the pages that follow.

Andes CHILE

Rising at the break of dawn, Comet Lovejoy (C/2011 W3) is photographed using a star-tracker mount for a longer exposure. The mount tracks stars, cancelling the movement of the sky that results from Earth's rotation. The effect is to make the foreground move instead, appearing blurred and lending a fine-art, abstract look to the resulting image. The comet is rising here in the morning twilight.

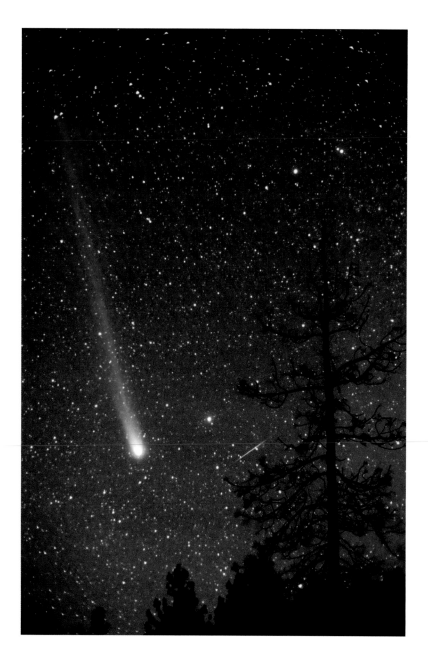

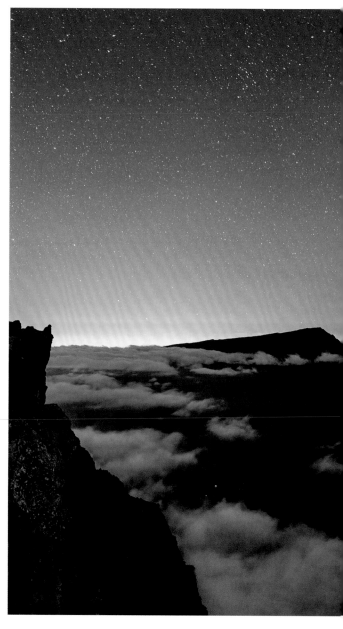

California USA

Captured in this image are the exceptionally long tail of Comet Hyakutake and a faint meteor. Hyakutake passed very close to Earth in March 1996. One of the closest cometary approaches of the previous 200 years, the event took place less than two months after the comet's discovery. Rapidly approaching the sun, the comet grew an ion tail so large that it was visible extended across the sky up to 90 degrees in the darkest night skies – that's like saying that, if the comet head was on the horizon, the end of the tail would be directly overhead.

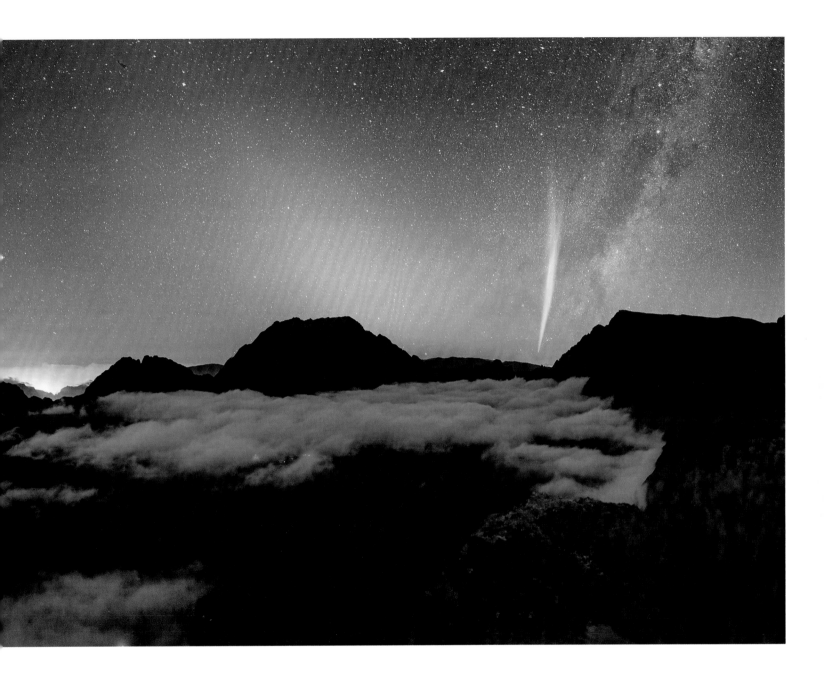

Réunion SOUTH INDIAN OCEAN

Comet Lovejoy (C/2011 W3) appears at dawn, in the southern hemisphere sky above Réunion Island. The light cone to the left of the comet is caused by zodiacal light above the Cirque de Mafate caldera, partially covered by low cloud. Known as a sungrazer, Lovejoy was just 185,000 km (115,000 miles) at perihelion – the point at which its orbit was closest to the sun. These comets do not usually survive such a close approach to the sun and Lovejoy lost a lot of its icy body, leading to the bizarre headless form seen here, in comparison to the bright concentrated head of Comet Hyakutake (opposite).

Cerro Paranal CHILE [overleaf]

Many comets that become visible to the naked eye are small, fuzzy objects unless photographed through a telescope. In this rare sight, two comets are visible in the same part of the sky above the Atacama Desert in Chile. The Large and Small Magellanic Clouds are above the European Southern Observatory site at Cerro Paranal. The small comets can be seen to the right of the image, in the morning twilight: PanSTARRS (C/2011 L4) on the horizon and Lemmon (C/2012 F6) higher up.

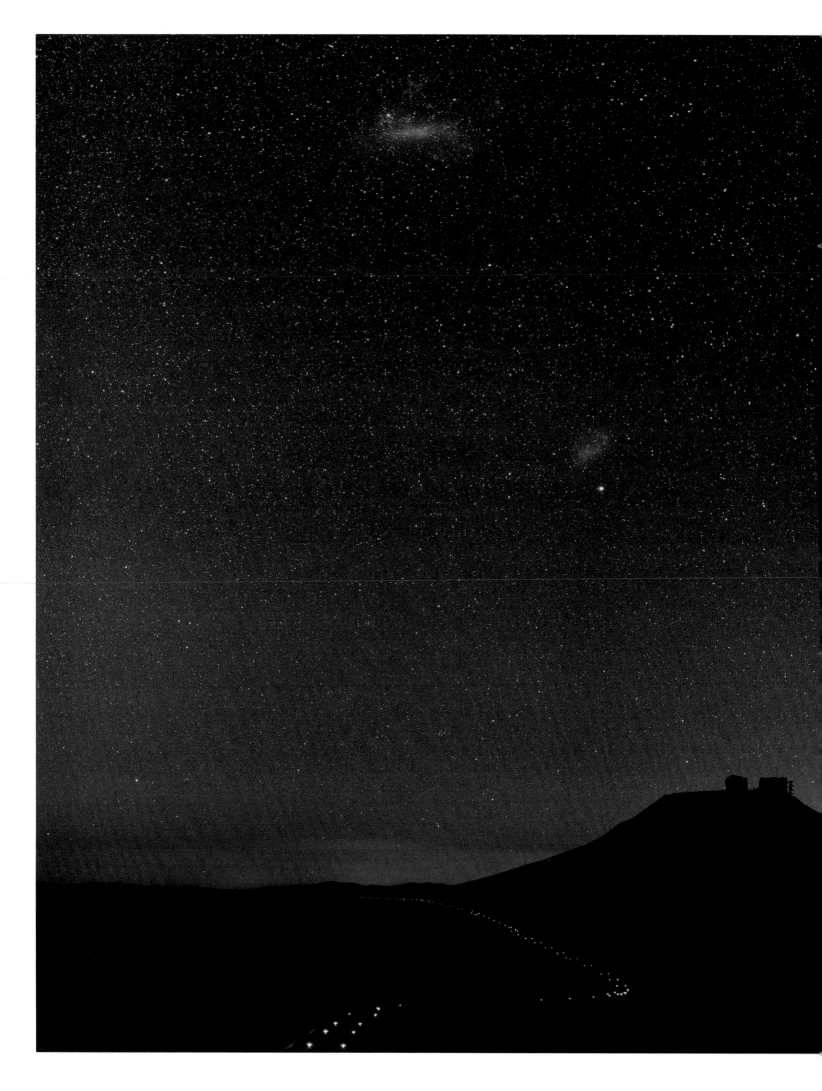

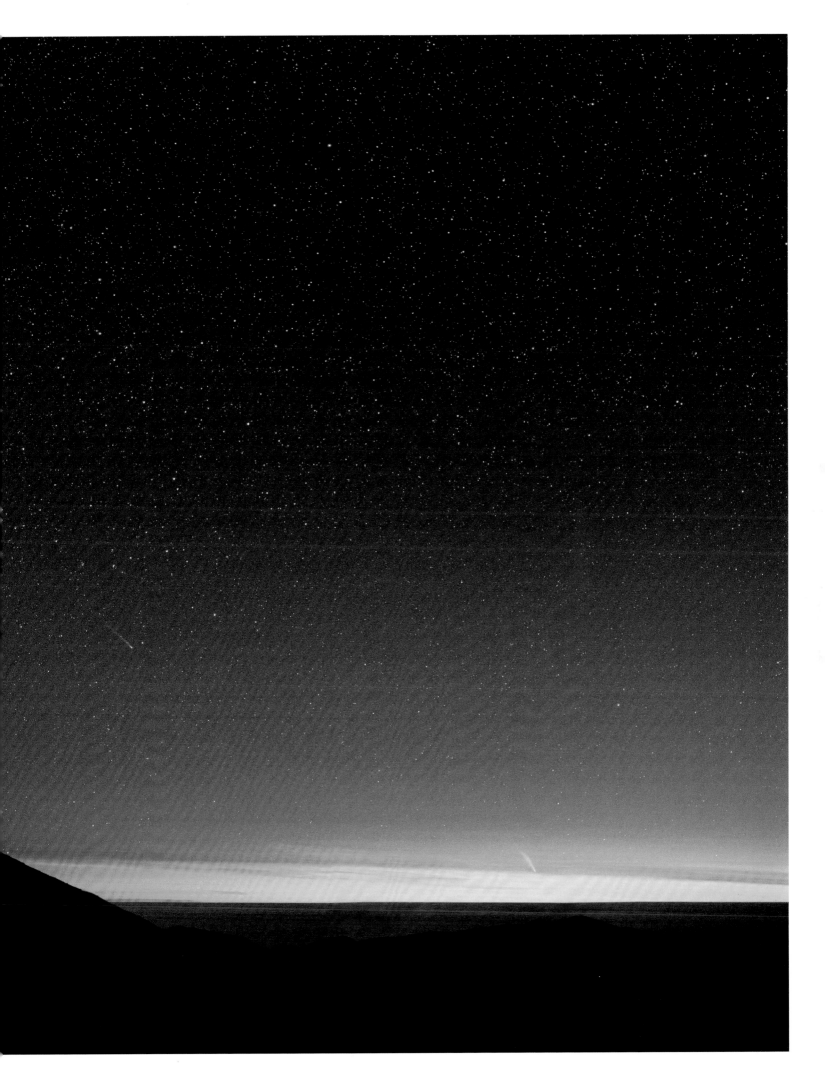

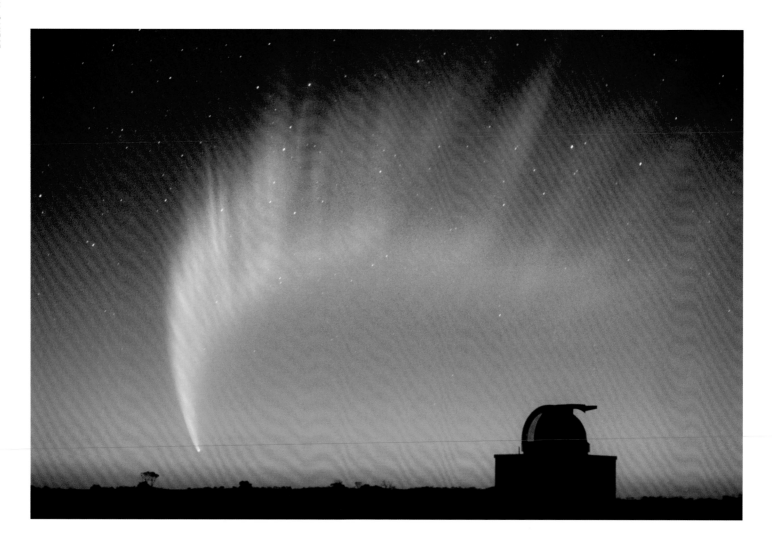

[above]

Western Australia AUSTRALIA

In January 2007, Comet McNaught (C/2006 P1) became the brightest comet in four decades, reaching a magnitude of –5 and surpassing even Venus in brightness. In the northern hemisphere the comet was only visible close to the sun, and with a little tail barely visible in the twilight glow on the horizon. As its orbit took the comet away from the sun, it emerged out of the evening twilight in the southern hemisphere, to present a spectacular view, as captured here, above a small observatory.

[opposite]

Victoria AUSTRALIA

The elegant tail of Comet Lovejoy (C/2011 W3) is captured in the morning sky above Cape Schanck, 90 km (56 miles) from Melbourne. The 200 m (660 ft) icy body not only survived its close perihelion – but in the days that followed, it held together and reformed its dust and gas tails.

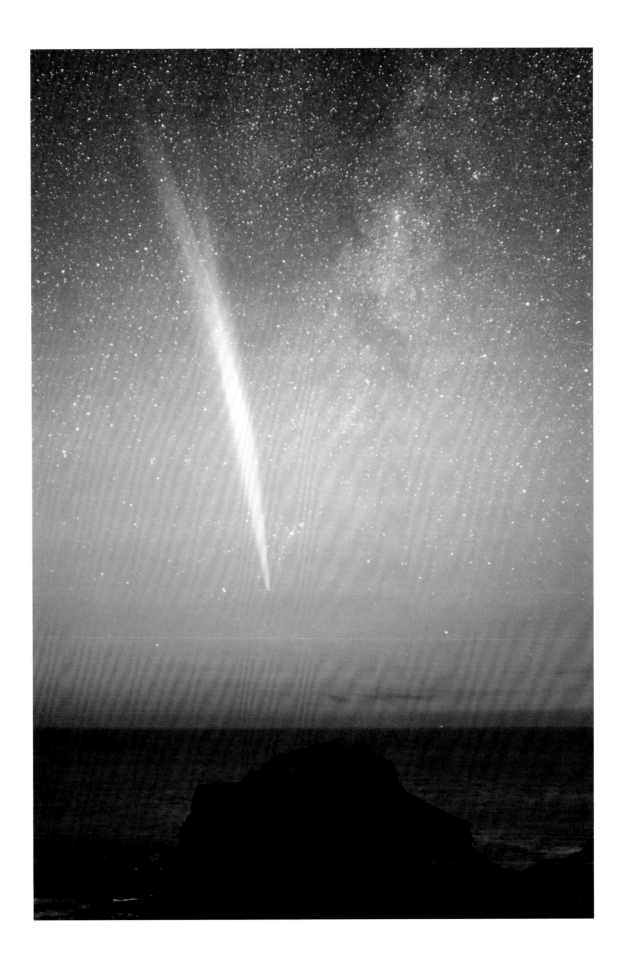

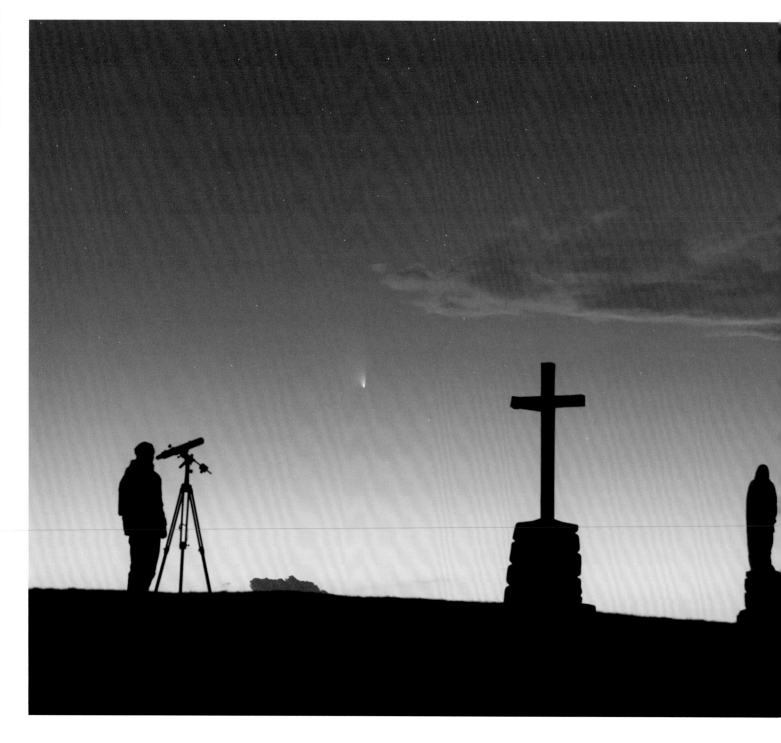

Lake Balaton HUNGARY

Reaching a magnitude of 4, Comet PanSTARRS
(C/2011 L4) was easily visible to the naked eye
in this clear twilight sky, but only as a small,
elongated patch of light.

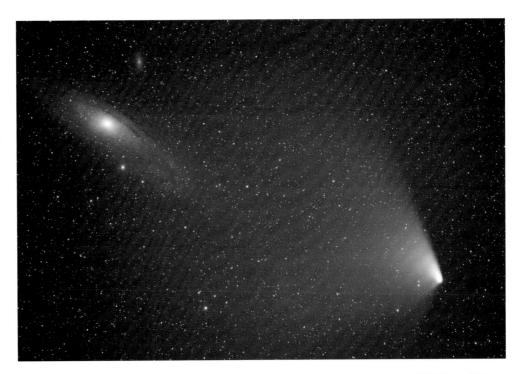

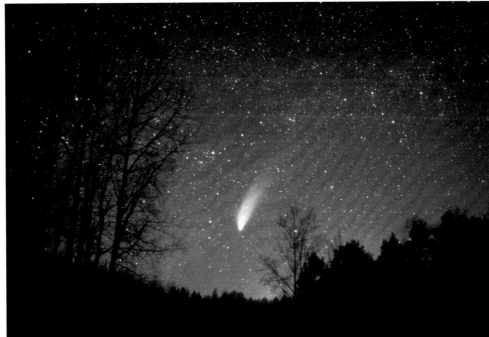

This telephoto view captures an unusual alignment of Comet PanSTARRS (C/2011 L4) and the Andromeda Galaxy (M31). Similar in brightness and visible to the naked eye, one is a small mountain of ice in our solar system, while the other is a cosmic island with a trillion stars. Larger than the Milky Way, the Andromeda Galaxy is about 2.5 million light years away.

Comet Hale-Bopp appeared at its brightest in April 1997, pictured here with a beautiful, separate blue ion (gas) tail as well as its white dust tail, against a backdrop of constellation Perseus. It was discovered by two American astronomers, independently from one another and on the same night in July 1995. The two men, Alan Hale and Thomas Bopp, could not have imagined that the faint halo they observed through their telescopes would go on to become worldwide news.

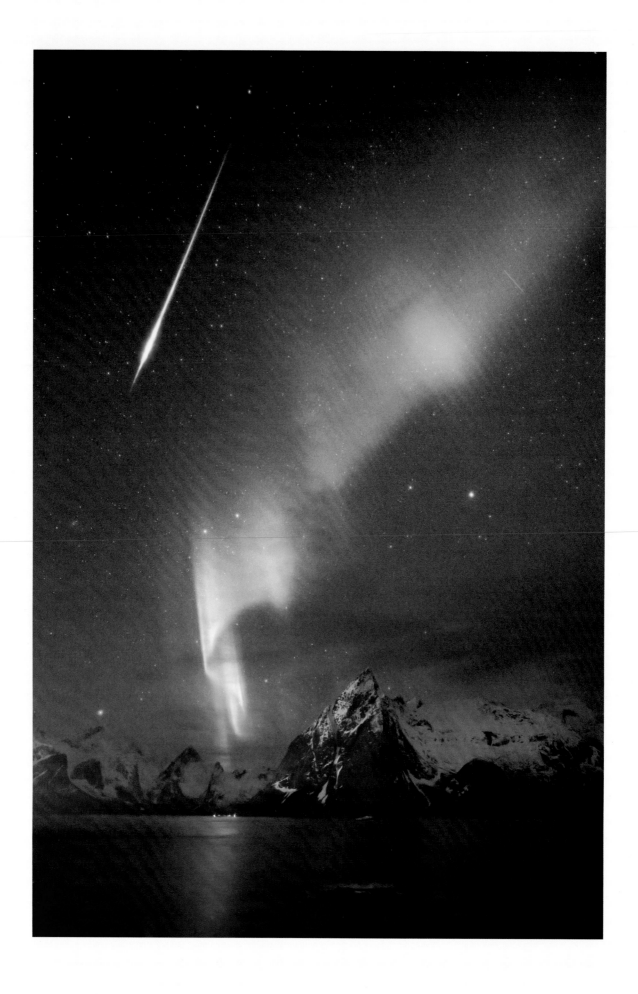

METEOR SHOWERS

On any moonless night, a keen observer might see a meteor every ten minutes on average, especially towards morning. These sporadic meteors are random wandering meteoroids – fragments of rock or ice – that enter Earth's atmosphere at very high speeds ranging from 11–72 km/sec (25,000–160,000 mph). On certain days of the year, our planet passes streams of debris created by comets, where particles left behind the comet tail and coma continue to follow the comet's path around the sun. On these nights, the number of meteors increases several times. While these meteor showers repeat annually, almost on the same night, the predicted peak varies by several hours each year, depending on which part of the world is facing the stream at the time. Such displays also depend on the moon phase. The faintest meteors will not be visible on a night with a full moon. Light pollution also reduces visibility.

The most popular meteor showers, seen in both hemispheres, are the Perseids, which peak on 12–13 August and the Geminids on 14–15 December. Showers are active from around one week before they peak and continue for up to a week after, but at much lower rates. During peak activity, the rate of visible meteors reaches 100 or more per hour. The Leonids, in November, are the most spectacular meteor showers, but they only become notably active every three decades, when the parent comet (Tempel-Tuttle) returns to the inner solar system and enriches the stream.

The Leonids displayed spectacular meteor storms from 1998 to 2002 and such a display is expected again in the 2030s. During one of these storms, in 1966, the rate of the shower reached an incredible 1,000 meteors per minute.

The brilliant flash of light from a meteor is not caused so much by its mass, but is a result of the high kinetic energy generated by the speed. Most visible meteors are dimmer and do not create meteorites – rocks that fall to Earth. They are caused by particles about the size of a small pebble down to a grain of sand and weigh less than 1–2 grams. Fireballs, on the other hand, are generated by tennis-ball-sized meteoroids and may reach the ground in the form of a small rock, depending on its composition (ice, metal or rock). Around 10,000 tonnes of this material falls to Earth each year, ranging in size from small rocks to micrometeorite dust.

In the southern hemisphere and the tropics, the Eta Aquariid meteor shower from 6–7 May has notable activity that can reach sixty meteors per hour. In northern latitudes, the Quadrantid meteor shower has a rich display of up to 100 meteors per hour on 3-4 January. However, the shower's short, sharp peak is only visible from certain longitudes, reaching a particular high just before dawn as the shower's radiant, close to the handle of the Big Dipper, rises high in the sky. In any meteor shower the radiant is the area of sky to which the backward motion of a meteor points.

Lofoten Islands NORWAY

A rarity, this photograph captures a fireball and the bright aurora borealis in one frame. The bright star Capella is to the right of the image and the constellation Gemini (the Twins) are below the meteor. According to the American Meteor Society, even experienced observers can expect to see just one fireball of this brightness (magnitude –6) in every 200 hours of observation. Brighter fireballs are an incredibly rare spot and even less likely to be photographed.

Alsace FRANCE

In this circular fisheye image, a dazzling green light crosses the sky from east to west, five hours before the peak of the Leonid meteor shower on 18 November 2012. Most meteors are sub-second flashes of light, but these Earthgrazers take several seconds to cross the entire sky as they graze Earth's atmosphere instead of falling down towards the planet. They often occur at the beginning of the night before the shower's radiant constellation rises in the sky. Green is the most common colour, but they also appear in yellow-red, bright blue and, rarely, violet. The velocity and dominant composition of a meteoroid plays a part in the observed colours. For example, vaporized sodium from the object produces a bright-yellow colour, nickel shows as green and magnesium as blue-white. The excited atoms in the atmosphere along the path of the meteor glow as well.

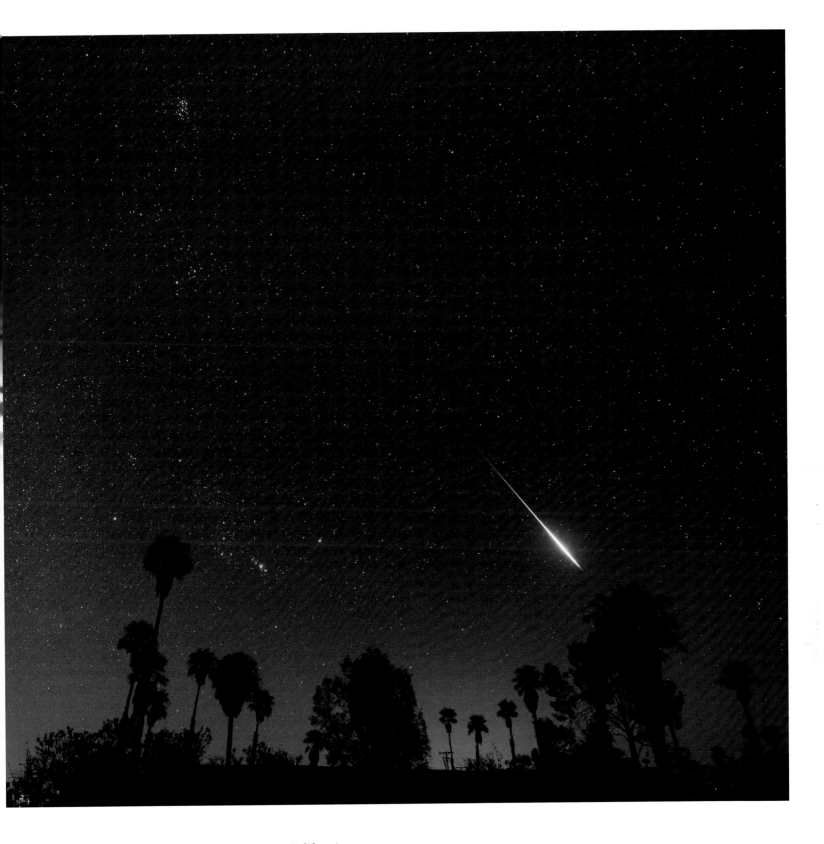

California USA

A fireball flashes in the sky during the Perseid meteor shower of August 2016. Photographed in the Anza-Borrego Desert State Park, this is just one photograph from more than 1,700 frames in a time-lapse sequence. Fireballs are meteors that burn more brightly than planet Venus, which is the brightest object in the night sky after the moon. On the astronomical magnitude scale they are brighter than −4, but they are rare.

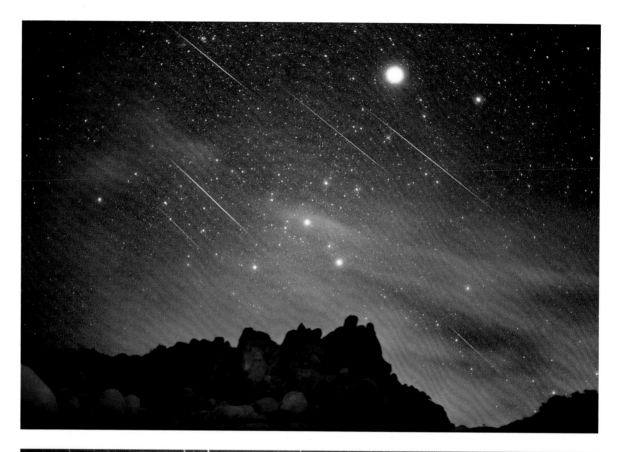

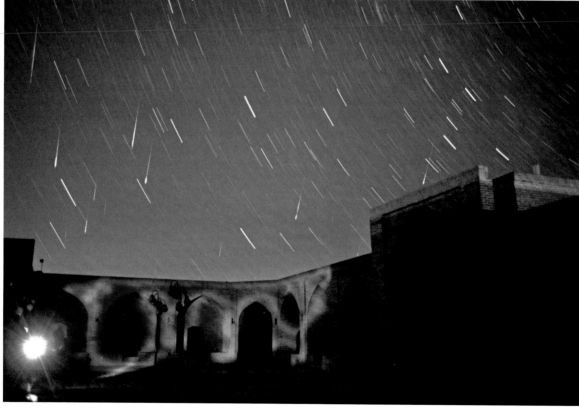

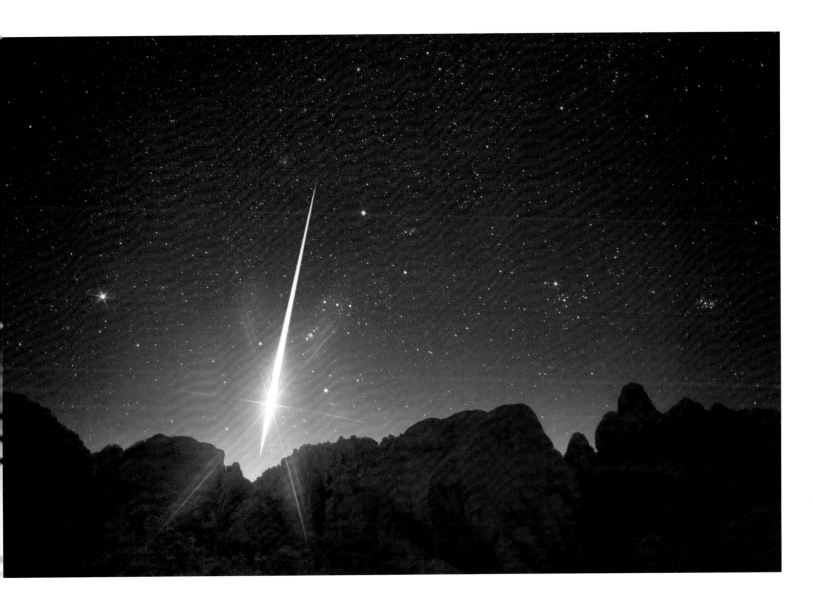

California USA

The Leonids meteor storm of November 2001 bursts over Joshua Tree National Park. This single exposure of twenty seconds on film has captured six green meteors in the small field of view of a 50 mm lens, highlighting constellation Canis Major (the Big Dog) and its bright star Sirius. The meteors come from sand-sized particles ejected from Comet Tempel-Tuttle during trips to the inner solar system.

Semnan IRAN

On 17 November 1998, an unexpected Leonid meteor storm filled the sky a night before its predicted peak, displaying many dazzling fireballs. The Earth passed through a dense stream from the storm's parent comet, rich in larger debris and, therefore, brighter meteors. In this single exposure of twenty minutes on film, seventeen meteors are captured over the historic Caravanserai of Deh Namak along the ancient Silk Road in Iran.

California USA

This cosmic sword of Orion (the Hunter) is an amazingly bright fireball, as captured during the December 2009 Geminid meteor shower. As bright as the full moon, such a meteor is known as a bollide. This dramatic view, taken from the Hercules Finger rock formation in the Mojave Desert of the southwestern United States includes the setting prominent winter stars from the dazzling Sirius (left) to constellations Orion and Taurus, with the open star cluster Pleiades (Seven Sisters) to the right end. Only one in 12,000 meteors reaches a magnitude of −8. This fireball reached a magnitude of −14, in a lucky shot from among around 1,500 photos taken this cold night.

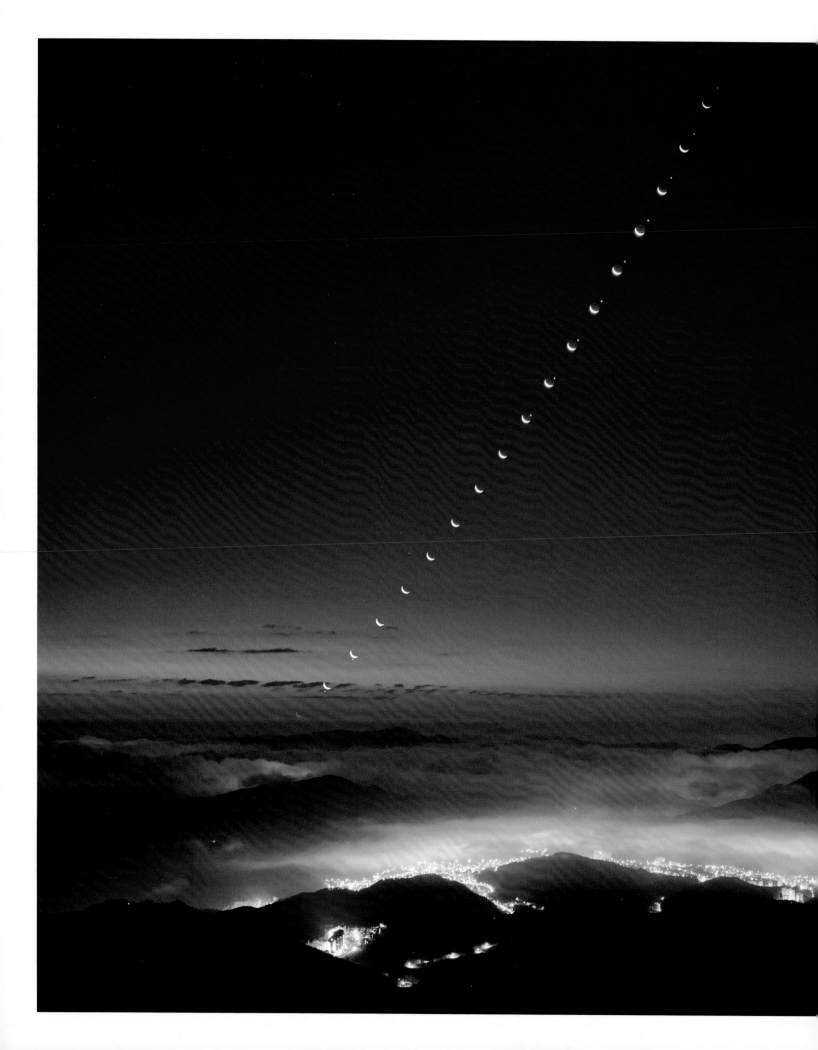

CONJUNCTIONS

A conjunction takes place when two or more celestial bodies appear to be close together in our night sky. This could involve two planets or a planet and the moon or a planet and a bright star. These pairings do not represent any physical approach between the celestial bodies – they are many millions of kilometres apart – but are simply aligned from the perspective of our planet. Conjunctions were important to ancient stargazers, when astronomical observations were very much involved with astrology. Today, we understand that these celestial meetings do not affect our lives, yet they continue to generate wonder and public attention. One of the many failed 'doomsday' predictions was the planetary alignment of 5 May 2000 when Mercury, Venus, Mars, Jupiter and Saturn were aligned with Earth in the solar system, although this was not visible in our night sky. On the evening of 23 February 1999, the night sky's two brightest planets, Venus and Jupiter, appeared only eight arc minutes from each other. This is roughly the same as one-quarter of the disc size of the moon or the sun in the sky. Visually, this has a similar effect to seeing a car's headlights from a distance of 1 km (0.6 miles), barely resolving to two, and the two celestial beacons appeared to be merging at first glance. The combination of their great brightness and low altitude caused many people to report a UFO sighting. The next close conjunction of Venus and Jupiter will happen on the morning of 30 April 2022 and the evening of 2 March 2023. Conjunctions of the moon and Venus appear far more frequently. Depending on the position of Venus as a morning or evening 'star', the crescent moon passes close to the planet at the beginning or end of every lunar month. The elegant pairing of the moon and Venus has inspired many of our greatest writers and poets. 'If you catch a glimpse of this brightness, you will set sleep afire: for by night-faring and servitude Venus became the companion of the moon,' as described in the *Mystical Poems* of the thirteenth-century Persian poet, Rumi.

Gangwon Province SOUTH KOREA

Rising in the dark hours before dawn, Venus appears as the morning star in this photo sequence during the moon-Venus conjunction of 13 August 2012. From this location in eastern Asia, a lunar occultation takes place, meaning that the waning crescent moon appears to pass directly in front of the bright planet. The occultation begins near the horizon and progresses as the pair rise. Venus disappears behind the moon's sunlit crescent, to emerge from the dark lunar limb before dawn. The image is constructed from frames made at ten-minute intervals, and follows the celestial performance from above the city lights and clouds over the city of Taebaek.

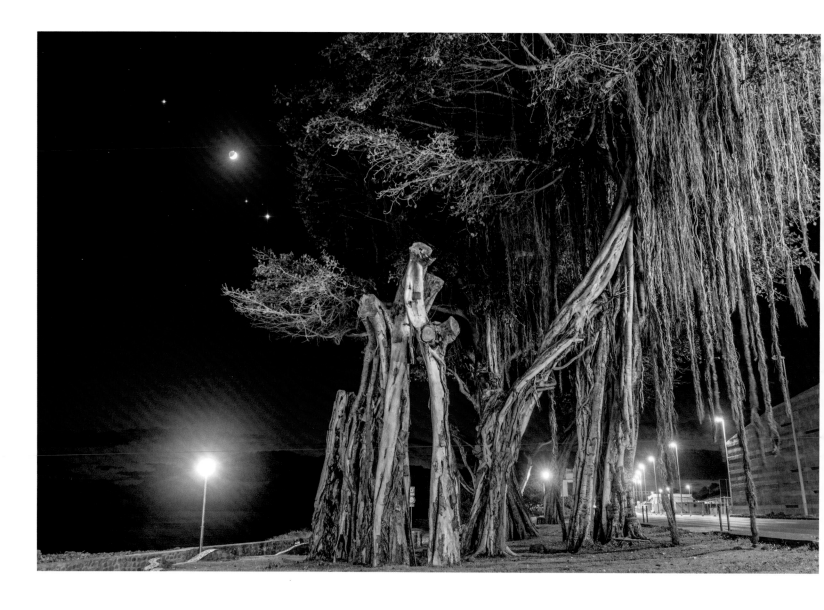

[above]

[opposite]

Réunion SOUTH INDIAN OCEAN

This triple conjunction of Jupiter, Mars and Venus, together with the moon, was captured on 7 November 2017. In the foreground is a beautiful banyan on Réunion Island. The bizarre-looking tree is the national tree of India, which is home to some of the greatest and oldest specimens.

Cologne GERMANY

A new moon and Venus (lower-right) are captured at dusk on 2 January 2014. Both appear as thin crescents above the World Heritage site of Cologne Cathedral, which stands 157 m (515 ft) tall. When Venus is close to the orbital position between Earth and the sun, it appears as a crescent, large enough to be visible using mid-sized binoculars, a small telescope or a camera with a telephoto lens.

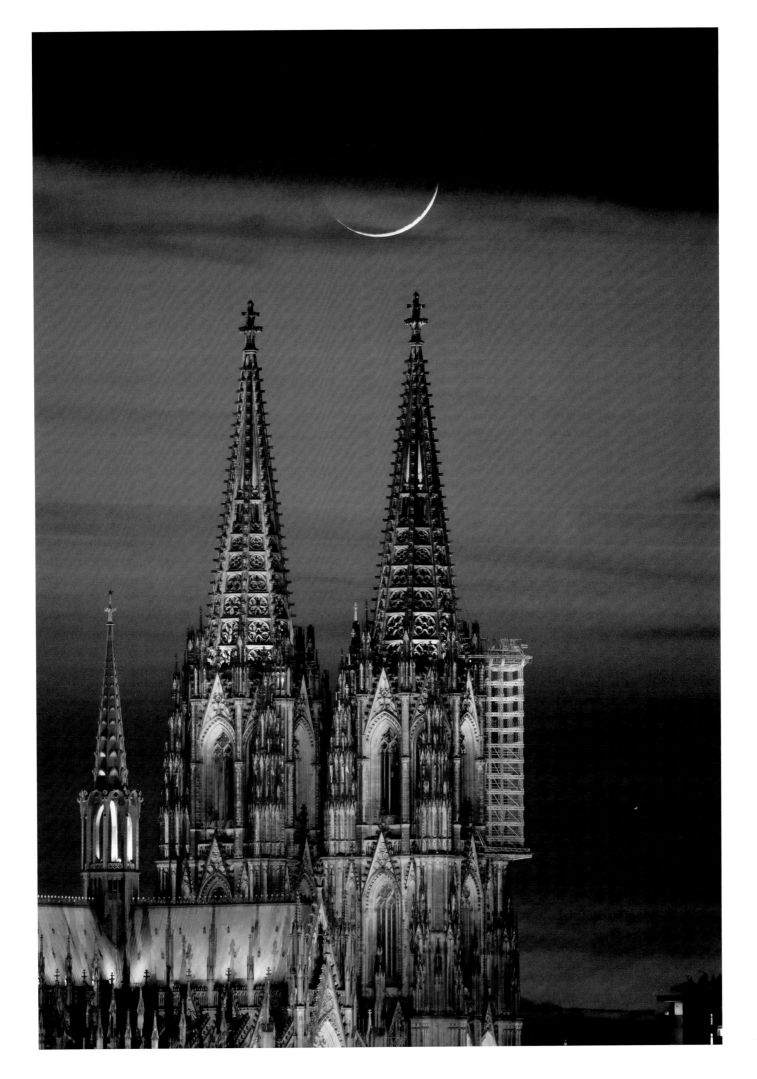

Santiago CHILE

The crescent moon is captured approaching a pair of bright planets, Venus and Jupiter, in the western sky of Santiago de Chile on the evening of 30 November 2008. The planets are only 2 degrees apart in this panoramic image. Despite bright city lights, celestial events that include brighter planets and the moon are often remarkably visible.

Alberta CANADA

This close conjunction of the crescent moon and Venus occurred on the evening of 15 July 2018. It was taken from Banff National Park, a popular destination for stargazing in Canada. In the foreground is the Continental Divide of the Americas. A westbound train crossing the Bow River is heading in the direction of the divide.

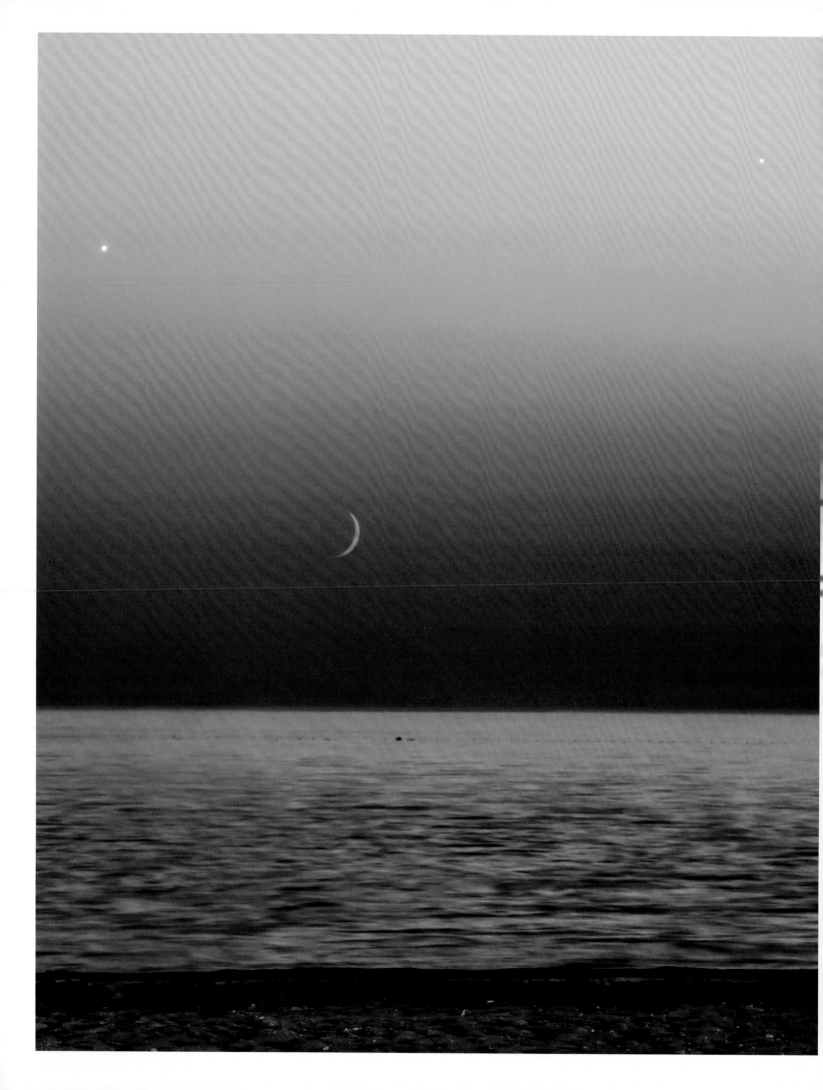

ATMOSPHERIC

We are living through an exciting era of space exploration, allowing us to learn more about the surfaces and atmospheres of other worlds by sending probes to every wonder in the solar system. Yet there are still countless mysteries to unravel below and above our immediate living surface. For example, Earth's atmosphere fascinates atmospheric scientists and photographers alike. Among the more puzzling phenomena are 'sprites', large-scale electrical discharges that occur high above thunderstorm clouds and give rise to a range of visual shapes that flicker in the night sky. Sprites are usually triggered by discharges of positive lightning between an underlying thundercloud and the ground. First photographed in 1989, they appear as luminous, reddish-orange flashes, often occuring in clusters above the troposphere at altitudes of 50–90 km (30–55 miles). Other atmospheric appearances relate to rocket activity. Long-range rockets or satellite launchers leave colourful glowing clouds in the night sky to the surprise of unsuspecting viewers. The re-entry of an old satellite is another wonder to look out for. When they burn in the upper atmosphere, some 100–60 km (60–40 miles) above the surface, they can create a flock of fireballs above certain areas.

Zaton CROATIA

As dusk colours settle over the Adriatic Sea, the crescent moon, Venus (top-left), and Jupiter (top-right) set above the Croatian coast.

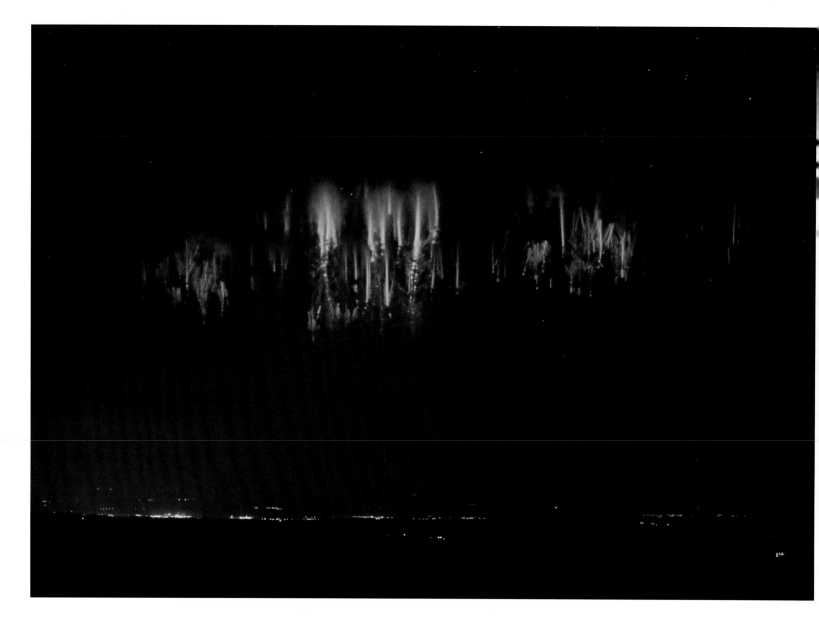

[above]

[opposite]

Alsace FRANCE

The rarely seen Red Sprites on a summer's night in France, these large-scale electrical discharges occur high above thunderstorm clouds. They flash in the sky for a fraction of a second and are much fainter than lightning strikes. The key to seeing and capturing sprites is a combination of a clear sky, with a thunderstorm around 200–300 km (125–185 miles) away.

California USA

At the annual Nightfall Star Party in Borrego Springs, in November 2015, the southwestern sky lit up in a weird glow that surprised the stargazers, as shown in the top image. They learned that the glow had come from a Trident II (D5) missile, which had been test launched from a submarine off the coast of San Diego.

Two years later, on 22 December 2017, a Falcon 9 rocket launch from Vandenberg Air Force Base produced an equally spectacular show above the same location, as shown here.

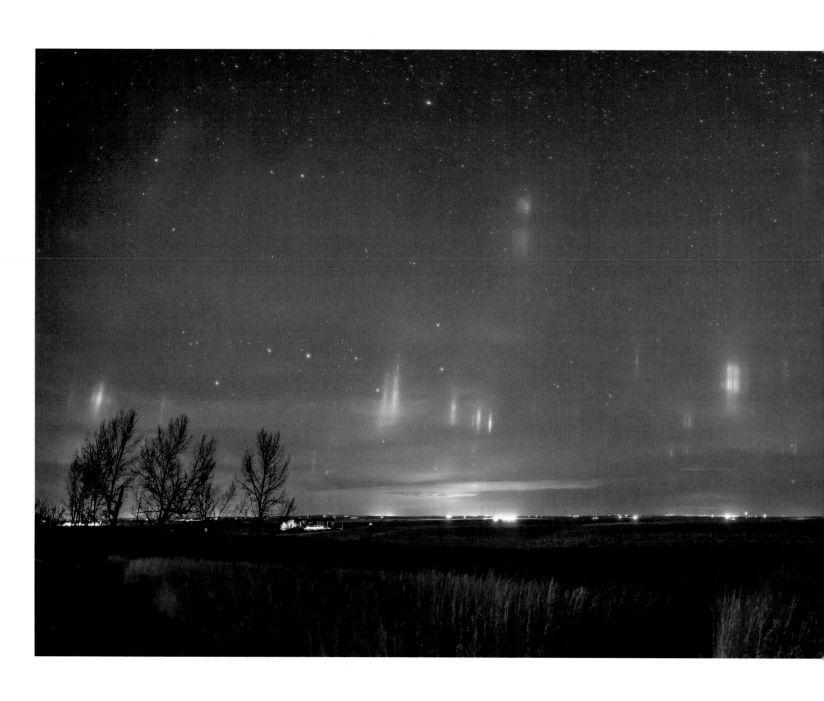

Alberta
CANADA

This panorama offers an exceptionally clear view of atmospheric optical phenomena known as 'light pillars'. Photographed on a cold night in rural Alberta, the sky from north (left) to south is filled with pillars of flat ice crystals hanging in the still air. They reflect the lights below – in this case emanating from farms and gas plants, and from towns in the distance. On this occasion, the effect was short-lived and was over in half an hour. It had snowed earlier in the day and the air was moist, creating enough icy haze and fog to produce the light pillars, but not dense enough to obscure the stars. The Big Dipper and Polaris are to the left. Auriga, Taurus and the Pleiades cluster are rising centre right.

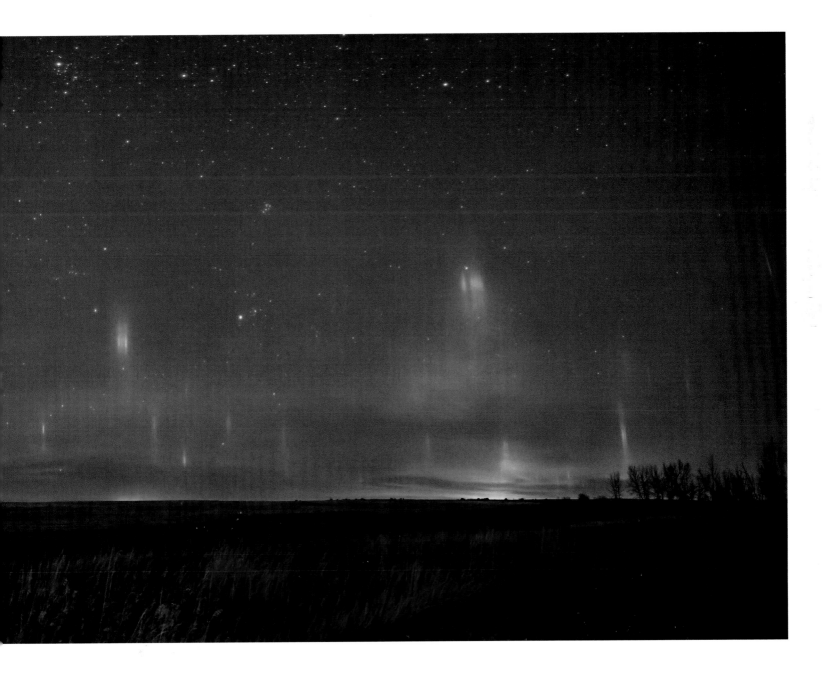

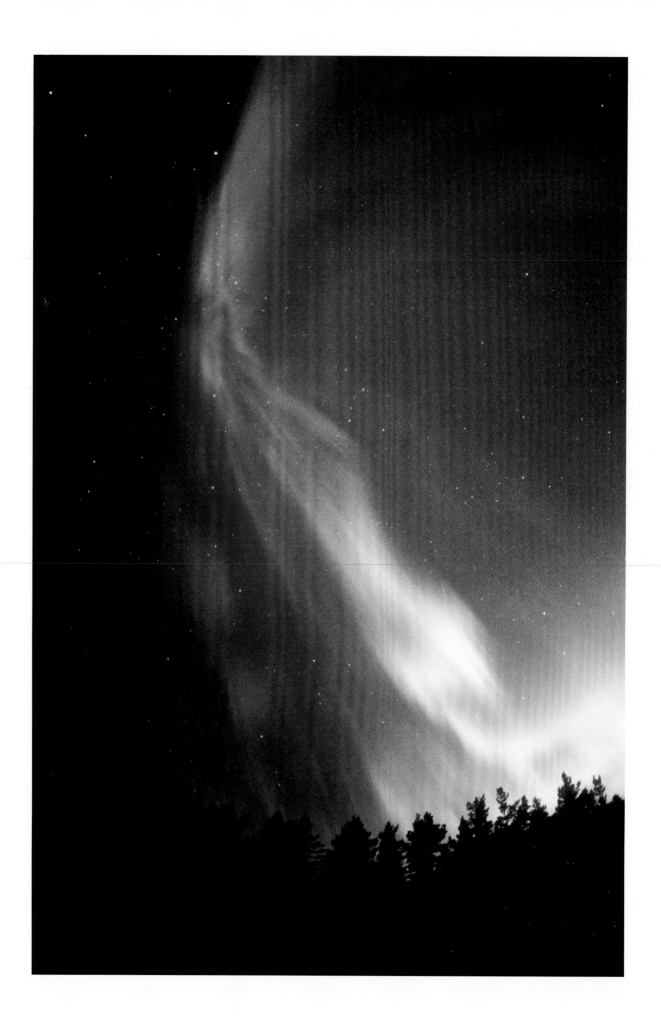

AURORA STORM

Witnessing an aurora when a solar flare creates a geomagnetic storm around the planet can be a lifetime's experience. At such times, an aurora crown forms overhead, appearing to boil with motion and colour across the entire spectrum. Such a phenomenon dominates the entire sky, illuminating the surrounding landscape and casting shadows. It is less colourful to the naked eye than it is to a camera, as the human eye's colour-detecting cones need more light for activation. Intensity varies in each person, too. Green is usually the first discernable colour, with red and purple being the next, followed by blue, although this is rare. The activity level is measured by something called a Kp index: 0 to 3 is weak to regular and only visible from polar latitudes; 4 to 5 indicates a semi-storm and is visible as low as 55 degrees magnetic latitude; above 6 promises a major show; 8 to 9 is visible from surprisingly low latitudes.

During an Earth-directed solar flare – usually generated by a large active sunspot – a massive stream of high-energy charged particles are ejected from the sun's magnetic field and into the solar wind. It's difficult for scientists to predict whether or not the stream will hit Earth's magnetic field. Should this happen, however, particles reach Earth within around two days, starting an aurora show that can last anything from just a few hours up to several nights. They are best witnessed from high latitudes.

On average, and with dark skies, these events are strong enough to appear on the northern horizon once a year, at such low latitudes of 30–35 degrees in North America. This is because the location is directly beneath the North Geomagnetic Pole. In Europe, events will occur 5–10 degrees higher. Moving away from the North Geomagnetic Pole, in the eastern hemisphere, an observer should be even higher to see a glimpse of these lights (this is reversed in the southern hemisphere).

The most intense geomagnetic storms have been reported as a red glow even from the tropics. The 1958 extreme aurora was seen from Mexico City. The most potent recorded storm occured in 1909, and was seen from Singapore at the equator. These superstorms often occur close to the peak of the eleven-year solar activity cycle – next expected between 2024 and 2026.

Uusimaa FINLAND

A strong aurora storm resembles a standing red queen in the sky. This natural display is produced when charged particles from the sun – mostly electrons but also protons and heavier particles – become trapped in Earth's magnetosphere, colliding with atoms and molecules at altitudes above 80 km (50 miles).

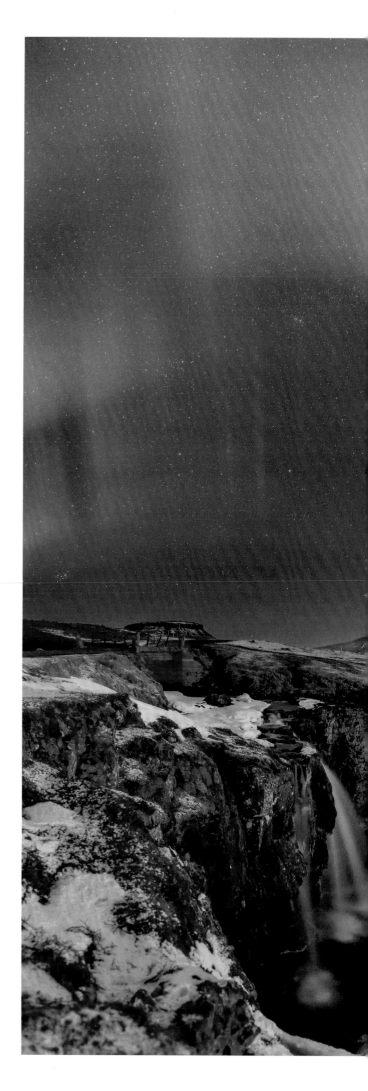

Snaefellsnes Peninsula 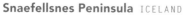 ICELAND

One of the strongest aurora storms of the past
two decades was caused by a solar eruption that
impacted on Earth on 17–18 March 2015. Here,
the Northern Lights appear in a range of pastel
colours above the iconic Icelandic landmark that
comprises the miniature waterfalls and coastal
mountain of Kirkjufell (Church Mountain).

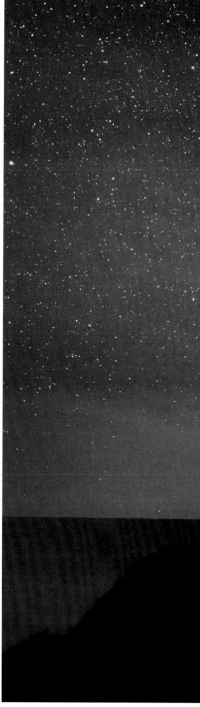

Southern California USA

This is one of very few images of an auroral display behind palm trees, captured when an extremely strong aurora storm on 14–15 May 2005 sparked displays as far south as the Anza-Borrego Desert State Park near San Diego. The event was rather colourless to the naked eye, but not to the camera. The bright star visible centre top is Polaris, at an altitude of 33 degrees. This shows how high the aurora display appeared on this night.

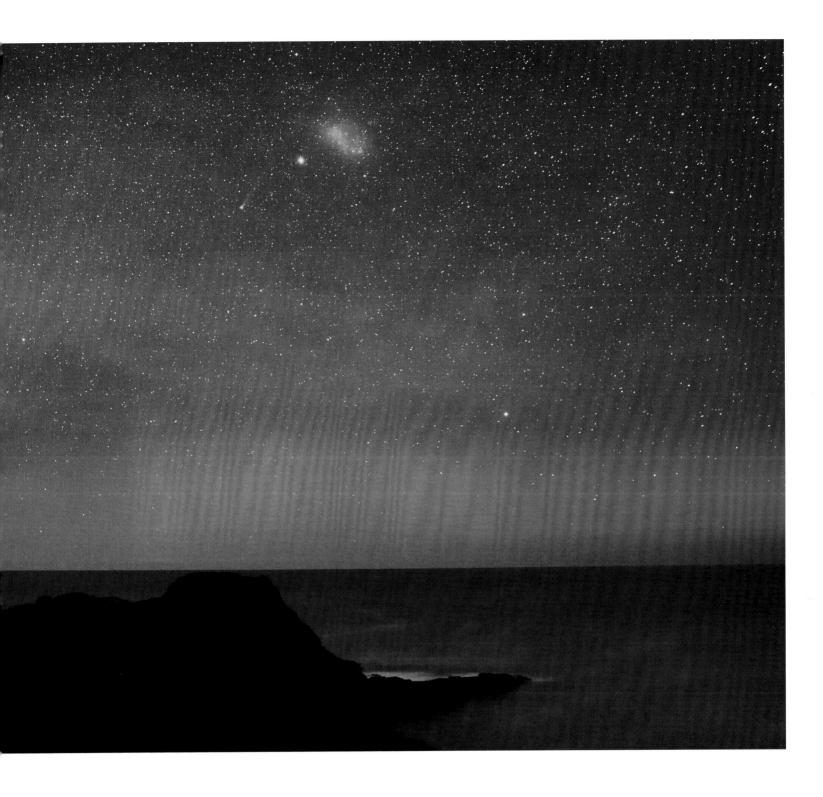

Victoria AUSTRALIA

A sudden red burst of aurora australis, the Small Magellanic
Cloud and Comet Lemmon (C/2012 F6), captured on
17 February 2013. This timely image, taken from the
southeastern shore of Australia, also shows a green cast
of airglow. You can spot the comet with its faint thin tail
and green coma at the centre top of the image.

Fragile Beauty of Darkness

BY LOSING THE NIGHT SKY WE RISK THE LOSS OF A DEEP-ROOTED CONNECTION TO OUR ORIGINS.

For most of human history, the night sky has provided a useful tool for our ancestors – a natural means of keeping track of the seasons, of navigating ways across the planet and of providing the natural illumination of the full moon. With today's technological advances such tools are no longer essential to our lives. Not only has the night sky become largely redundant but, filled as it is with reflected and refracted light – scattered rays from our overlit cities – it is not even dark enough for the Milky Way to be visible. Today, most night skies above cities are virtually empty of stars. There is a whole generation of human beings who have never seen a natural night sky. By losing the night sky we risk the loss of a deep-rooted connection to our origins. It is possible to change this by sharing concerns with others and leading our communities towards using the wide range of sky-friendly lighting that is now widely available.

Artificial light is essential for modern living, but much of it is unshielded and so scatters to the horizon and sky instead of illuminating the ground. It is this that causes a large share of light pollution. Such careless excess is not only an astronomer's problem, but is a major waste of energy and, like any other form of pollution, disrupts ecosystems leading to adverse health problems.

Affecting nearly 80 per cent of the planet, artificial lighting represents one of the most significant global changes caused by human activity. Close to cities, cloudy skies that reflect streetlights are now hundreds, even thousands of times brighter than they were 200 years ago. Essential wild-life behaviours such as mating, breeding, migrating, navigating and finding food are dependent on natural night darkness and are disrupted when this is lacking. A major concern lies in the decline of insect populations due to their fatal attraction to artificial lights. Should numbers continue to decline, entire ecosystems could collapse through starvation of the species that depend on insects for food.

With the LED revolution, light pollution has entered a new phase. There is no doubt that LED lights have benefits, helping us to preserve resource. Being energy efficient, they help to create a greener planet. But a more sinister aspect of LED lights is beginning to reveal itself. A certain group of the LED lights, commercially known as cold LED, has a blue-rich light and is popular for outdoor lighting. In many cities, it has replaced the more traditional, yellow sodium

streetlights. In 2016, the American Medical Association (AMA) made an official statement concerning the use of these LEDs, stating that these blue-rich LED lights are five times more disruptive to the human sleep cycle than conventional streetlighting. It seems that the human brain detects the blue light as day-time sky and so suppresses the production of melatonin, which usually increases at night-time and is essential to the deep sleep that allows the body to restore itself. An additional concern of using white LED lights lies in their intensity, or lumen output. Our eyes are not very sensitive to orange light. A white LED with the same lumen as an orange or yellow light appears much brighter to our eyes.

Hopefully, as technology advances, these issues will become obsolete. All lights have a Kelvin temperature. Temperatures of 2000–3000K are associated with yellow light, which is considered warmer and is known commercially as soft light. Temperatures of 4000–6000K are referred to as cold lights. While appropriate for dental surgeries and operating theatres, such cold lights can contribute to health issues if used for streetlights and in bedrooms. LED manufacturers now produce soft lights, too, although their use is not yet widespread in large cities. Lights with much lower temperatures (1800K) – phosphor-converted (PC) amber light – are similar to firelight and already popular in sky-friendly communities, dark sky parks and observatories. Change is underway. Chicago, one of the world's brightest cities, has followed AMA's guidelines to install 3000K soft LED lights for its streetlighting. This will become a model as other municipalities acknowledge the long-term hazards of cold lights.

In the coming pages Dark Sky refuges – preserved and protected places that allow visitors to experience darkness without artificial lights – are juxtaposed with urban arenas. The immediate comparison of the beauty that is hidden behind light, with the light show of urban worlds, serves to expose the loss of the silent dark sky. In the City Skies section a couple of images use digital techniques to reveal hidden stars in the urban skies. Known as 'stacking', such techniques involve photo sequences of many short-exposure images. We may have lost the night sky in many cities, but this method – and that of using skyglow filters to dim the dominant artificial sky brightness – enables photographers to uncover many stars. Their images offer a profound reminder of what exists beyond the vanishing curtain of light pollution.

[previous]

Dubai UAE

The moon is the only celestial beacon that comes close to competing with the city lights in this nightscape – a situation that is all too familiar to urban skygazers. The futuristic-looking scene is dominated by the 828 m (2717 ft) tall Burj Khalifa, the tallest freestanding structure on Earth. Only the very brightest stars remain visible in this urban sky: Capella to the left of the tower and Aldebaran next to the moon.

ABOVE OUR LIGHTS

In recent decades, the nocturnal face of our planet has changed dramatically, owing to the rapidly growing levels of artificial light being sent into space. In many places – predominantly vast urban areas and industrial centres – the natural night sky is almost entirely gone, while others offer just a glimpse of what lies hidden beyond the artificial lights. This section showcases such skies, battlefields in which the starry sky interacts with its rival: light pollution. The images record scenes all over the globe – from Alpine towns in western Europe, where the night sky suddenly reappears just a short drive from the brightly lit valleys and ski resorts, to ocean waters in which thousands of fishing boats use bright attractors to light up the sea and the sky, and from a lighthouse on the coast of Brittany, France, to a barely dark sky in Belgium, one of the world's most constantly illuminated countries. Such images reveal the impact of human activity on the natural environment in ways that daytime imagery cannot.

Perhaps the most arresting images are those that capture one-off events. At such times, unusual circumstances bring the natural sky temporarily into view, surprising local residents by revealing what has been lost in all its splendour. Incredibly, in 1994, when an earthquake that rumbled beneath Los Angeles caused a city-wide power outage just before dawn, residents called emergency centres and a local observatory to report a mysterious cloud overhead that turned out to be the band of the Milky Way, long obscured from view. In 1997, during the appearance of the great comet Hale-Bopp, the city of Milan briefly turned off the streetlights for residents to enjoy the natural wonder. The capital of Iceland, Reykjavik, occasionally turns off its lights during major aurora activity so it can be better seen from the city.

Innsbruck AUSTRIA

In this wintry scene from the Tyrolean Alps, the mountains are softly lit by moonlight, while the city's streetlights illuminate fog hanging in the valley. The iconic section of constellation Pisces (the Fishes) is framed above the mountains, a pentagon of stars representing the 'western' fish. This asterism is known as the circlet, and is famous for marking the vernal equinox – the point at which the sun is located in the northern hemisphere. The highest peak visible is the Schlicker Seespitze at 2804 m (9,199 ft).

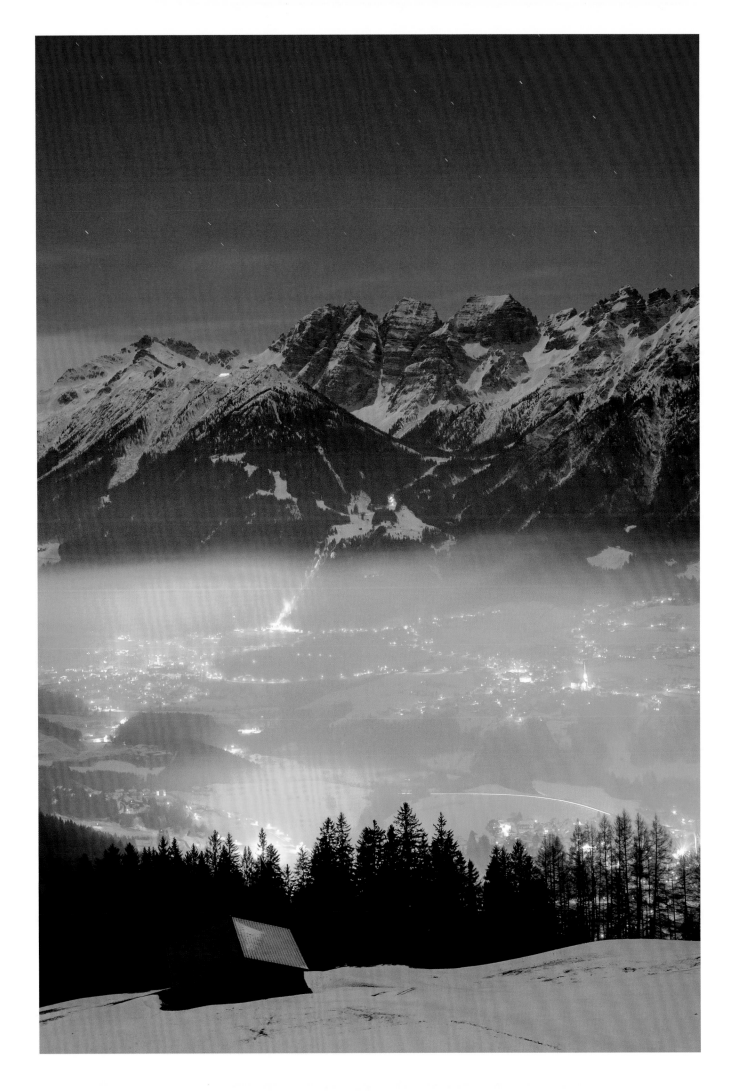

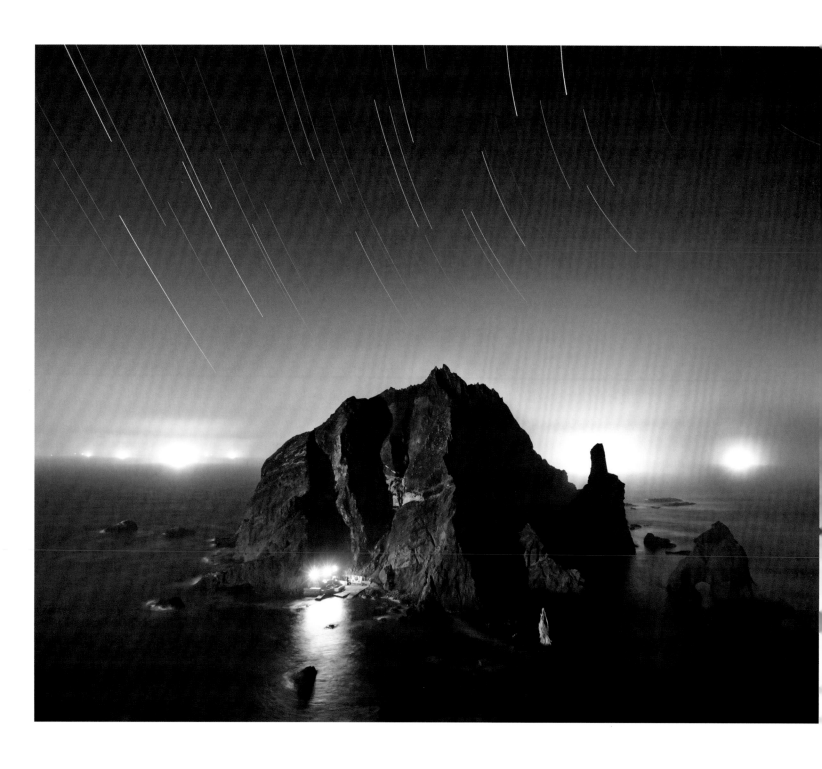

Liancourt Rocks (Dokdo)

SEA OF JAPAN (EAST SEA)

This composite of time-lapse images captures the trails of stars as they set above Liancourt Rocks, a group of small islets between Korea and Japan. The bright lights of many fishing boats mask stars close to the horizon. Fishermen use intensely bright LED arrays known as fishing light attractors to lure fish and members of their food chain into their nets. Some of the strongest lights are used in squid boats, which carry more than 100 such lamps, generating as much as 300 kW of light per boat. Scientists first became aware of this night lighting of the seas in the late 1970s and early 1980s, while compiling the first satellite maps of the Earth at night.

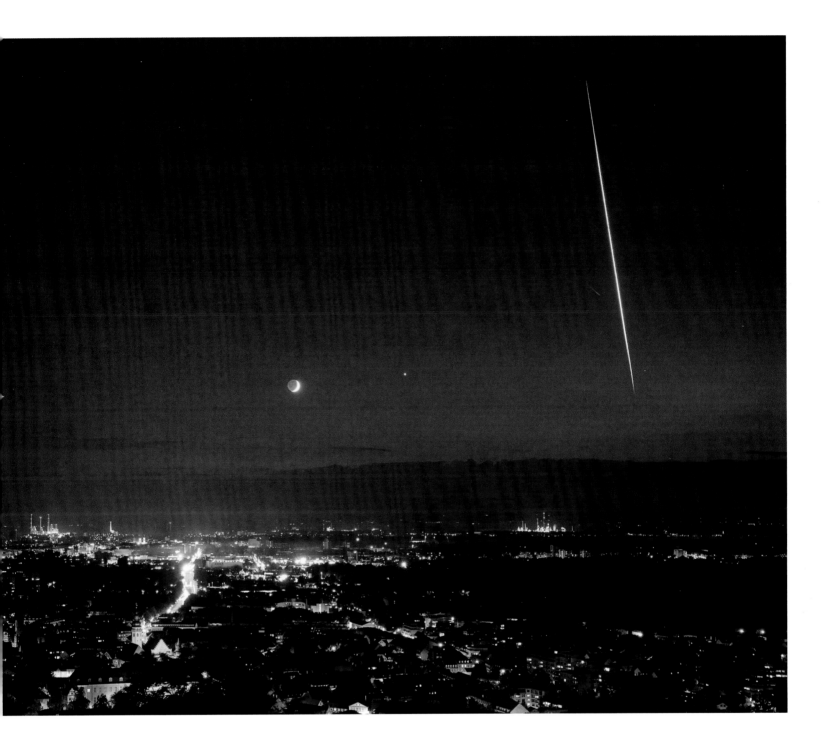

[above]

Saarland GERMANY

A bright meteor and the setting new moon compete with the lights of small towns and a couple of power plants in this German scene. Densely populated, and with large industrial areas, Germany is one of several European countries where really dark places at night are rare. This country has one of the world's most active professional and amateur astronomy communities, but its members have few chances of seeing the wonders of the starry sky from their own neighbourhoods.

[overleaf]

Brittany FRANCE

Our galaxy is seen against a backdrop of lights in this image taken from Point Penmarch lighthouse on the Atlantic Ocean shores of Brittany close to midnight on the shortest night of the year. To the left of the image, thin cirrus clouds glow orange as they reflect the light pollution. To the right of the image, directly over the ocean, the clouds are dark and almost invisible. The brightest point, close to the right-hand edge, is the planet Saturn. In the centre-left, the bright summer star Altair in constellation Aquila dominates the Milky Way band.

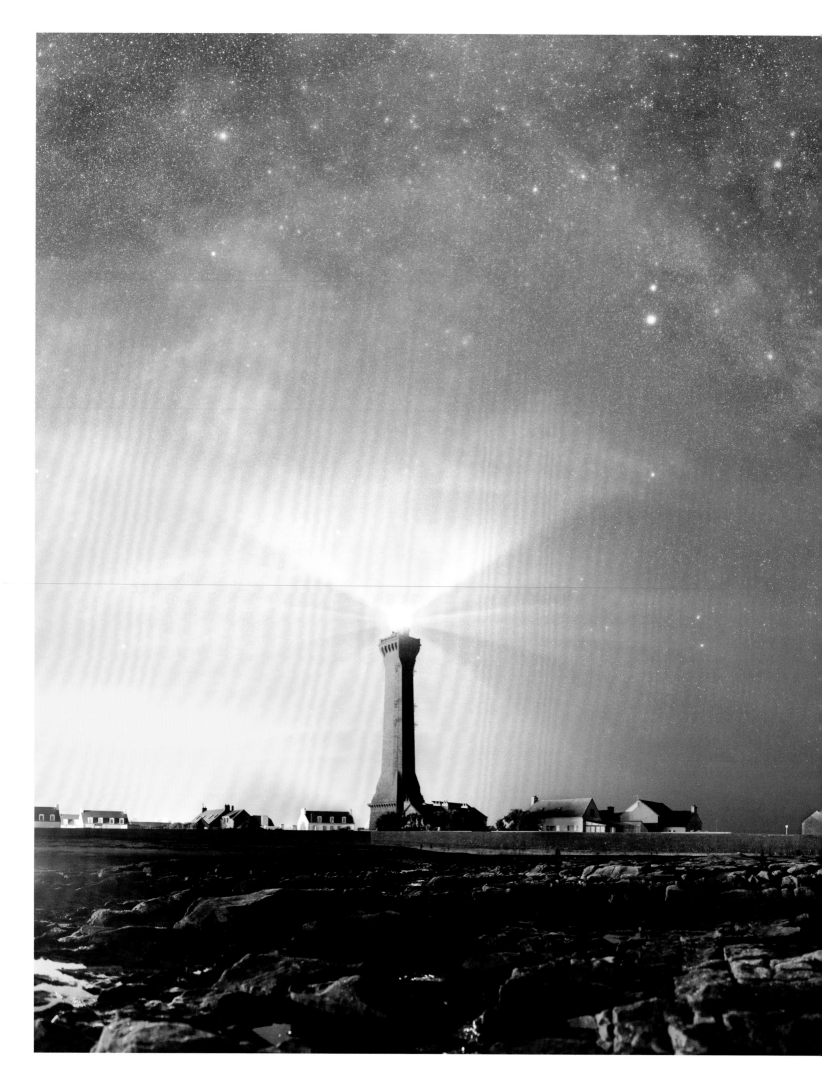

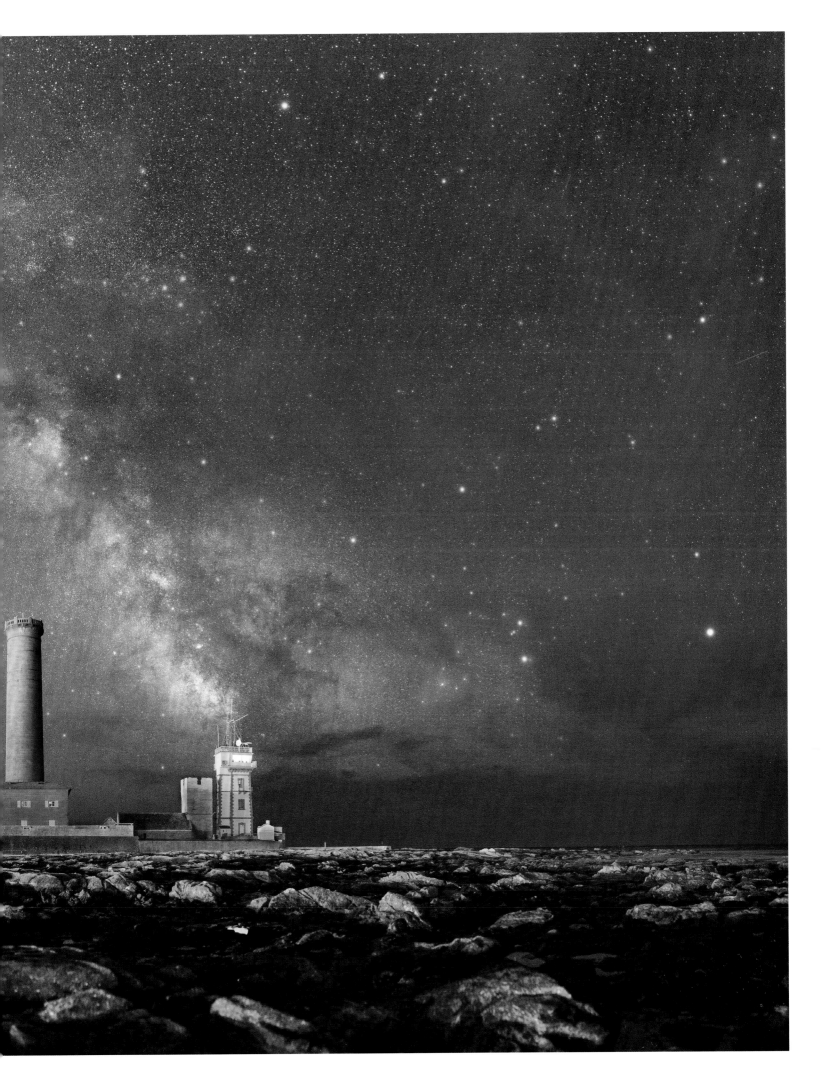

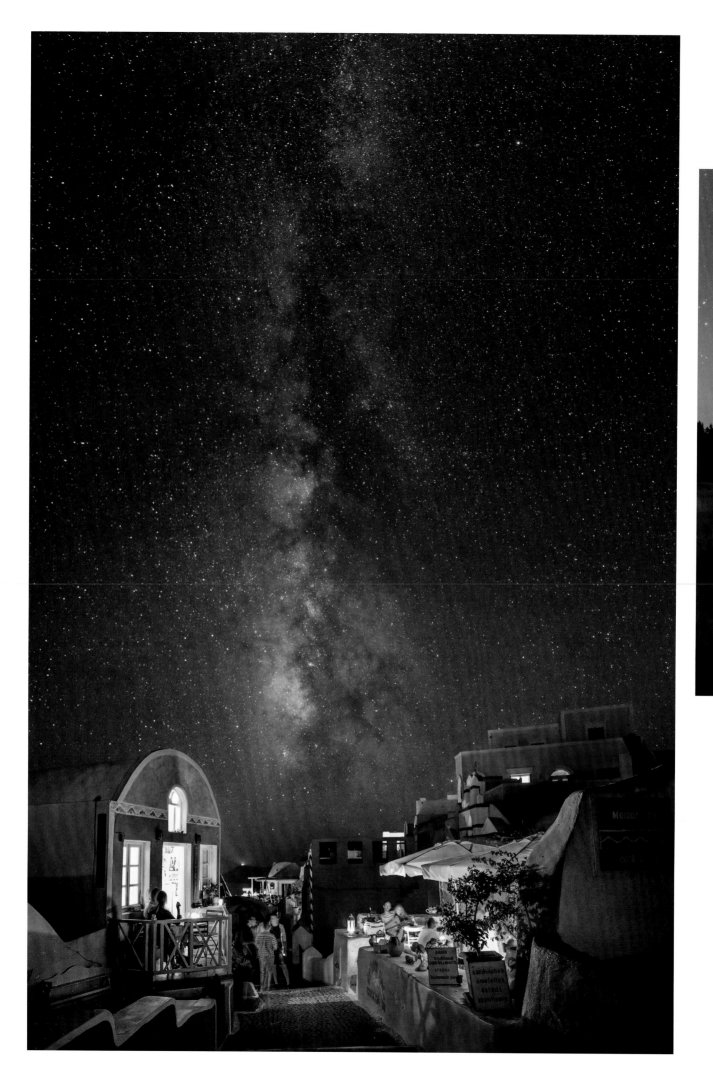

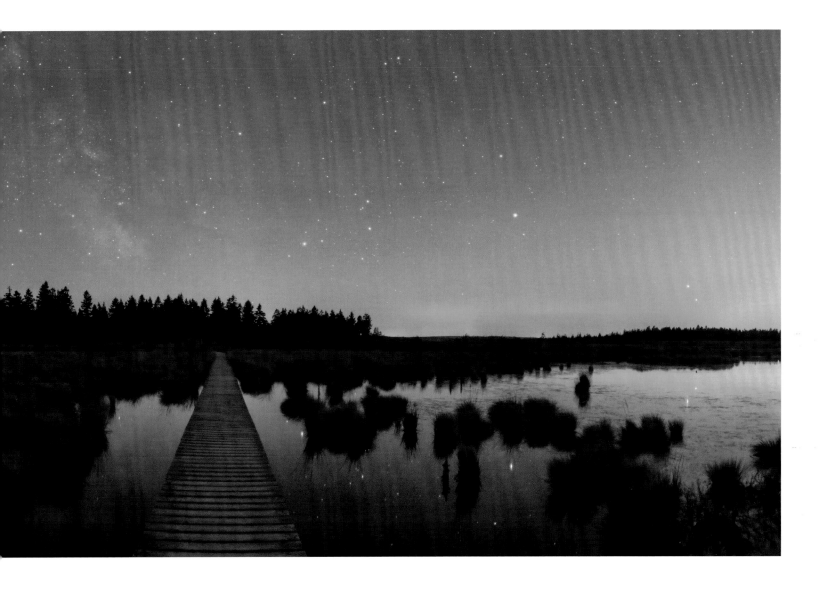

[opposite]

Santorini GREECE

This exceptional night view from Oia, a town on the Greek
island of Santorini in the southern Aegean Sea, surprised
locals, who are usually denied such dark skies. The Milky Way,
from constellations Scorpius (the Scorpion) and Sagittarius
(the Archer; bottom) to Cygnus (the Swan; top), appears above
candle-lit restaurants during a blackout. The island is known for
its postcard views of cliff-top towns on the edge of Santorini
caldera. The depths of the night sky are usually obscured by
the thousands of lights in this popular tourist hotspot.

[above]

Hautes Fagnes Nature Park BELGIUM

The summer Milky Way is pictured here during moonrise over
a nature reserve known as the High Fens swamps, close to the
Belgian–German border. One of the most light-dominated
countries in the developed world, Belgium is not known for
starry skies. However, there are still a few areas from which to
glimpse the beauty of the natural night sky, and this is one of
them. At the centre lies the bright star Antares, at the heart
of Scorpius (the Scorpion). To its right is Saturn in Libra, with
Mars even further to the right, on the western horizon.

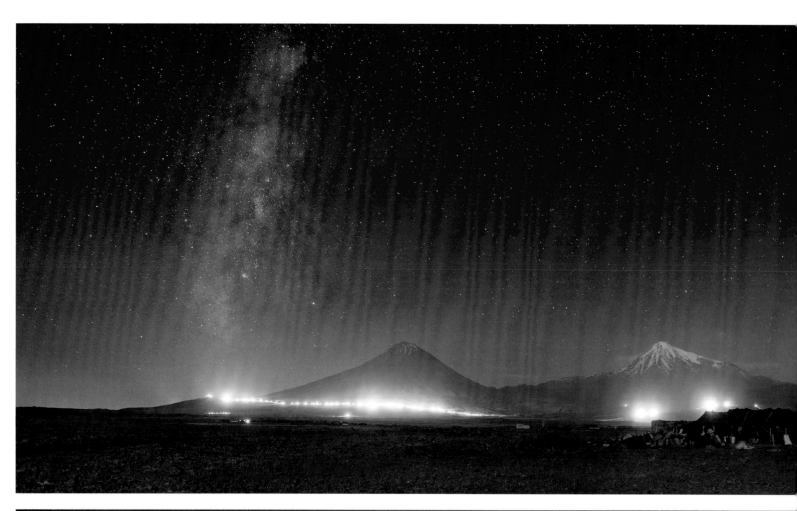

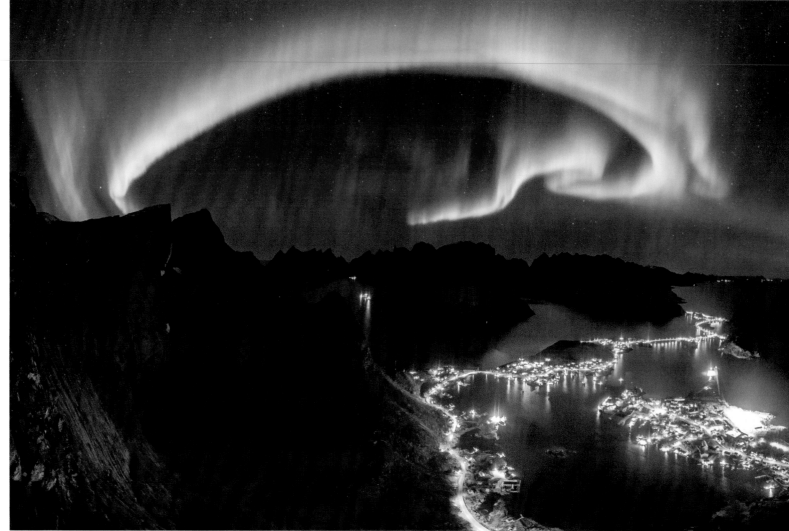

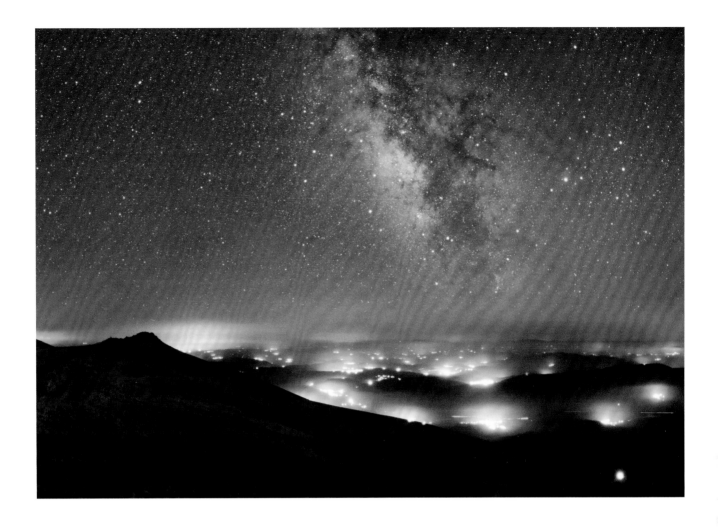

[above left]

Maku IRAN

The twin volcano cones of Mount Ararat provide
a dramatic backdrop for this nomad tent close to
the brightly lit border between Iran and Turkey.
Thanks to the high-altitude clear sky and a few
kilometres distance from the border, the summer
Milky Way is clearly visible above the mountain.

[above]

Mount Uludağ TURKEY

Hanging above the scattered glow of nearby
lights, this mountaintop vista offers a dark sky
refuge thanks to the change of altitude and
sky transparency. The central bulge of our
home galaxy is photographed close to the
2540 m (8333 ft) barren granite summit of
Mount Uludağ, overlooking the brightly lit
villages near the city of Bursa.

[left]

Lofoten Islands NORWAY

In this wide-angle panorama taken from Mount
Reinebringen, a giant arc of the Northern Lights
appears above the fishing village of Reine, one
of the most scenic views in Norway. Unlike the
fainter, elusive Milky Way, auroras are often
bright enough to be visible despite the lights
of villages, or even small cities.

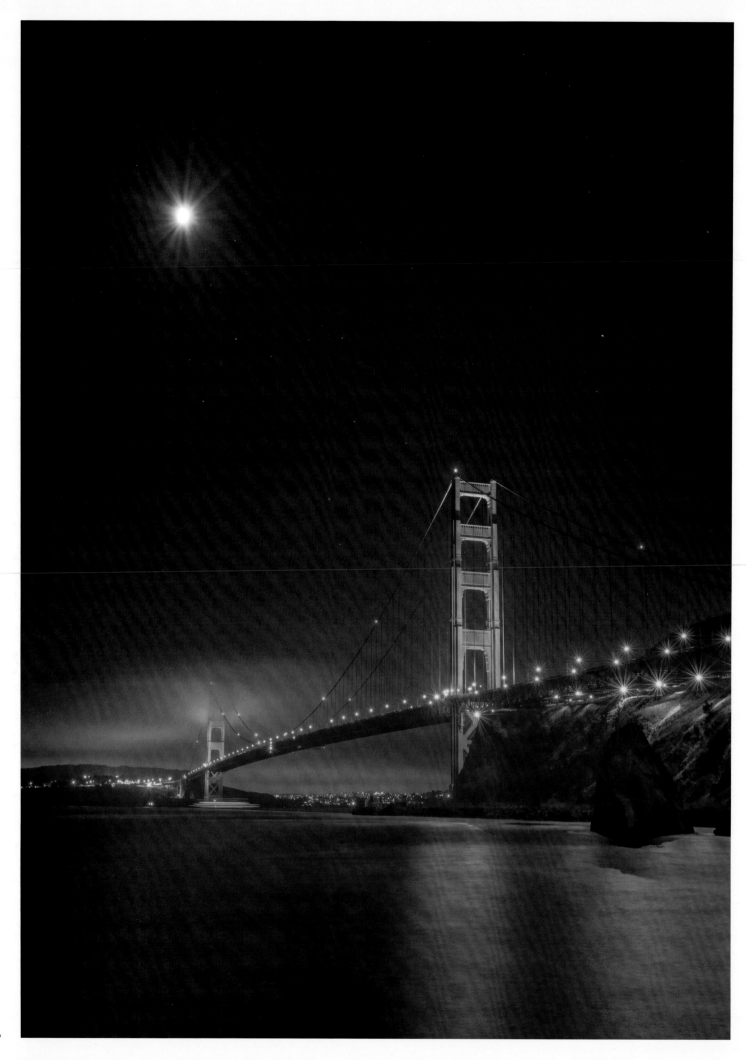

CITY SKIES

According to the United Nations (UN), more than half of the human population lives in urban areas – a rate that is set to increase to 60 per cent by 2030, at which time one in every three people will be living in a city with at least half a million inhabitants. With a few exceptions, these are the places over which the night sky has lost the battle with light pollution. Among those cities leading the way towards a better future for urban stargazers, Tucson, Arizona, and the smaller city of Flagstaff, have streetlights that are shielded to the ground in support of the region's astronomical observatories and to preserve some of the natural night-time environment. There are several misunderstandings about light and safety. Of course, we need some light for safety and security reasons, yet various case studies show that brighter lights in urban areas do not necessarily prevent crime. Floodlights create very bright areas, but also very dark shadows, for example. Also, when not properly shielded and pointed to the ground, bright lights can present a driving hazard, creating glare that causes a momentary lack of sight.

Artificial light is also used for purposes beyond safety. Many major cities use lighting to create an identity; cities in warm areas prefer blue-rich LED lights to create the impression of a cooler atmosphere, for example. In recent years, more than 90 per cent of Indian streetlighting has been upgraded to white LEDs with temperatures of more than 5000K. Similar developments are emerging across Southeast and eastern Asia. Still, there is a movment in the West to start action against white LEDs, with US cities that include Lake Worth, Florida, and Gloucester, Massachussetts, installing lower-temperature alternatives – not only to the relief of astonomers keen to see the night skies above their homes, but also in light of growing concerns about the health concerns related to higher-intensity LED streetlights (see page 164).

San Francisco, California USA

Golden Gate Bridge stretches beneath a bright moon. The most photographed bridge in the world, it spans the channel of water between San Francisco Bay and the Pacific Ocean and has been declared one of the Wonders of the Modern World by the American Society of Civil Engineers. But the area is also one of the most light-polluted nature reserves in the country. Here, a few stars appear with the help of a skyglow filter used to partly cut the light pollution.

Tehran IRAN

This unusual view shows a rich field of star trails above an ocean of streetlights and is a combination of many hundreds of continuously taken photos, each just a few seconds long for a total exposure of four hours. This technique helps to reveal stars that are otherwise hidden in the bright skyglow. The brightest trails are those of the setting moon and Jupiter. Home to about 15 million people, Tehran is seen here from Milad Tower (the tallest tower in the country). A close look at the image shows a blurring of the city lights due to the wind that caused the tower to move during the photo sequence.

Melbourne AUSTRALIA

The sky above Melbourne is devoid of stars, instead illuminated by the glow of the city. Our cosmic neighbour, the moon, is the only remaining celestial wonder in this view, photographed from the city's 300 m (985 ft) tall Eureka Tower.

Stockholm

SWEDEN

One of the strongest aurora displays of the decade competes with light pollution above Stockholm. On 17 March 2015, a massive solar storm collided with Earth's magnetic field, producing intensely bright auroras in high latitudes. It is rare for the residents of Stockholm to see the Northern Lights in such splendour due to the city's lights.

Shanghai CHINA

One of the world's largest cities, Shanghai never sleeps. Parading extravagant electric signs on skyscrapers, apartments and even boats along Huangpu River, this is a city without a night sky. Most Shanghai adults will have childhood memories of fantastic starry summer nights before the local authorities began to develop the lighting in the late 1980s. Now the bright night-time view of the city attracts millions of tourists and is a large part of the city's modern identity. In light of emerging concerns about the negative effects of excessive night lights on the human sleep cycle, Shanghai authorities have established regulations prohibiting intense lighting in residential buildings, schools, hospitals, parks, nature reserves and observatories.

London UK

The moon and a few stars can be seen on a clear night on the banks of London's Thames River. More than two centuries have passed since the first gas-lit public streetlight was installed in the city, in 1807, replacing older oil lamps and starting a revolution in world streetlighting that has led to more efficient electric lights. In this image the nineteenth-century Tower Bridge, an iconic symbol that transports the viewer to Victorian London, is seen against the modern architecture of the Shard, a ninety-five-storey glass-clad skyscraper, completed in 2012.

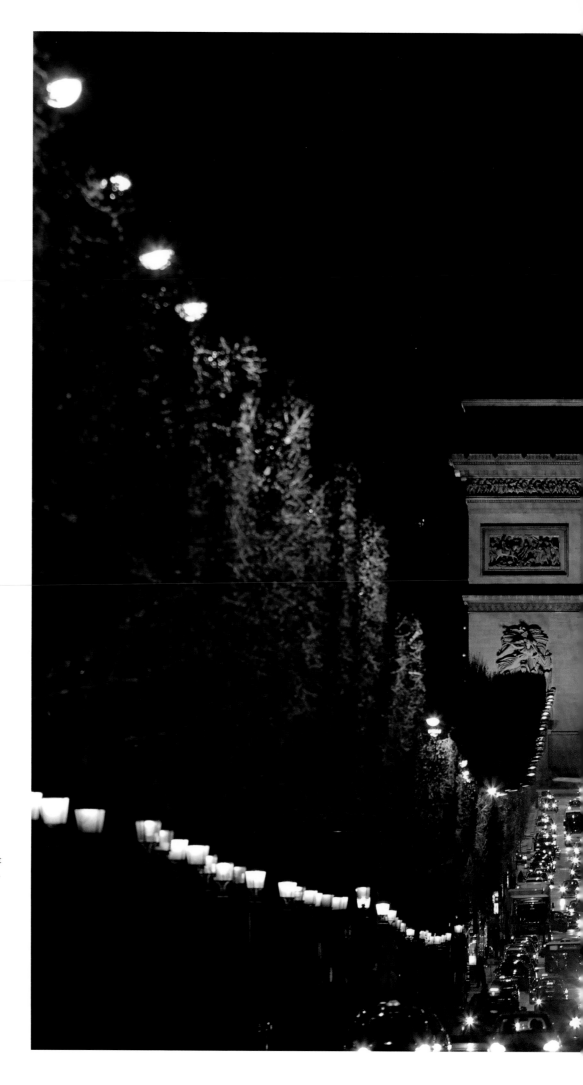

Paris FRANCE

A single-exposure photograph, taken using a long telephoto lens, captures the setting moon above the Arc de Triomphe on a busy night on the Avenue des Champs-Élysées. The well-planned image shows the setting moon and a few 'stars' around it, but in fact, these are the aircraft-warning lights on top of the skyscrapers of the modern La Défense business district.

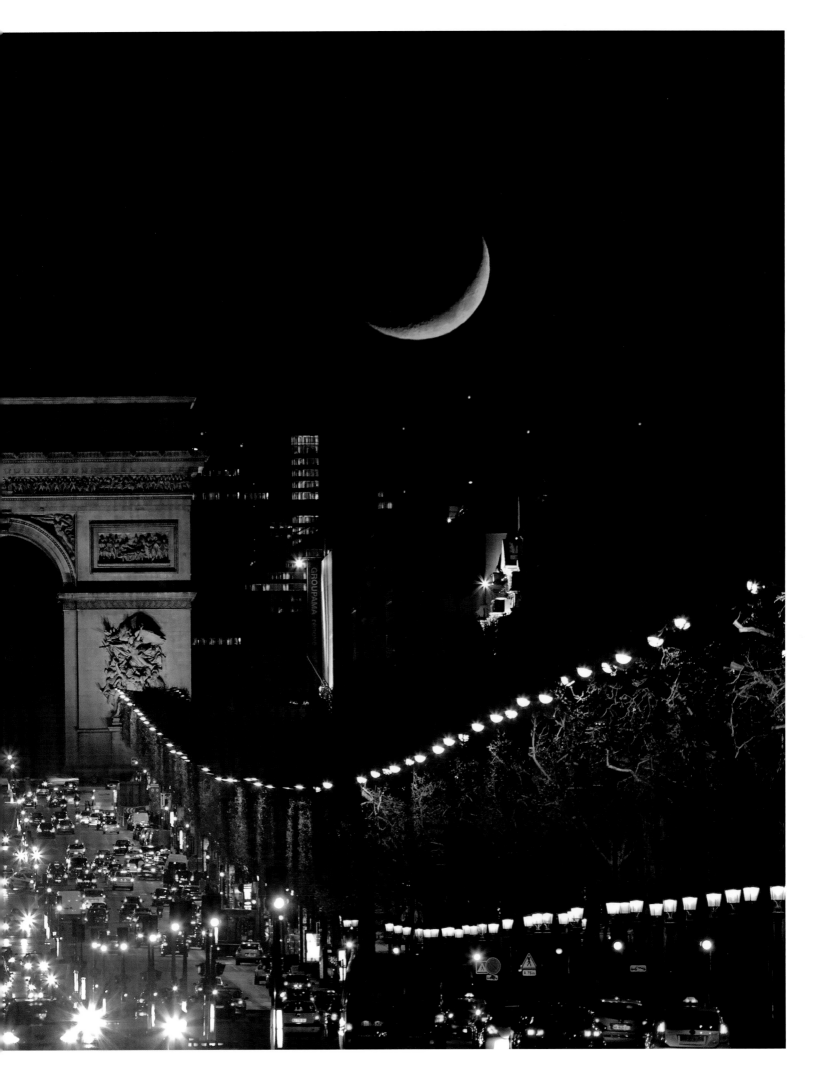

ENVIRONMENTAL IMPACT

Although light pollution swallows the darkness, obscuring the Milky Way, this is not the worst effect of it. Beyond any astronomer's concerns, excessive artificial lighting affects wildlife, human health, energy, heritage and even safety. On a global average, artificial light is growing at a rate of 6 per cent per year and the night sky is brightening by around 2 per cent. Humans, birds and several other species are finding it increasingly challenging to experience night-time uninterrupted by artificial light, which disrupts the natural rhythms of mating and feeding. Among those most affected, migrating birds drift off course, turtle hatchlings are lured away from the ocean and insects are forced to hover around light sources until they die from exhaustion.

Scientists have known about the negative effects of light on birds for at least two centuries. Nineteenth-century ornithologists reported on birds killed by flying into lighthouses. Today, brightly lit buildings lure birds to their deaths at a shocking rate. Up to 1 billion birds die from building collisions each year in the United States alone. Although the vast majority of these happen

in the daytime, such collisions are related to light pollution drawing migrating birds into unfamiliar urban environments. Many birds use the stars for navigation. Intense lights send bright beams into the sky, especially on moonless nights, disrupting migratory paths and causing birds to circle buildings repeatedly, dying from exhaustion if not collision. Bats and insects are also affected, as are plants, which have seen a large drop in the number of insects moving pollen at night. Light pollution can also affect day-active insects, such as bees, by disrupting their sleep cycle.

All of these problems can be solved by improving the design of lighting, by sharing concerns among other members of your community and by following a few simple steps: light only what you need, point light sources to the ground and shield them, and use warmer (yellower) lights. Timed and motion-sensor energy-saving features on outdoor lights can help, too. It does not take much to imagine the impact such actions could have on the visibility of the night sky if followed by the majority of the people living on this planet.

Brittany FRANCE
Plankton glows in the surf of this beach scene, with the Milky Way hanging in the night sky. Glowing on the horizon, like a rising sun, are the lights of a nearby town.

Arizona USA

A cloud is heavily lit by safety floodlights at the Navajo Generation Station in northern Arizona – evidence that a large amount of light energy is being wasted to the sky. One of the last remaining coal-fired power plants in the United States, the station is close to the protected nature reserves and wildlife sanctuaries of Glen Canyon and Lake Powell.

Alberta CANADA

Below a green aurora arc, a deer wanders across a wheat field, stopping briefly to look at the camera and holding still for the ten-second exposure. The landscape is illuminated by the light of a nearby town. Stars of constellation Cassiopeia and Perseus appear to the upper right of the deer with the faint autumn Milky Way. The Andromeda Galaxy (M31) is in the top-right corner of the image.

Sydney

A time-lapse image of Sydney Opera House shows ghostly trails across the sky, made by flying birds illuminated by the monument's floodlights. Birds, both local and migrating, are attracted and trapped by intense artificial lights, resulting in changes of behaviour and often leading to their deaths. Birds trapped in floodlights often appear disoriented, circling endlessly around the source.

Tak Bai THAILAND

Covered in a blanket of low-lying cloud, Tak Bai is heavily illuminated at night by bright blue-rich LEDs from the area's many hotels and resorts. The light obscures the view of twinkling stars overhead that, more often than not, remain visible only from outside the city.

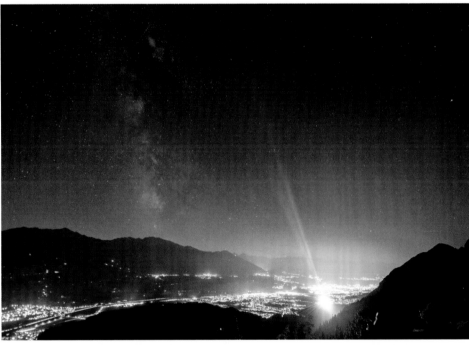

Innsbruck AUSTRIA'

Close to Innsbruck, the capital of Austria's Tyrol region, an intense blue beam pierces the sky during an evening light show at Swarovski Crystal Worlds museum. At high altitudes such as this, the air becomes thinner. It is more transparent as a result, minimizing skyglow scattering and allowing the Milky Way to remain visible despite the city lights down below, in the valley.

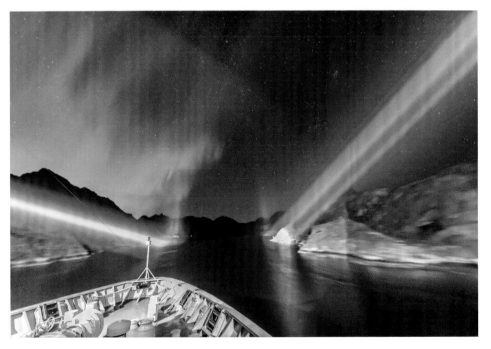

Trollfjord NORWAY

A cruise ship navigates the Arctic fjord of Trollfjorden using the ship's spotlights to illuminate the walls of the narrow fjord. Beyond the beams, green aurorae borealis dance in the clear night sky.

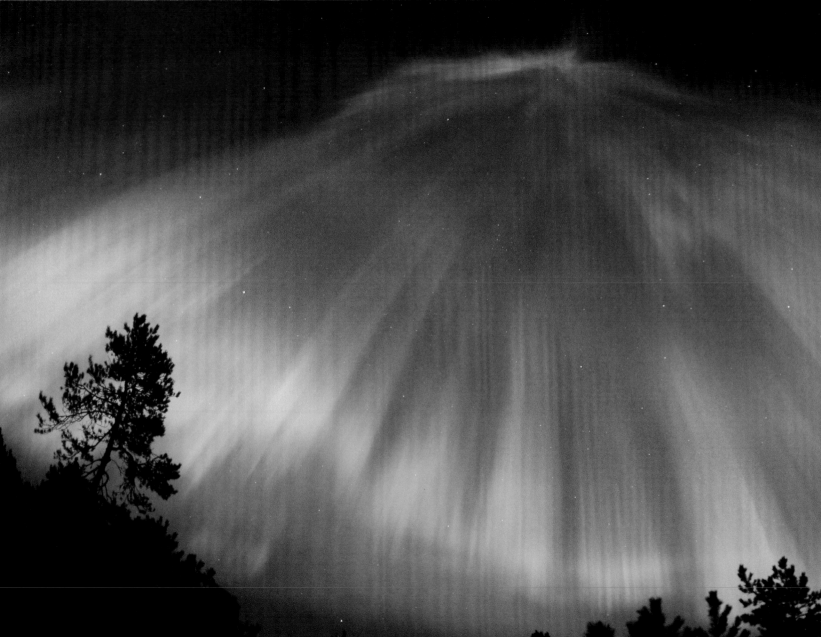

Dark
Sky
Refuges

SEEING A TRULY DARK SKY IS AN UNFORGETTABLE EXPERIENCE.

With most of the planet's landmass impacted by light pollution, several organizations – and an emerging astrotourism industry – are seeking to reclaim our natural starry nights. The movement has been led by the efforts of the nonprofit International Dark Sky Association (IDA) based in Arizona, USA, with members around the world, and which has fostered important collaborations with research institutes and light industry.

High, dry, dark and accessible sites are ideal, such as the locations of major astronomical observatories and places designated by the IDA as Dark Sky parks, reserves and sanctuaries. In 2007, the Natural Bridges National Monument in Utah, USA, became the first Dark Sky park and, today, the list includes about 100 sites in North America and across the world. Canada has the largest Dark Sky park, Wood Buffalo National Park, which is larger than the country of Denmark. In Europe, more than twenty sites span the continent from Ukraine, Czechia and Hungary, to Germany and Spain. A similiar European designation, the Starlight Reserve, has emerged with the support of UNESCO, also with a growing list of sites across the globe.

Many areas with natural night sky and existing ecotourism or cultural tourism have the basic infra-structure to protect their dark skies and welcome stargazers. Among the sites featured in this chapter are New Zealand's Lake Tekapo and the Alqueva Dark Sky Reserve in Portugal, both examples of the ways in which astrotourism can become a sustainable source for the local community. Sites with an official designation need to meet certain criteria in order to qualify, such as the local community taking measures to protect the sky from light pollution. But numerous other destinations are suitable for stargazing, without having an official designation. These 'dark spots' are visible in the New World Atlas of Artificial Sky Brightness and can be seen in NASA's Earth at Night satellite images. However, the World Atlas maps do not account for the very effective altitude factor. Even close to metropolitan areas, which appear very bright in satellite images, stargazers can experience better air transparency in elevated locations, where the thinner atmosphere helps to decrease the amount of scattered light pollution known as skyglow. The narrow band of dark sky above the Alps in western Europe is a prominent example of this, where starry skies are visible close to valleys packed with lights from the towns and ski resorts. Mount Wilson and Mount Palomar observatories in the Southern California, USA, are other notable examples. Although close to Los Angeles and San Diego, leading research is still possible from these locations thanks to an 1,800 m (6,000 ft) gain in altitude from the light-polluted cities at sea level. Resembling an unreachable castle atop a rugged peak in the Pyrenees, in Europe, Pic du Midi Observatory is also surrounded by lights from towns in southern France and northern Spain, from its altitude of 2,877 m (9,500 ft), yet the Milky Way is still prominently visible.

Some of the world's finest dark skies feature in this chapter. A favourite among astronomers is the Atacama Desert in Chile, one of the world's driest places and home to several major observatories. Walking in the arid desert, on the red soil scattered with rocks and boulders, feels like being on Mars under the Earth sky. The town of San Pedro de Atacama is a busy stargazing hub. In summer the best locations are close to the Altiplano highlands, while in winter months, the lower desert flats offer the best vistas. At the southern end of the desert, the wine region of Elqui Valley near the city of La Serena is another prime astrotourism destination, with high mountains and hotels specifically designed for stargazing. The islands of Hawaii are also worth a mention, in particular the Big Island itself, the dormant volcano Mauna Kea, on which the Mauna Kea Observatory sits some 4,200 m (13,800 ft) above sea level. It's a position that has made the observatory one of the world's leaders in astronomy. The Haleakala Crater on the Hawaiian island of Maui is home to another, very accessible observatory. The Canary Islands in the Atlantic Ocean are well known to stargazers – in particular, the environmentally protected island of La Palma, 300 miles (480 km) off the coast of north-western Africa, with a major observatory at a very dramatic edge of a massive caldera. The island is often called the stargazing paradise of Europe.

With its profound motto 'half the park is after dark', The Night Skies Program operated by the US National Park Service is pioneering in its efforts to protect the last remaining natural dark skies. The US Southwest has the most popular stargazing destinations from various Utah parks to the Grand Canyon, Yosemite and Death Valley (one of the world's largest dark-sky places). Many other parks, although not four-season stargazing destinations, have truly dark skies and include Acadia in the northeast, Mount Rainier in the northwest, Grand Teton and Yellowstone in Wyoming, the Badlands in South Dakota and the Big Bend in Texas.

NASA's Earth at Night satellite images evidently display how dark skies grow above the Australian outback. From Uluru-Kata Tjuta National Park in the country's central desert to Western Australia and the southern coastline of Victoria, along the Great Ocean Road, there are many favourite places to camp beneath the stars.

Seeing a truly dark sky is an unforgettable experience. To witness the patchy glow of our home galaxy shimmering from afar, just above the horizon of our little planet is breathtaking whether it is your first experience or you are a seasoned night-sky observer. Today, many people who have not seen a natural sky might think such descriptions belong to science fiction, but this view still exists. Seeing a dark night sky is not just a visual sensation, but an experience that connects us both to our past and to our future. Dark skies constitute a unique natural heritage both to appreciate and to actively preserve.

[previous]

FINLAND

Colourful curtains of the Northern Lights reveal their most majestic beauty in a naturally dark night environment just a few hours drive from the Finnish capital.

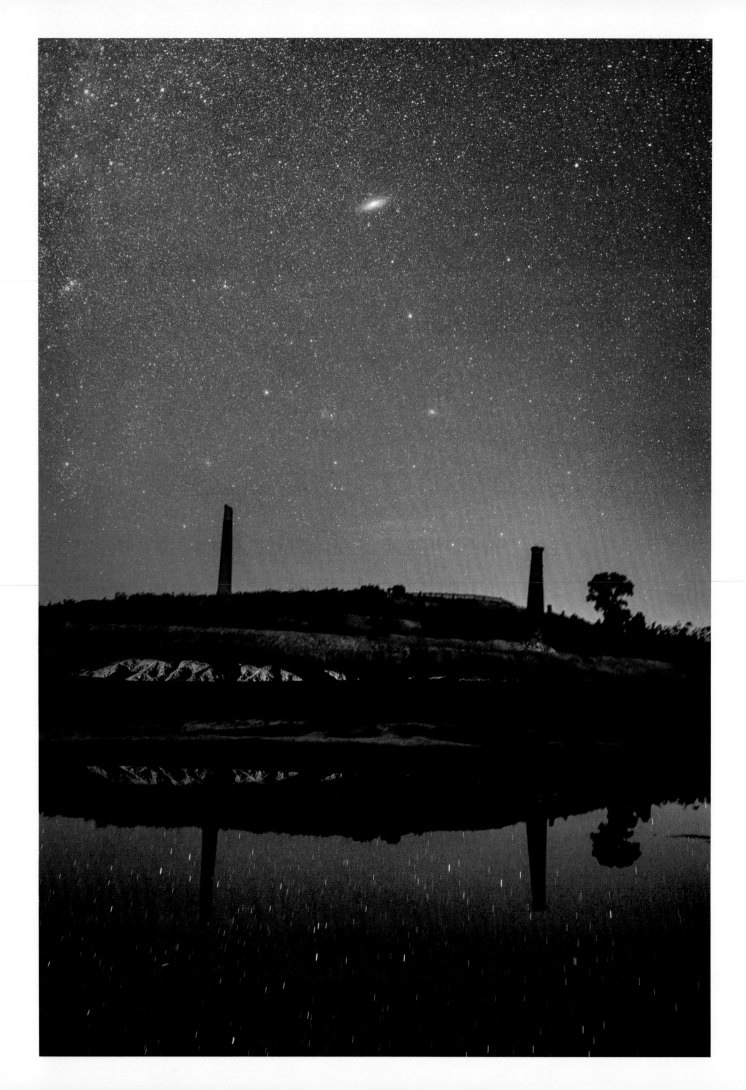

DARK SKY RESERVES

Publicly accessible, Dark Sky preserves possess an exceptional and distinguished quality of starry nights in nocturnal environments that are specifically protected as much for their scientific, natural, educational and cultural heritage as for public enjoyment. A designation from the International Dark Sky Association (IDA), or as part of the Starlight Reserves initiative under UNESCO, helps raise the profile of a location, increasing astrotourism and contributing to a more sustainable local economy. With the growing awareness of the value of a truly dark sky, there is also an increase in travel to places with a protected natural night environment.

Not all of the 100 plus designated Dark Sky places (darksky.org/idsp) provide a similar quality of night sky. Those listed as Dark Sky communities and Urban Night Sky Places, for example, are simply legally organized cities and towns that have adopted quality outdoor lighting and seek to educate residents about the importance of dark skies. The night sky is not spectacularly dark in these places, but is better than in other urban areas. The first such place was Flagstaff, Arizona, USA. Places listed as Dark Sky parks include a number of national parks in North America, while Dark Sky reserves consist of a dark 'core' zone with a populated periphery. Dark Sky sanctuaries represent the most extreme category, and are the most remote (and often darkest) places in the world, whose conservation state is most fragile. Some of the world's most notable observatory sites feature in this category.

Mértola PORTUGAL

Constellation Andromeda hangs in the sky above the century-old, now water-filled mine of Sao Domingos in Mértola. Towards the top of the image, the fuzzy light of the Andromeda Galaxy (M31) is visible against a faint greenish background of airglow activity. At more than 200,000 light years wide, this neighbouring galaxy is larger than the Milky Way, and at a distance of 2.5 million light years from Earth, its light is older than the emergence of our earliest ancestors, Homo habilis (around 2 million years). M31 is one of the two closest spirals to our Milky Way, the other one being the Triangulum Galaxy (M33), seen as a faint halo at the centre of this image. In ideal conditions, M33 is the furthest object barely visible to the naked eye at a distance of 3 million light years away.

Brittany FRANCE

Photographed from the Pointe de Pen-Hir
in Brittany on a clear September evening,
the Milky Way appears to emerge from the
Atlantic Ocean. A nearby town brightens
the sky behind the cliffs to the left, but the
night sky towards the ocean is unspoiled of
light pollution. The bright central bulge of
the galaxy in Sagittarius stands above small
islets, beyond which are the lights of Cap
Sizun some 25 km (15 miles) away across
the water.

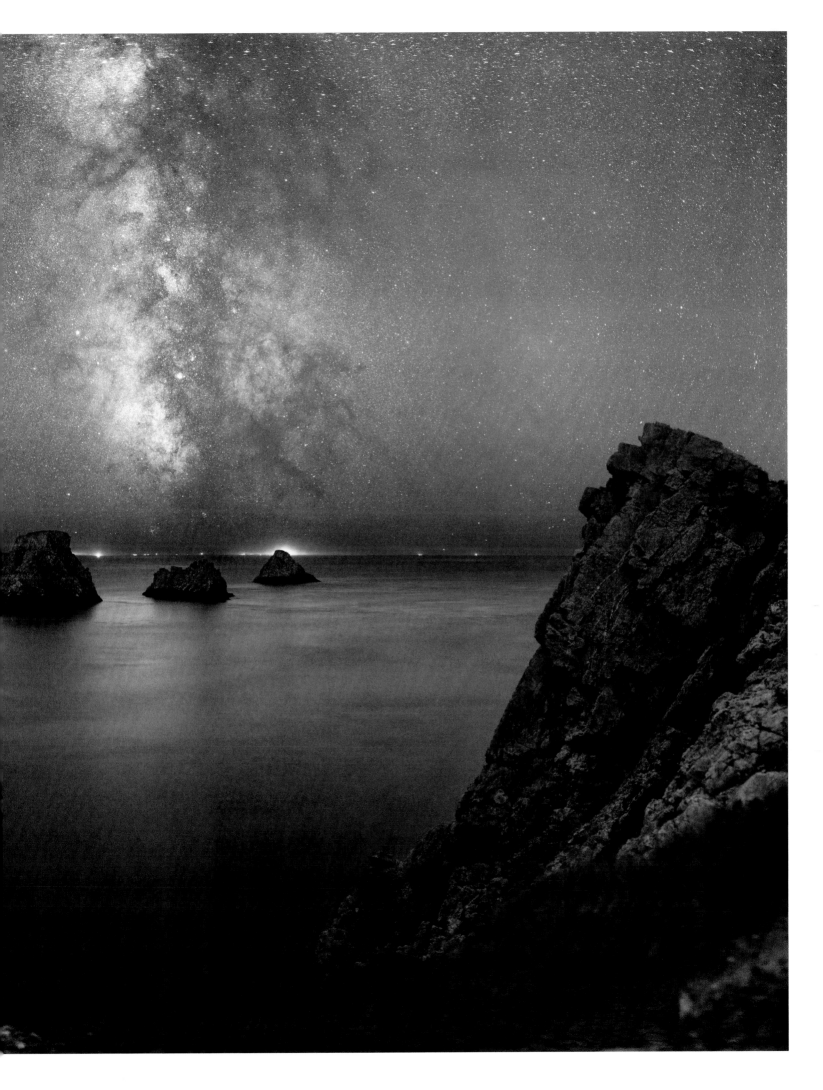

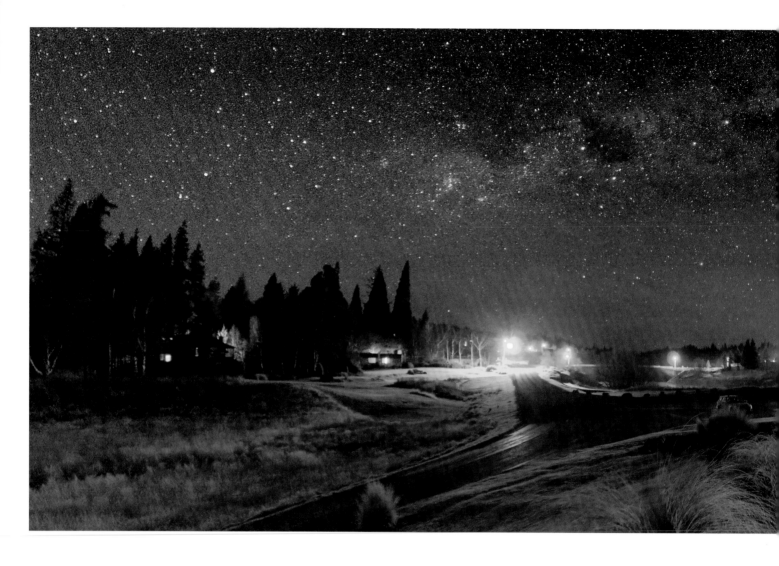

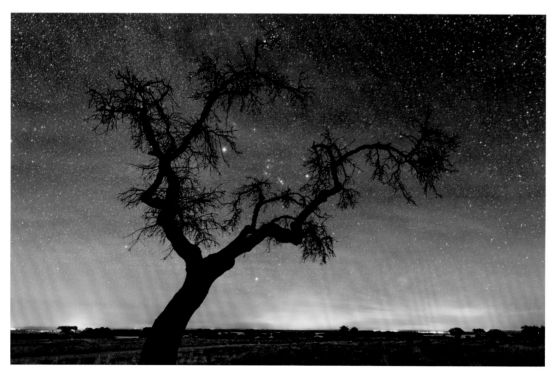

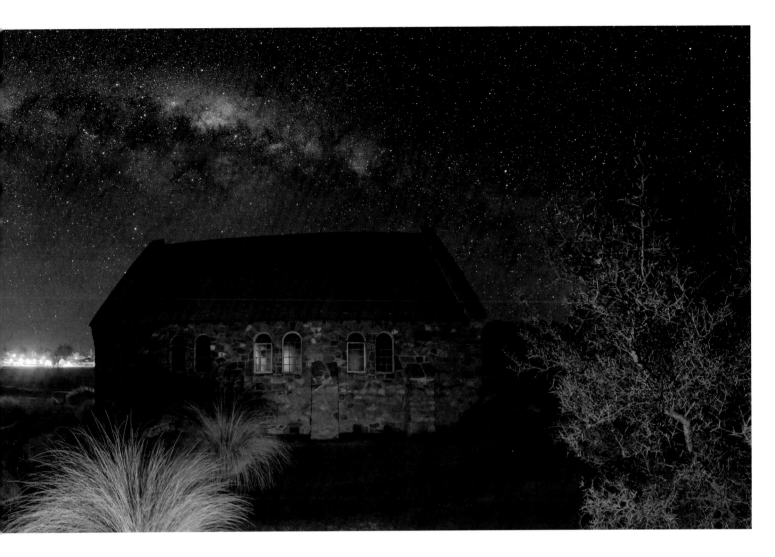

[opposite]

Alqueva PORTUGAL

Constellation Orion (the Hunter) is seen away from city lights in the Alentejo region of Portugal. Known as Dark Sky Alqueva, this area was the first site to be certified as a Starlight Tourism Destination by the Starlight Foundation. Encompassing both Portuguese and Spanish councils, it is a unique cross-border Dark Sky place and testimony to the fact that the sky removes our boundaries. Just below the tree's branches, the bright winter star Sirius rises above a far-city glow. A deep-sky object is also clearly in view, close to the centre of the image – a small fuzzy 'star' just to the right of the three aligned blue stars of Orion's belt. This is the Orion Nebula (M42), magnificent when seen using a telescope, but a tiny ghost to the naked eye.

[above]

Mackenzie NEW ZEALAND

The large number of protected natural areas within New Zealand make it a fantastic destination for stargazing. Here, at Lake Tekapo within Aoraki Mackenzie International Dark Sky Reserve, the Church of the Good Shepherd is illuminated by sky-friendly lights that allow the galaxy to remain visible. This panoramic image takes in the southern Milky Way from the Carina Nebula (pink halo) to the left of the Crux constellation (the Southern Cross) and two bright stars of Alpha and Beta Centauri (centre). The bright galactic bulge in Sagittarius (the Archer) can be seen on the right.

NATIONAL PARKS

The well-established Night Skies Program organized by US national parks serves as a model for Dark Sky activities in other countries around the world. Such sites run astronomy programmes through which people of all ages can learn more about the wonders of the night sky. In the United States and Canada, events include telescopic observation and full-moon walks with rangers, with programmes culminating in a Dark Sky festival in the summer (in colder climates). There is also a focus on International Dark Sky Week, which takes place during the new moon in April. The Grand Canyon in northwestern Arizona has around 5 million visitors each year, many of whom come to see the night sky, and presents perhaps the greatest example of raising public awareness of the values of the natural night sky.

During summer, in California's Yosemite National Park, amateur astronomy clubs from the Bay Area set up telescopes and host star parties almost every Friday night, weather permitting. These fantastic, public stargazing sessions are held at the Glacier Point Amphitheater, one of the most scenic places on the planet. Rangers also offer astronomy night walks in the valley. Death Valley, one of the world's largest Dark Sky refuges, is an all-seasons stargazing destination with an annual dark sky festival in March, at which NASA scientists give talks on and tours of the geological wonders of the park. Both Wood Buffalo and Jasper national parks in Alberta, Canada, hold Dark Sky festivals – in August and October respectively – during which it is possible to view the Northern Lights.

Many national parks in Europe run stargazing programmes. In England several national parks organize a joint festival in February or March with events in the Yorkshire Dales, Northumberland, North York Moors and the South Downs. Hortobágy in Hungary and Poloniny in Slovenia are both designated Dark Sky parks. In the Canaries, Teide National Park in Tenerife and Caldera de Taburiente National Park in La Palma are popular both with individual stargazers and groups arranged by local astrotourism companies.

In the southern hemisphere, Uluru-Kata Tjuta National Park in the heart of Australia's outback offers astronomy talks and stargazing on most weekends. Warrumbungle National Park in New South Wales, home to the Sliding Spring Observatory and host of many stargazing tours and events, is also the location of OZSky StarSafari, held twice a year in March to April and September to October.

Death Valley National Park, California USA

One of the world's largest Dark Sky parks, Death Valley presents a natural night sky just a few hours drive from heavily light-polluted Las Vegas and Los Angeles. The remote Racetrack Playa pictured here offers welcome respite from the punishing heat of the day. One of the mysterious Sailing Stones for which the area is known sits beneath the rising summer Milky Way. A geological curiosity, these stones move naturally along the smooth, high-altitude valley floor, transported on very thin night-time surface ice sheets that are driven by wind.

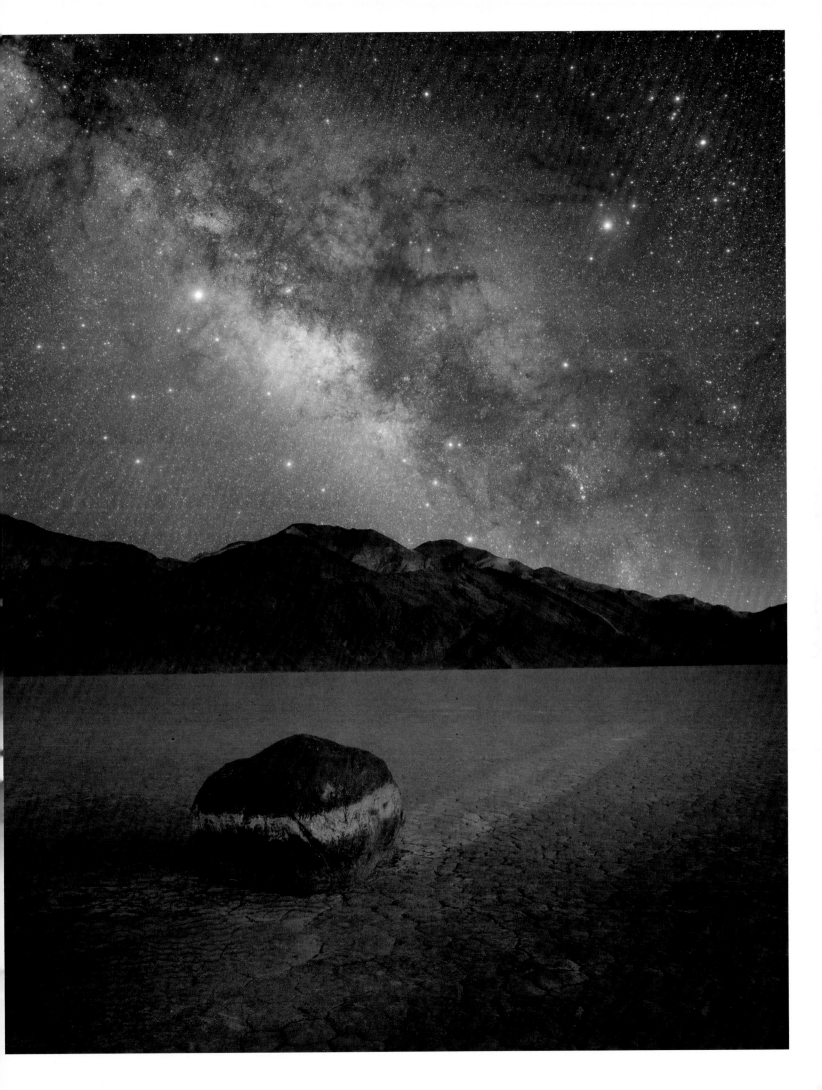

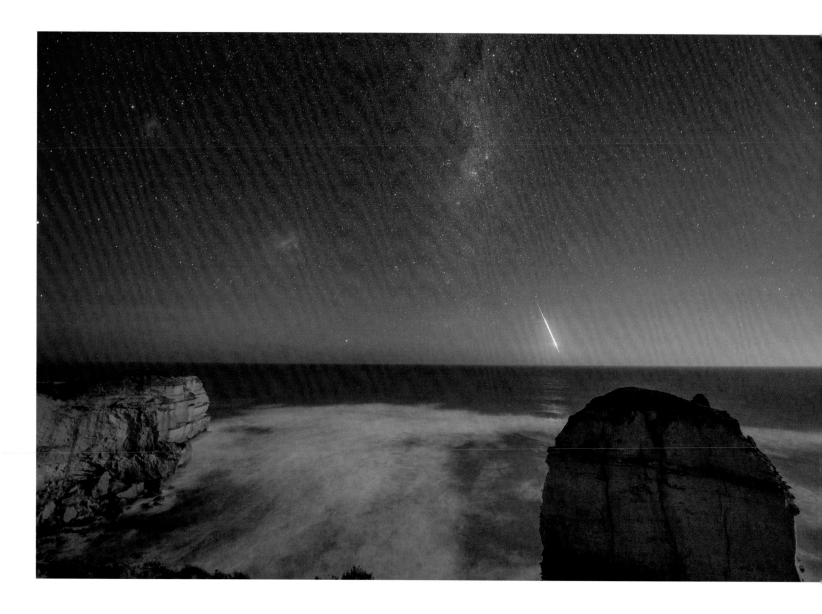

12 Apostles National Park, Victoria AUSTRALIA

Above the Southern Ocean and beneath an ocean of stars on
the Great Ocean Road, a brilliant fireball (bright meteor) lights
up the sky in the 12 Apostles National Park. The southern
Milky Way and Magellanic Clouds are visible in the sky, and
limestone rock formations are illuminated by the setting moon.
From this vantage point looking south, there is no landmass
between the viewer and Antarctica, just the immense Southern
Ocean. Standing here leaves you feeling connected to the
planet, embraced by the entire universe.

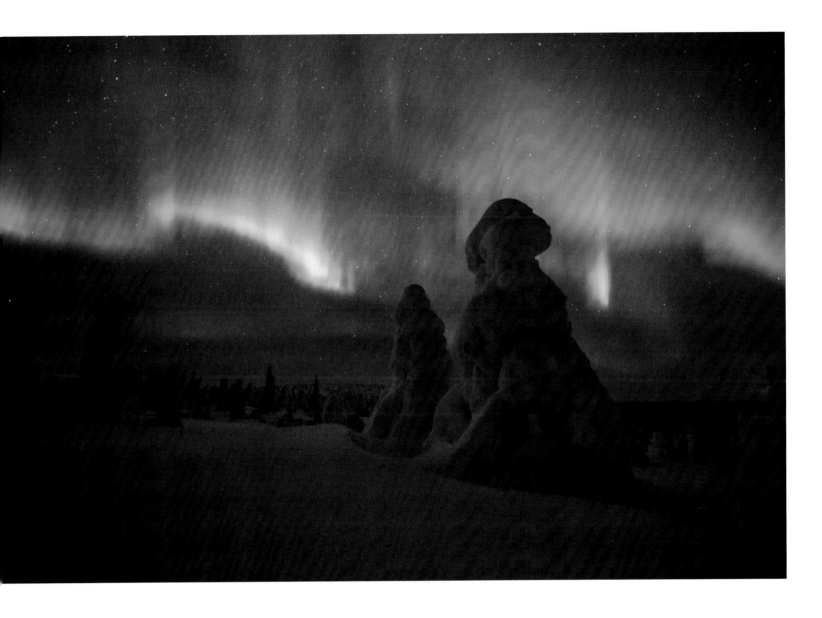

Riisitunturi National Park, Lapland FINLAND

A vibrant green aurora flashes in the clear night sky behind the *tykky* sculptures, or 'frozen' trees, in Riisitunturi National Park. Located at 66 degrees north, close to the Arctic Circle, the park's forests are well known for these surreal-looking snow-covered trees. During winter in Lapland, the northernmost region of Finland, snow accumulation ranges from 60–90 cm (23–35 in).

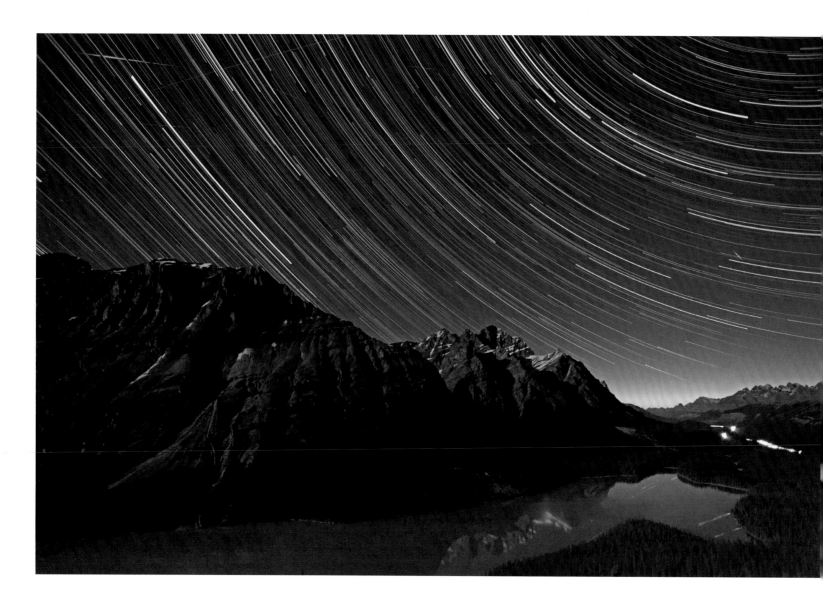

[above]

Banff National Park, Alberta CANADA

The star trails captured in this long-exposure image were
formed during the course of one hour of Earth's rotation.
A couple of satellites can also be seen at the top left of the
image. The mountains are illuminated by the moon, while
the yellow glow on the horizon comes from the long-lasting
twilight of this high-latitude summer night – after the sunset
here, the sun's path remains close to the horizon. The World
Heritage site of Banff National Park is around 2,000 m
(6,000 ft) above sea level. Pictured here is Peyto Lake,
one of the region's main attractions.

[opposite]

Yosemite National Park, California CALIFORNIA

Yosemite has inspired numerous artists, writers and environmentalists, not
least legendary landscape photographer Ansel Adams. Here, the stars
of Orion are set in the crystal-clear sky above a river in the Sierra Nevada
mountains, captured in a cold after-midnight moment in January. The three
aligned stars of Orion's belt and the Orion Nebula are near the centre of
the image. Above is the orange star Betelgeuse, one of the ten brightest
in the night sky. Most surprising, however, is the appearance of the elusive
Rosette Nebula in the upper centre. Under dark skies, this is bright enough
to be glimpsed through a small telescope using a wide-field eyepiece. Its
distinctive pink-red colour is invisible to the human eye, as we are almost
colour blind in low light. At a distance of over 5,000 light years away, the
Rosette Nebula is 130 light years wide – more than 50,000 times wider
than the entire solar system's planetary boundary.

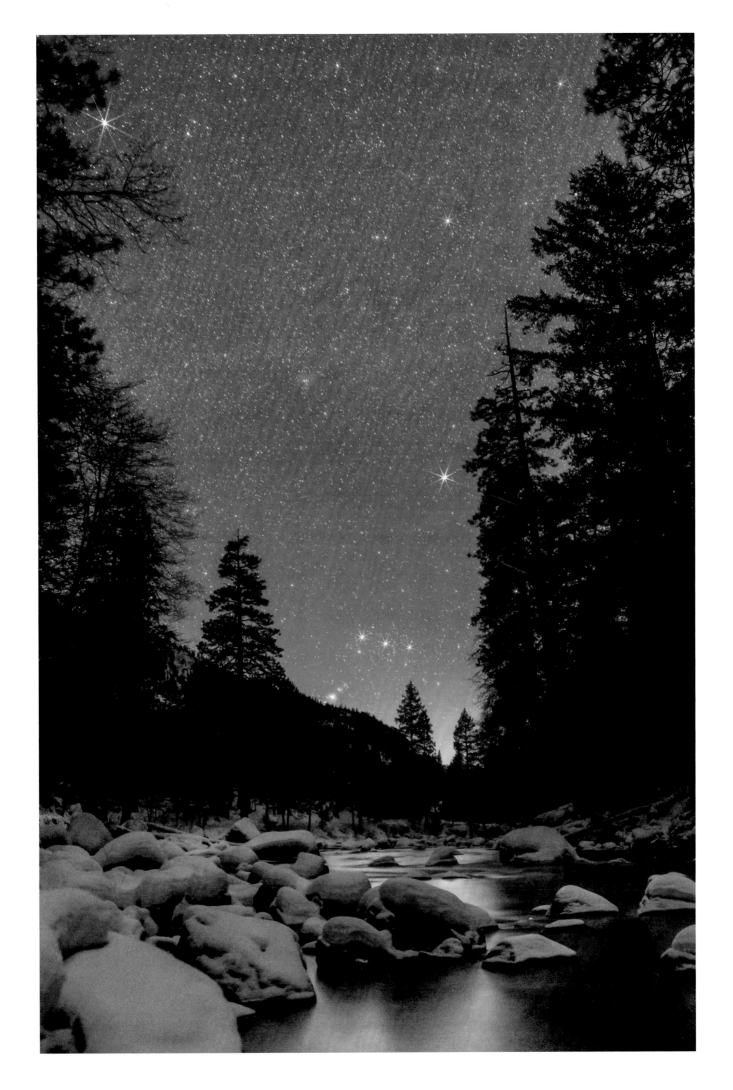

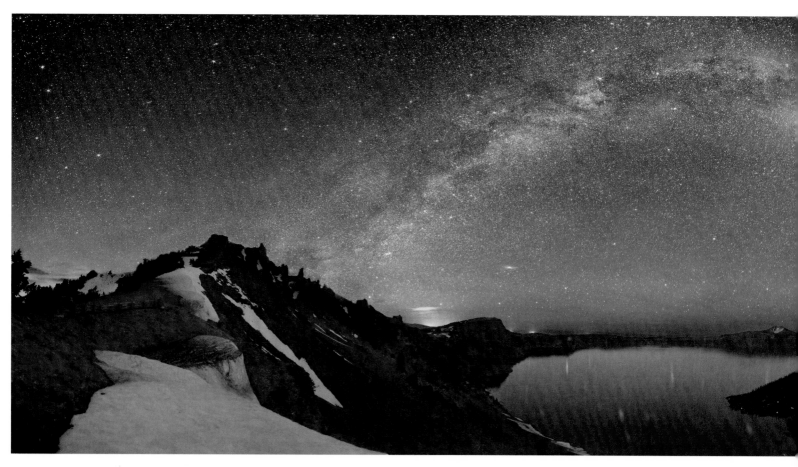

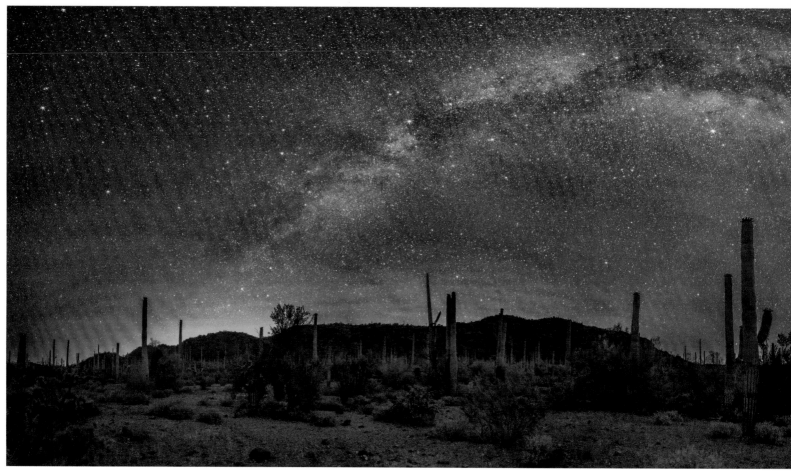

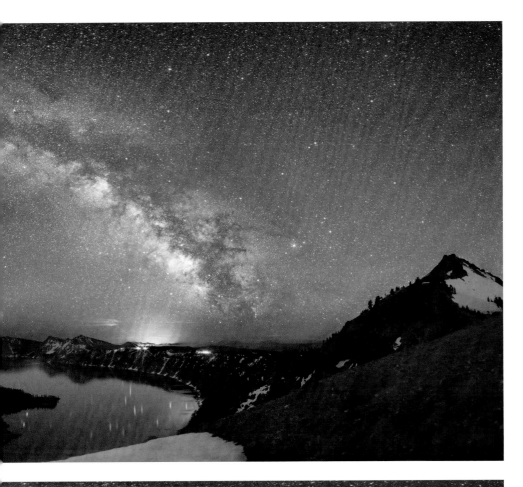

Crater Lake National Park, Oregon USA

Our home galaxy, the Milky Way, arcs above the 10 km (6 mile) wide Crater Lake in northwestern America. Constellations Ursa Major (the Big Bear) and Ursa Minor (the Little Bear) are to the far left of the image, while W-shaped Cassiopeia is visible at the beginning of the arc. The bright star Deneb and the notable red North America Nebula are in the upper centre. To their right is Altair, the next bright star along the Milky Way. Above the crater to the right of the image is the brightest region of the Milky Way – the central bulge. The bright star to the right of the Milky Way is Antares at the heart of constellation Scorpius (the Scorpion).

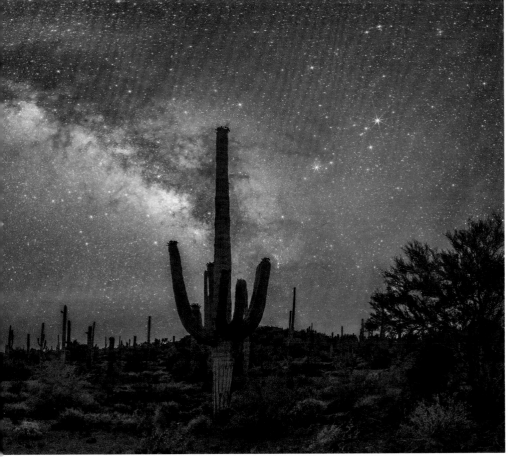

Organ Pipe Cactus NM, Arizona USA

The cactus knows no borders. The Organ Pipe Cactus National Monument is a UNESCO biosphere reserve in southern Arizona, with territory that continues into the Mexican state of Sonora. It is the only place in the United States where the organ pipe cactus grows wild. The green 'clouds' visible in the sky are airglow, caused by natural emissions in Earth's upper atmosphere. The yellow-orange glow is light pollution coming from the city of Phoenix in the northwest, some 160 km (100 miles) away. The rising band of the Milky Way also appears in this after-midnight-hour May sky.

NEAR THE LIGHTS

Countless adventures await those who stay awake to experience the night. Like explorers of the unseen, stargazers enjoy views that most people miss as they sleep or spend nights under the starless skies of the cities. From most places on our planet there is at least some hint of artificial light on the horizon, but even near these lights are plenty of celestial wonders to see.

In satellite maps of Earth at night, some of the most populated areas on the planet, such as western Europe, appear to be totally dominated by artificial light, but dark spots do exist within these regions. These include naturally protected areas and mountainous regions. Bavaria in southern Germany and the Alps in Austria, Italy, Switzerland and France are examples of locations with relatively dark sky areas in highly populated areas.

Destinations surrounded by bright areas include the Westhavelland Nature Park, just 100 km (60 miles) west of Berlin, and South Downs National Park, a similar distance from London, in England. The British Isles has more than a dozen international Dark Sky places. Thanks to lower populations and large natural areas, both Northern Ireland and northern Scotland remain Dark Sky refuges where it is possible to see the Northern Lights on the horizon during high geomagnetic activity. Some 200 to 300 km (130 to 200 miles) west of London, almost all of Wales has active Dark Sky communities, with Snowdonia, Elan Valley and Brecon among the best-known. In southwest England, Exmoor National Park was Europe's first designated Dark Sky Reserve. Two small British isles enjoy a Dark Sky Community designation: Coll in northwest Scotland and Sark, less than 40 km (25 miles) from the coast of Normandy, in the English Channel. The latter has no cars or public lighting. The favourable stargazing seasons in the United Kingdom are from February to April and late summer.

Bavaria GERMANY

Neuschwanstein Castle sits on a hill-top in the Bavarian Alps, possibly the most iconic of 20,000 or so castles and palaces in Germany. It was built in the nineteenth century, as a home for the eccentric King Ludwig II. The king was obsessed with artistic and architectural projects and spent all his royal revenue on unusual castles such as this.

In less than one hour of total exposure, Earth's rotation creates star trails around the North Geomagnetic Pole. Light rays from the castle scatter in the sky and are typical of the light pollution seen at the world's most heavily lit monuments.

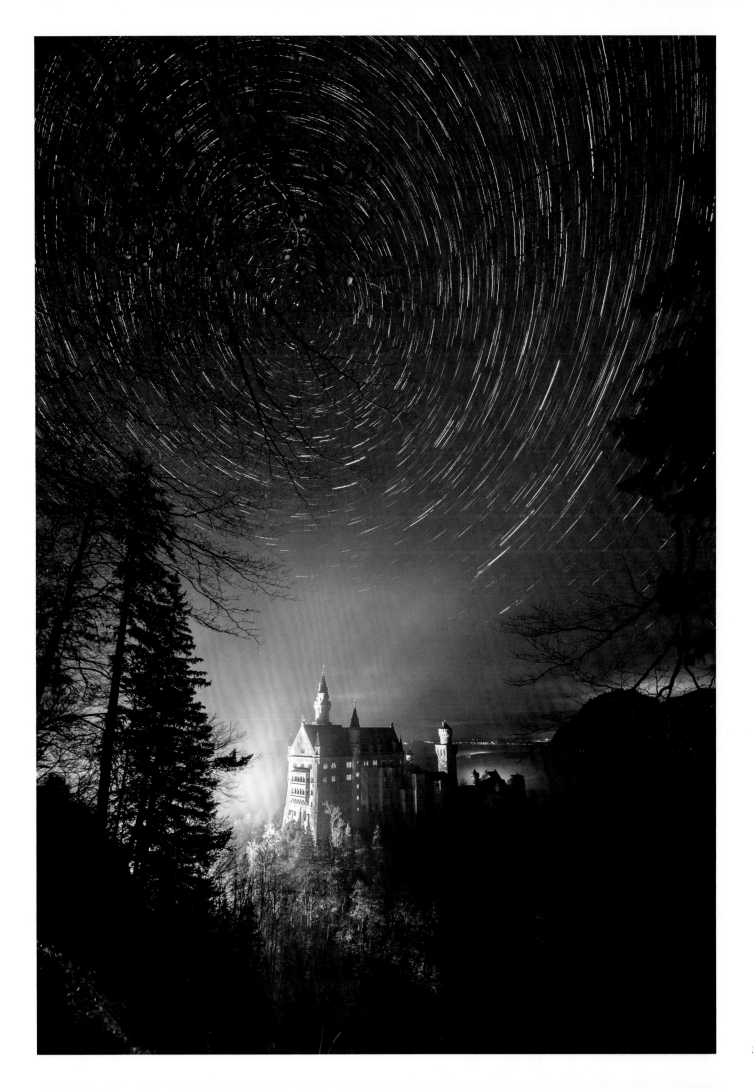

Kilimanjaro
TANZANIA

This single, long-exposure photograph, lasting the entire night and taken using a custom-made panoramic film camera shows star trails around the South Celestial Pole. It was captured very close to the equator on the high-altitude slopes of Mount Kilimanjaro in Tanzania. The altitude of the pole in the sky is equal to the latitude of the location, making this equatorial region the only place on land where the celestial poles are located right at the horizon. The lights of Moshi, the capital of the Kilimanjaro region, appear to the right of the image, reflected by the haze and layers of fog.

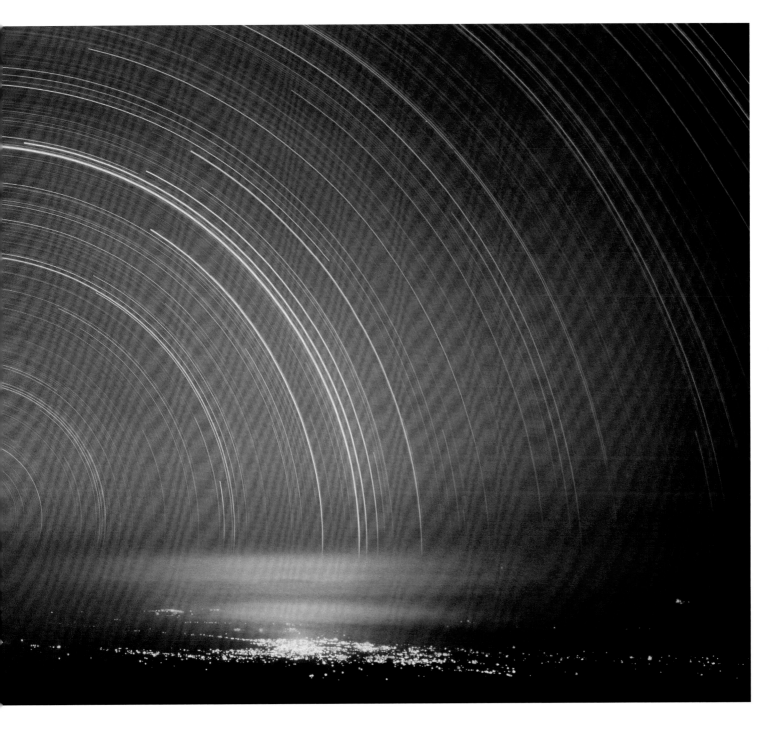

Bavaria

GERMANY

[overleaf]

A starry summer sky above Lake Königssee is embraced by the Bavarian Alps in southern Germany. Most of the lake is within the Berchtesgaden National Park, close to the Austrian border. Despite its distance of just 25 km (15 miles) from Salzburg, the high altitude of the area and obstruction of the horizon by the mountains provides a Dark Sky refuge, especially when looking south, as here. Along the Milky Way is the small constellation Scutum (the Shield). It doesn't have any bright star, but a dense star cluster known as the Wild Duck Cluster (M11) appears as a single star top centre of the image, on the edge of a brighter patch of the Milky Way known as the Scutum Star Cloud. Looking in this direction, we are facing the next spiral arm of the Milky Way, inward from our own, at a distance of 6,000 light years.

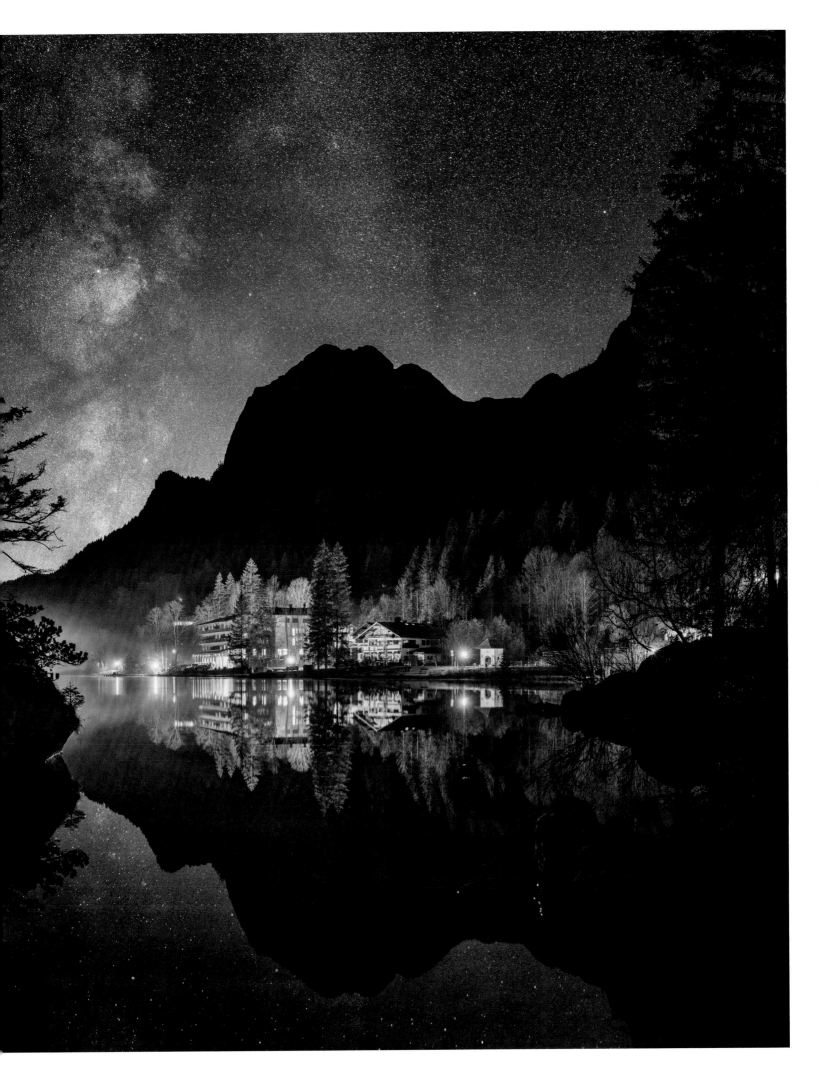

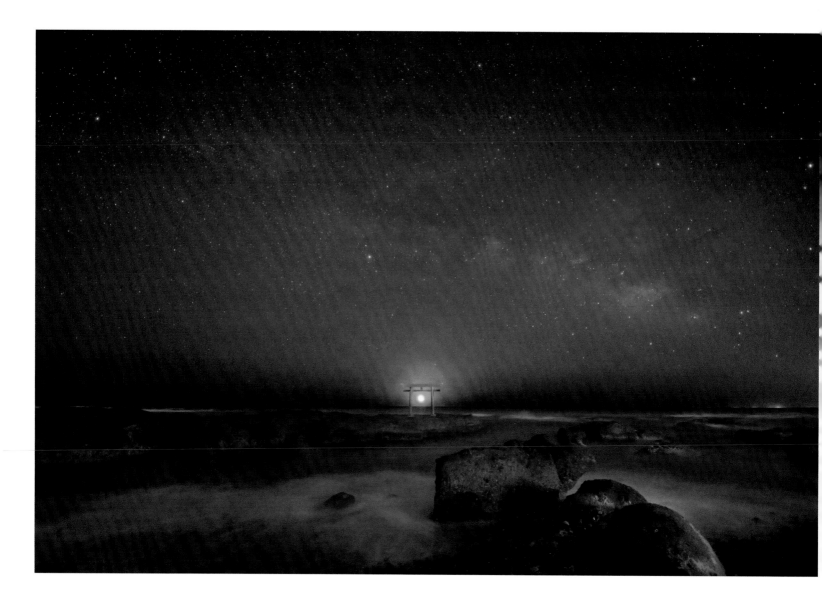

Ibaraki JAPAN

Taken at midnight in May, in Oarai, Ibaraki prefecture, this photograph sees a last-quarter moon rising with the Milky Way above the Pacific Ocean, Japan. Just like a rising or setting sun, the moon on the horizon is reddened by atmospheric refraction, as light has to pass through a thicker cut of the atmosphere in order to reach the viewer. At the centre is an iconic *torii*, the traditional Japanese gate commonly found at the entrance to a Shinto shrine, where it symbolically marks the transition from the profane to the sacred. In the sky, bright star Altair is at the centre of the image with Deneb in Cygnus (the Swan) top left.

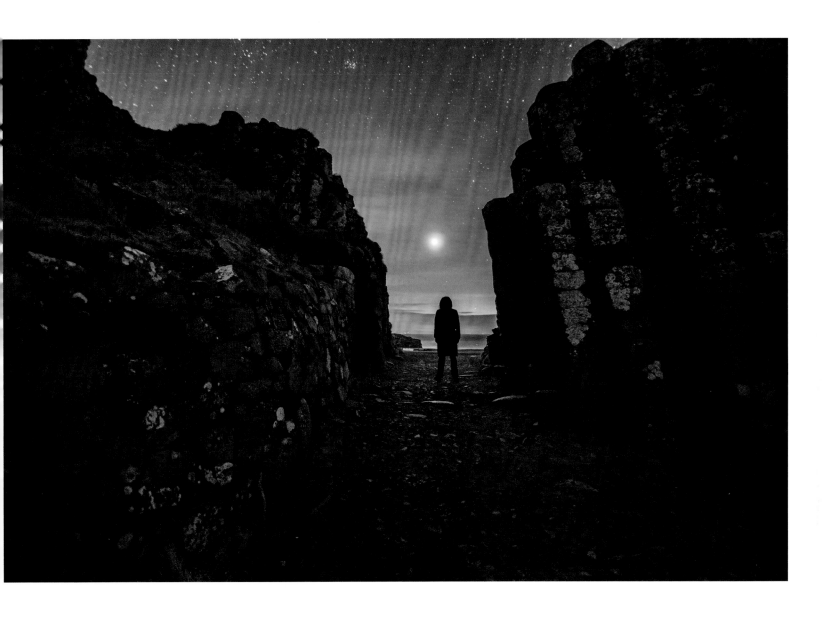

County Antrim NORTHERN IRELAND

In the early evening on the northeast coast of Ireland, a lone stargazer enjoys the dazzling light of planet Venus, the second-brightest object in the Earth sky after the moon. In the foreground is the World Heritage site of the Giant's Causeway, an area of around 40,000 interlocking basalt columns formed during a volcanic eruption 60 million years ago. Near the top of the image is the Pleiades star cluster (the Seven Sisters). Venus is surrounded by a halo, known as a corona. This atmospheric phenomenon can form around the sun, moon and bright planets, and occurs when small water droplets or tiny ice crystals in cloud diffract the light.

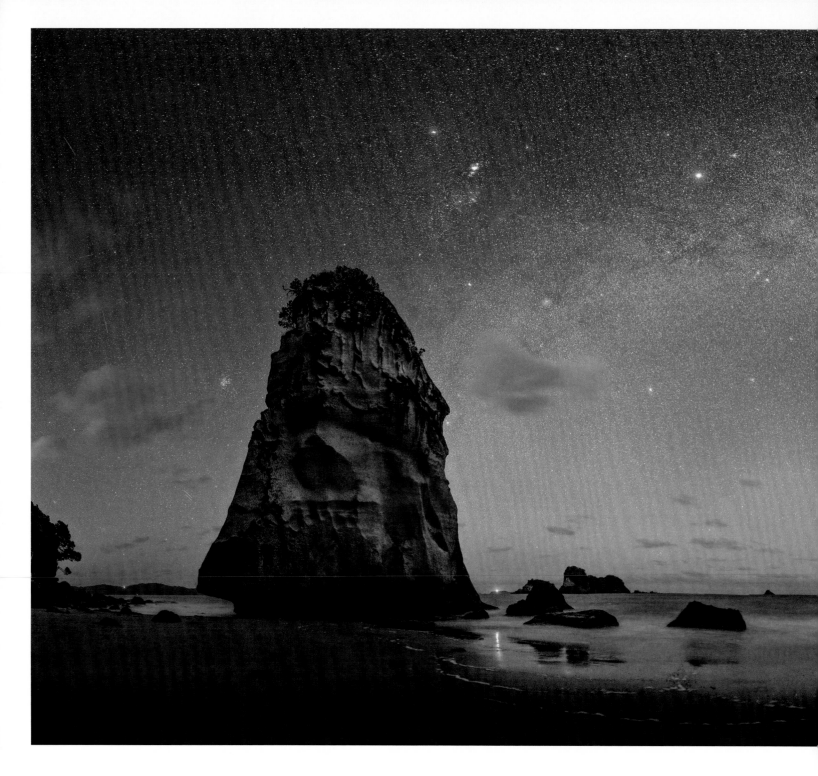

REMOTE

To travel somewhere truly remote is to experience the purest and the most peaceful darkness. Only in such places is it possible to enjoy the absolute silence of the night, surrounded and astounded by the wonders of the celestial arena above. It is in these places that you feel a profound sense of connection to the universe as you appreciate our planet's place in this great cosmic ocean.

The more remote destinations offer the clearest views of the Milky Way and provide an excellent perspective of our place in the universe, inside this massive spiral galaxy, a cosmic island of an estimated 100 to 400 billion stars. Our galaxy is 100,000 light years across but only 1,000 light years thick. That's like having a traditional thin-crust pizza measuring

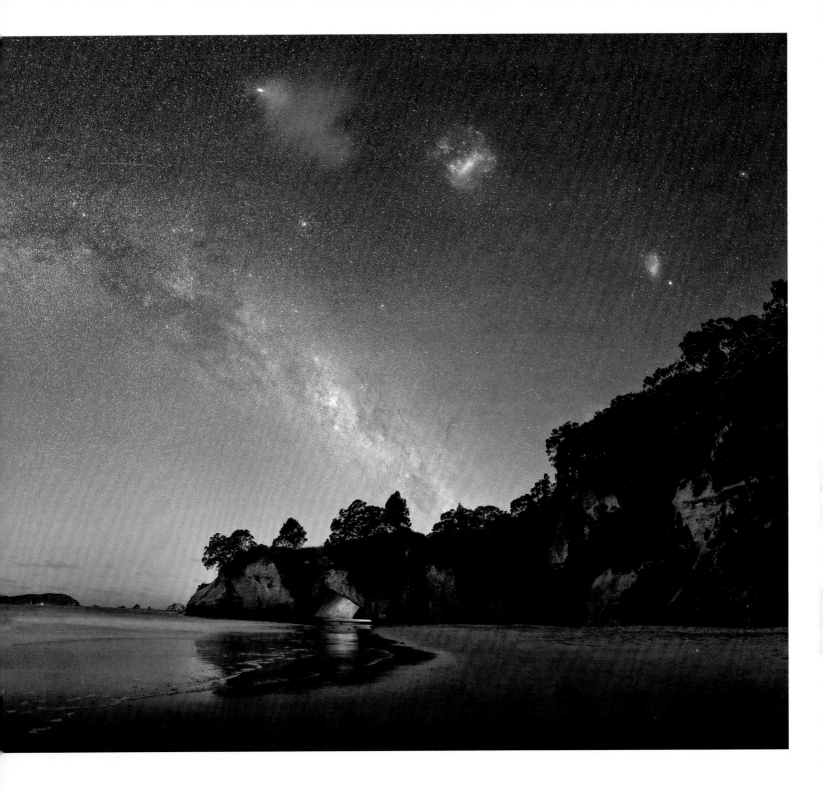

2 m (8 ft) in diameter! We live inside this disc, so our view of it is seen side on, as a thick stream of stars, gas and dust strewn across the sky.

One spectacular way to see the night sky as you have never seen it before is to look for a remote destination in the opposite hemisphere to the one in which you live. Even seasoned astronomers and nightscape photographers have been overwhelmed seeing the northern or the southern sky for the first time. Familiar constellations appear upside down and you are forced to navigate the sky afresh. There are also constellations that you will never have seen before, such as Crux (the Southern Cross) in the southern hemisphere and Ursa Major (the Big Bear) and Ursa Minor (the Little Bear) in the northern hemisphere.

Coromandel Peninsula NEW ZEALAND

Most people visit Cathedral Cove natural monument in the daytime, but for stargazers the show begins after dark. Those familiar with a northern hemisphere sky will see that Orion appears upside down above the giant sea stack to the left of the image. Following the band of the Milky Way to the right, bright star Sirius appears near the top. Further right, again at the top, is the bright star Canopus. Beside a fast-moving 'Earthly' cloud to the upper right of the image are the Magellanic Clouds. Cathedral Cove is an important marine reserve in New Zealand's Mercury Bay, known for its rich reefs and coastal life. In this panorama, the electric blue patches on the ocean are in fact the bioluminescent activity of plankton. The monument is known locally as Whanganui A Hei (the Great Bay of Hei), named after a priest named Hei, who first laid claim to the area at the time of the Polynesian migration to New Zealand in the mid-fourteenth century.

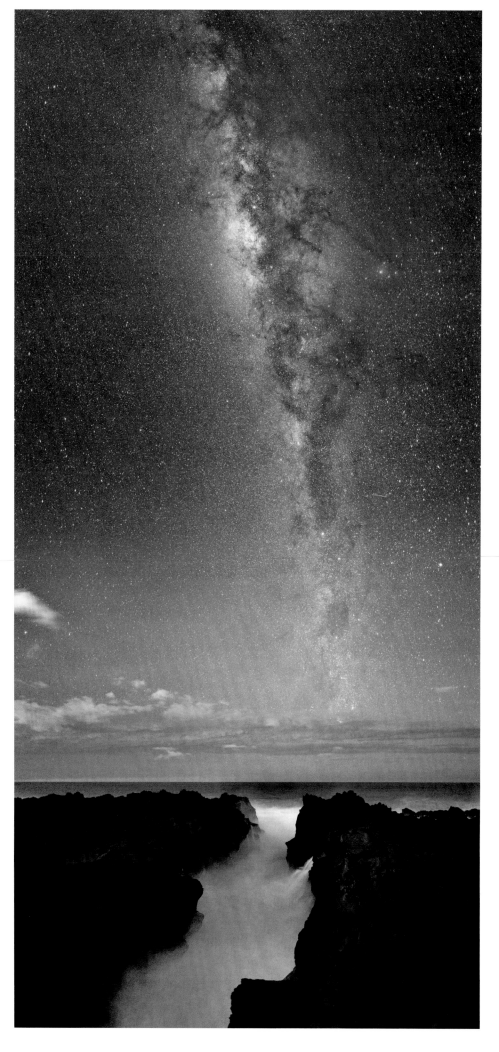
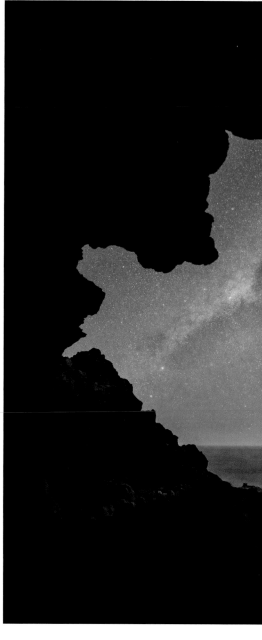

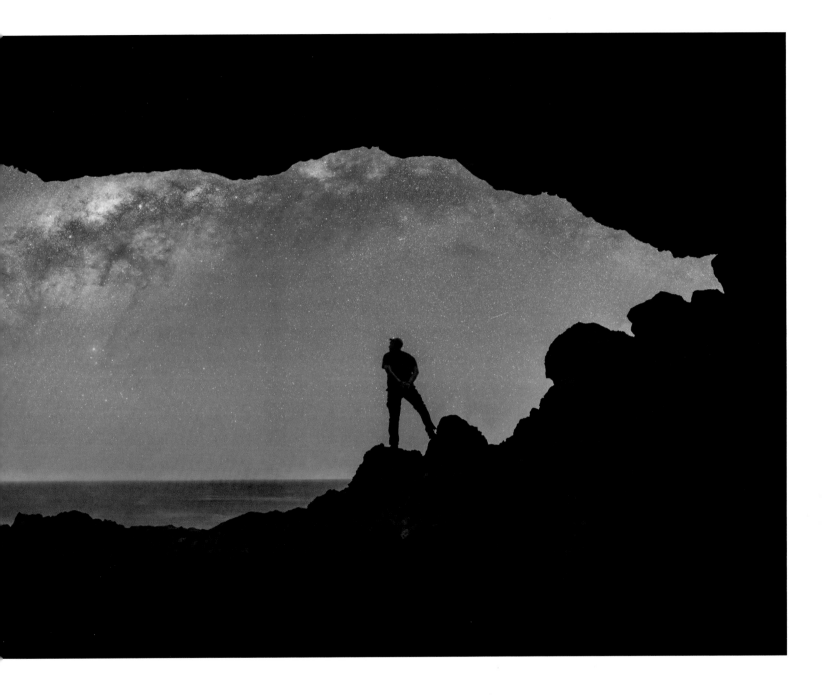

Réunion SOUTH INDIAN OCEAN

Standing on this French island at night gives a real sense that the ocean dominates more than two-thirds of the planet's surface. Pictured left is a rock formation known as Le Gouffre. Above it, the galaxy band runs vertically over the southern horizon in the September sky. Pictured on the right is a night in May. The central core of the Milky Way rises later in the night at this time of year and is photographed from inside a cave on the west coast of Réunion. Next to the galactic bulge, prominently visible in both photos, is the bright star Antares, the alpha star in Scorpius, marking the scorpion's heart. The name derives from an ancient rival of the Greek god Ares (Roman Mars), thought to derive from the fact that Antares is orange in colour and could be mistaken for the planet Mars. In fact Antares is a red supergiant near the end of its life. It is so huge that, were it placed at the centre of the solar system, its form would extend beyond the orbit of Mars.

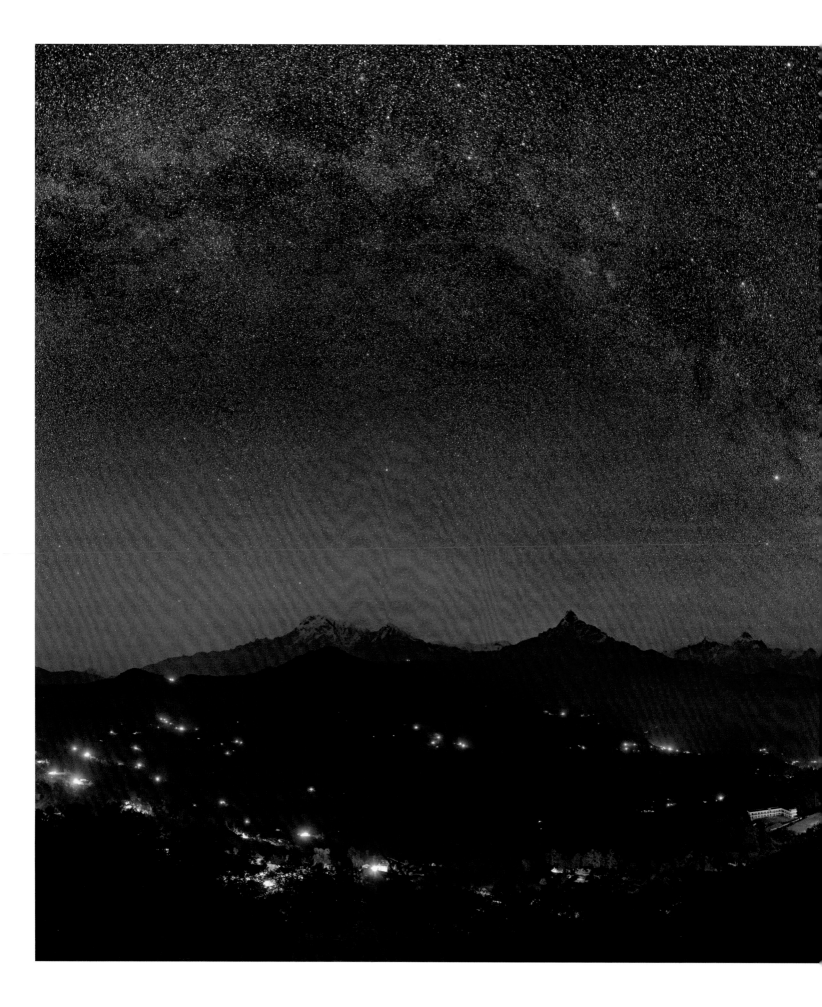

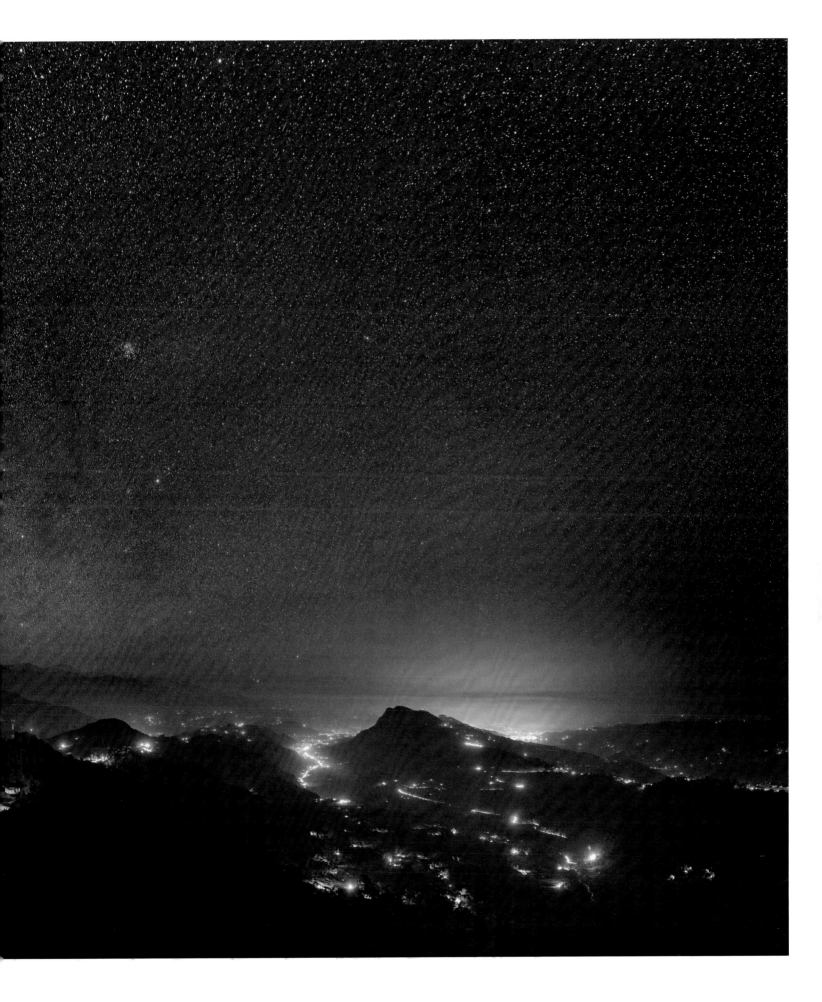

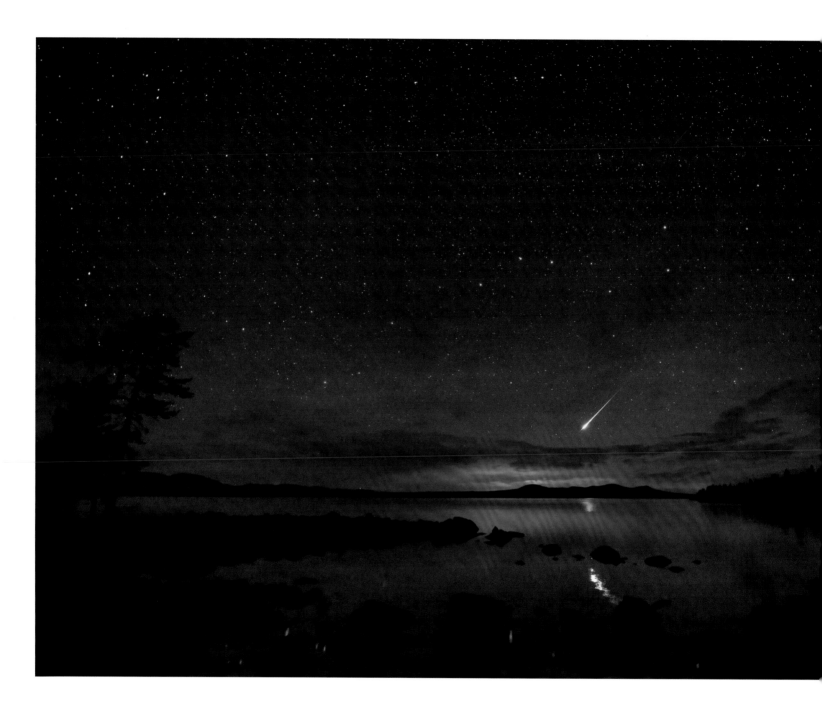

Annapurna range NEPAL [previous]

The city of Pokhara, in Nepal, has magnificent views of the 7–8,000 m (23–26,000 ft) peaks of the Himalayan Annapurna Massif. On a clear, dark night such as this, away from city lights, the vision is even more surreal. To the right of the image is artificial light emanating from Pokhara. Using a camera modified for astrophotography, which reveals more of the red end of the light spectrum, several red emission nebulae appear along the faint band of autumn Milky Way in constellations Auriga (centre), Perseus (higher), Cassiopeia and Cepheus (upper left). Natural airglow from Earth's upper atmosphere is responsible for the red glow above the peaks (see page 98).

Femundsmarka NP NORWAY

The many remote natural reserves of Norway still offer star-filled skies. Here, close to the Swedish border on a September night in Femundsmarka National Park, a fireball (bright meteor) breaks into the calm, peaceful sky. On the shore of Lake Femund, the second-largest natural lake in the country, the camera looks north with the seven stars of the Big Dipper (in Ursa Major) taking centre stage. There is the faint glow of a town on the horizon, shining on the low clouds. The meteor belongs to the lesser-seen September Epsilon Perseids meteor shower, which usually peaks at just ten meteors per hour.

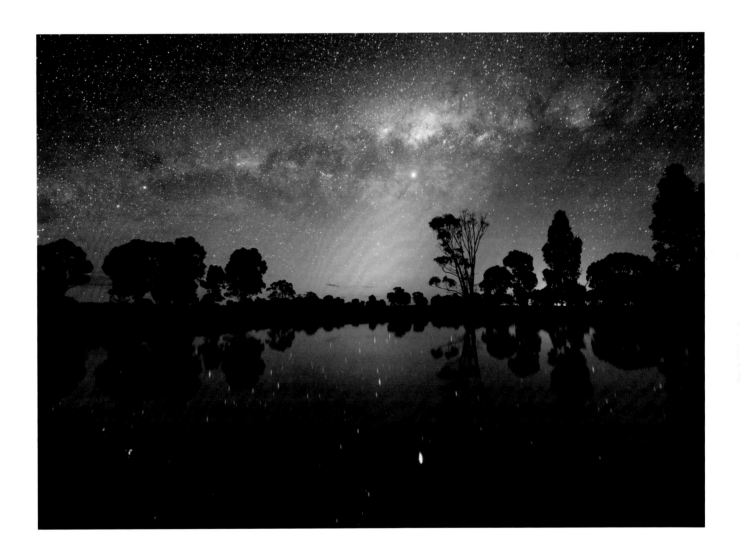

Victoria AUSTRALIA

The Milky Way and Venus are about to set in a pristine sky over central Victoria on this October evening. Venus is almost aligned with the galactic centre and resembles a bright supernova in our galaxy – a phenomenon that has not been seen for more than 400 years.

WORLD OBSERVATORIES

There are more than 500 astronomical observatories worldwide, and many more amateur and public observatories equipped with smaller telescopes. Many of the world's historical observatories, such as Greenwich in London, the Paris Observatory, Harvard College in Massachusetts and Yerkes in Wisconsin are now surrounded by city light and their equipment is outdated. These places now serve as museums and research centres, as well as functioning as administration offices for astronomers who use robotic telescopes in space or in distant corners of the planet. A few historic observatories have been upgraded to continue leading-edge research, and these include Mount Wilson on the outskirts of Los Angeles, California, or Pic du Midi in the French Pyrenees (pictured above).

Some of the world's major modern observatories are located within national parks and nature reserves, their presence serving to secure long-term protection of the dark sky above them. The IDA's Dark Sky Sanctuaries initiative relates perfectly to these sites which preserve the most pristine night skies on the planet, whether atop dormant volcanoes in the Hawaiian islands or crowning high peaks in the

Atacama Desert, the Canary Islands and the southwestern United States. These sites are not only selected for their great distances from city lights, they also happen to be perched up high, on isolated mountains. Although seashores and flat desert plains are popular stargazing destinations, astronomers do not favour them. The ideal observatory site has dark skies, a large percentage of clear nights per year, dry air, unobstructed views of the horizon and steady air conditions. Above all, it benefits from a high elevation where the atmosphere is thinner, thereby minimizing the effects of atmospheric extinction and turbulence. Such conditions offer the best astronomical 'seeing' and increased resolving power for giant telescopes. Moreover, at high altitudes, the atmosphere absorbs less infrared light, which is critical for viewing the most distant celestial objects – from the evolution of the universe itself to the clouds of gas and dust that give birth to stars and planets.

Pic du Midi FRANCE

This panoramic view of the Milky Way band rising on a June evening was taken from the Pic du Midi Observatory, on a remote peak in the Pyrenees mountains at an altitude of 2,877 m (9,440 ft). Accessible only by cable car, the observatory is located within the Pic du Midi Dark Sky Reserve, which spans the Pyrenees National Park and the Mont Perdu World Heritage site. Construction of the observatory began in 1878, when the mountain nightscape was free from artificial skyglow. Today, the light pollution of Tarbes, a town of 40,000 population just 30 km (20 miles) to the north (left in this image) is the main source of skyglow, followed by the much larger Toulouse (centre) at a distance of 130 km (80 miles). In the south (to the right of the image), the lack of any large city in the Spanish Pyrenees provides darker sky. Even on the French side, the light pollution reduces significantly at midnight when, due to a nationwide energy-saving law, many outdoor lights dim or switch off.

Los Angeles, California USA [above left]

The 150 cm (60 in) telescope at the Mount Wilson Observatory near Los Angeles is pointed towards Jupiter on a public observation night. This is one of the world's largest publicly accessible telescopes, and one that people can rent to observe the night sky. The telescope had its 'first light' in 1908, at which time it was the world's largest operational telescope. It was at Mount Wilson that Edwin Hubble proved the existence of galaxies beyond the Milky Way and later discovered the expansion of the universe.

Atacama Desert CHILE [above right]

Astronomers observe the centre of the Milky Way using the laser guide star facility of the Very Large Telescope (VLT), a group of four 8 m (26 ft) giant telescopes on Cerro Paranal mountain, one of the world's finest sites for astronomical observations. The telescopes use advanced laser technology to significantly reduce the natural blurring effects of Earth's atmosphere to allow sharper images of long-distance objects.

La Palma, Canary Islands SPAIN [opposite top]

A long-exposure image of star trails from the Roque de los Muchachos Observatory at an altitude of 2,400 m (7,900 ft) on the island of La Palma. The stars are reflected in one of the 17 m (56 ft) diameter MAGIC telescopes. These multi-mirrored detectors are not typical telescopes. They observe cosmic gamma rays by detecting brief flashes of optical light, called Cherenkov light, and allow scientists to explore such phenomena as black holes, solar flares, supernovae and neutron stars.

Western Australia AUSTRALIA [opposite bottom]

The southern night sky appears above the Murchison Widefield Array radio telescope antennas. Further than 800 km (500 miles) from Perth, the capital of Western Australia, in the remote Australian outback, more than 2,000 antennas are spread in groups across 3 sq km (1.2 sq miles). Even the faintest cosmic radio waves can be detected in this radio-silent area and the night sky is also extremely dark, giving spectacular views of the cosmos.

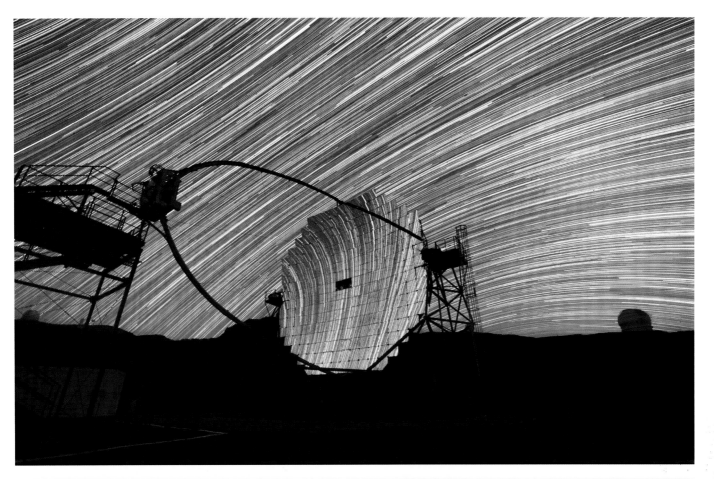

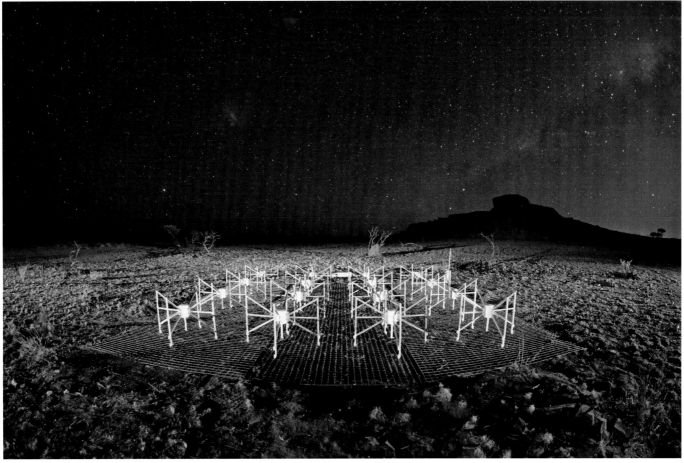

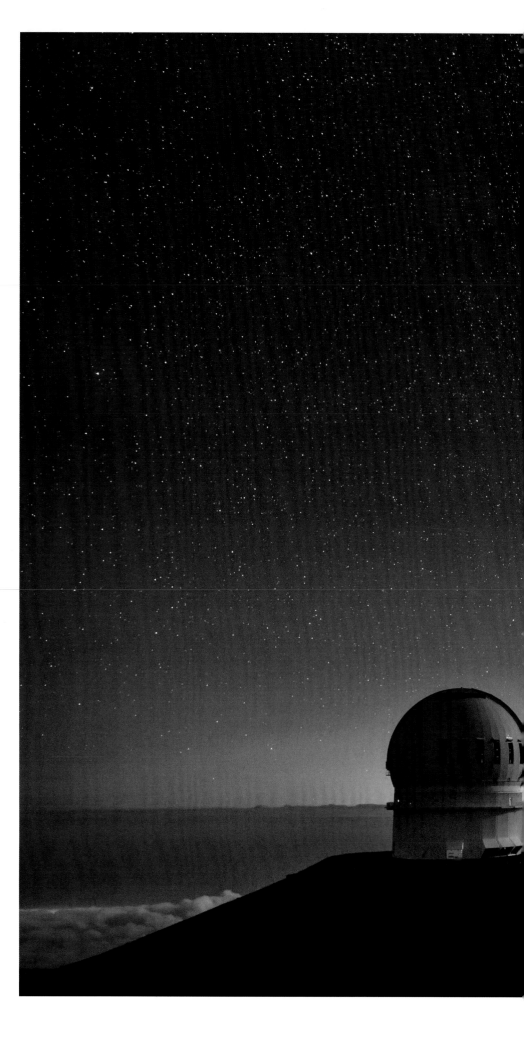

Maunakea, Hawaii USA

This starry sky at the break of dawn appears over two giant telescopes at Mauna Kea Observatory. At 4,200 m (13,800 ft) high, this summit is the highest point in Hawaii and the entire Pacific Ocean. A dormant volcano, Maunakea is 10,200 m (33,500 ft) tall when measured from its base on the ocean floor to its peak. Gemini North (foreground) is an 8 m (26 ft) telescope. The Canada-France-Hawaii Telescope (CFHT) is in the background. In the upper right of the image, the elongated halo of the Andromeda Galaxy (M31) is visible next to the faint band of the Milky Way. Maunakea peak is a popular destination for tourists, from sunrise to sunset, but is closed to visitors at night due to high-altitude hazards and the effect of car lights on the telescopes. Stargazers can enjoy the night sky from the more temperate altitude of the visitors' centre at 3,000 m (9,000 ft). In fact, human eyes see more stars from this level due to the increased oxygen sought by the brain and the retina.

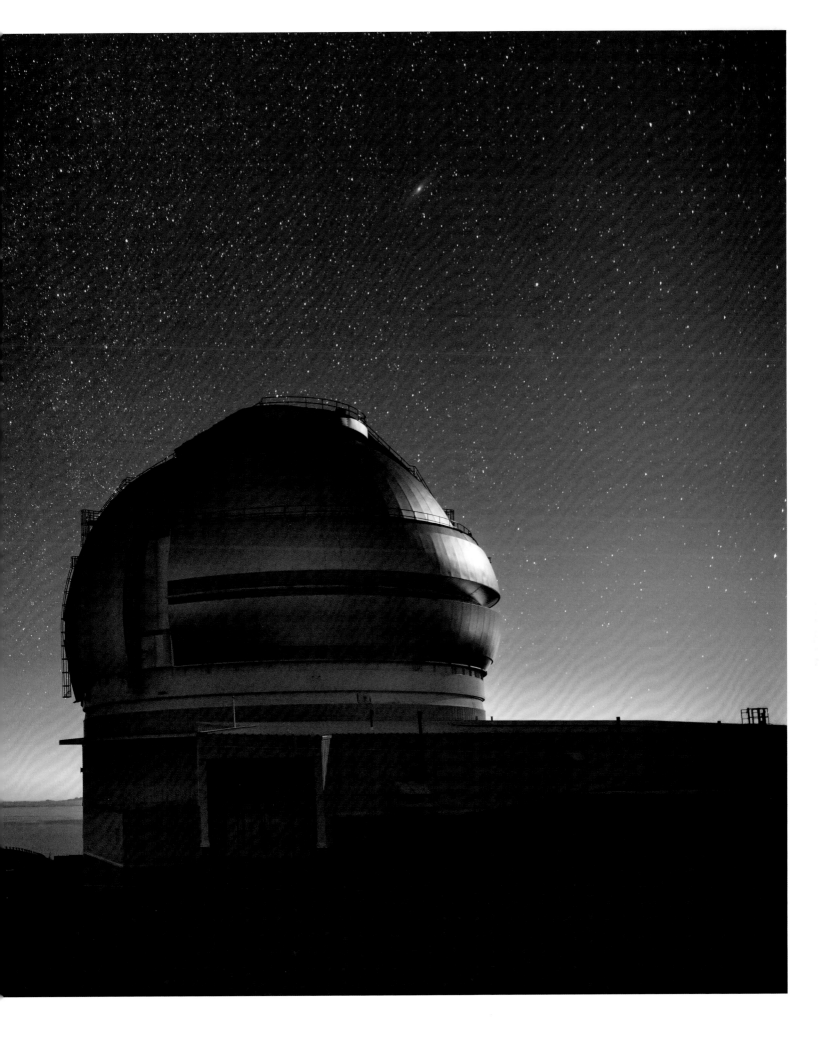

PHOTOGRAPHERS

Ajay Talwar INDIA

Ajay is the most prolific nightscape photographer in India, imaging the sky since 1987. Based in Delhi, he travels across the country and hopes to photograph many of India's heritage sites under the stars, blurring the sharp divide between scientific astrophotography and artistic photo-journalism. He regularly holds photo workshops in the Indian Himalayas. Some of his images of the world's cities at night are a joint effort with his wife Neelam Talwar, a talented photographer in her own right.

54, 190

Alan Dyer CANADA

Astronomy author and Alberta-based astrophotographer, Alan serves as associate editor of *SkyNews*, Canada's magazine of stargazing, and as a contributing editor to *Sky & Telescope*. He has co-authored several best-selling guidebooks for amateur astronomers, including *The Backyard Astronomer's Guide*, *Advanced SkyWatching* and the multi-media ebook *How to Photograph and Process Nightscapes and Time-Lapses*. Asteroid 78434 is named after him.

47, 87 (bottom), 148-9, 154-5, 189, 191 (bottom)

Alex Cherney AUSTRALIA

Originally from Ukraine and based in Melbourne, Alex is an IT consultant and holds a Masters degree in Astronomy. First inspired to take up astrophotography in 2007 by his daughter's kindergarten project on Space, Alex photographs beautiful nightscapes of Australia and beyond under the Milky Way, and loves to connect ocean, land and sky in his work. His images and timelapse videos have won prestigious Australian and international awards.

97 (left), 124 (top), 133, 161, 178 (bottom), 200-1 (top), 204, 225, 229 (top)

Alex Conu ROMANIA-NORWAY

Based in Oslo and often travelling to the Lofoten Islands chasing the Northern Lights through the Arctic latitudes, Alex is an award-winning photographer who holds a degree in Photography and a major in Astrophysics. Alex is the Chair of the Photographic Commission of The Romanian Society for Meteors and Astronomy (SARM) and collaborates with various astronomical institutions and associations around the world.

116-7 (top), 118, 136, 174 (bottom), 218-9

Amir Abolfath IRAN

Amir has been an avid amateur astronomer since he was a teenager. He is an astrophotography educator and innovative photographer with a special interest in deep sky imaging using telescopes and long exposures, time-lapse videos and star trails. His images are published world-wide. He runs a photo studio in Tehran by day and explores the sky above the mountains and deserts of Iran by night.

24-5, 178 (top)

Anthony Ayiomamitis GREECE

Anthony is a leading Greek astrophotographer in Athens. The 'one small step' of Neil Armstrong set him on his path of exploring the night sky. His work covers a broad range from nightscapes to deep sky, year-long analemma of sun's motion to detecting exoplanets using his home-based telescope. His special interest is close-up images of the rising and setting moon above Greek heritage sites, captured from a far distance.

26 (left, right), 75 (top, middle, bottom)

Babak Tafreshi IRAN-USA

Living in Boston but originally from Tehran, Babak is the *TWAN* founder, *National Geographic* night sky photographer and board member of *Astronomers Without Borders*. As a science journalist and astronomy educator, he merges art, culture and science. He received the 2009 Lennart Nilsson Award, the world's most recognized award for scientific photography at the time, for his global contribution to night sky photography.

See author bio p. 239

Ben Canales USA

Inspired by his first experience of the Milky Way while camping in the Australian Outback, Ben is now an Oregon-based film maker and photographer. His passion is to create media, including realtime and timelapse videos of the night sky, where the viewer can find a connection to the stars through a human element within each scene. His night sky photography won the 2011 *National Geographic* Travel Photo of the Year.

64, 237 (top)

Bernd Pröschold GERMANY

Based in Cologne, Bernd has been fascinated by astronomy since childhood but put his telescope aside to focus on photography after the Northern Lights appeared as far south as Germany in 2001. He is a pioneer and a leader in creating night sky timelapse videos over the past two decades with stunning day to night transitions. He also produces images for planetarium domes and international TV stations.

145, 173, 205, 224

Christoph Malin AUSTRIA

A professional mountain biker based in Innsbruck in the heart of the Alps, Christoph has combined his outdoor timelapse photography and film making with his mountaineering knowledge to create some of the finest astrophotography timelapse from dark places. Christoph has created content for some of the world's largest companies. He is also a photo ambassador for the European Southern Observatory (ESO), imaging the telescopes in the Atacama Desert.

71, 167, 182, 191 (middle)

Dennis Mammana USA

Dennis is a popular science writer and photographer, and a regular guest on radio and television worldwide. He devotes his time to writing, lecturing and photographing under the clear, dark skies of his home area of the Anza-Borrego Desert in Southern California. Alongside six books on astronomy, Dennis authors *Stargazer*, the only nationally syndicated weekly newspaper column on astronomy in the US.

40 (left), 128, 139, 153 (top, bottom), 160

Fred Espenak USA

Known as Mr Eclipse for his predictions of solar and lunar eclipses and authoring of NASA eclipse bulletins, Fred is a retired Goddard Space Flight Center astrophysicist who was exploring the atmospheres of the planets. Now he enjoys photographing the deep sky and nightscapes from his home-based observatory in Southern Arizona. The International Astronomical Union has named asteroid 14120 after Espenak.

9 (left, right)

Gernot Meiser GERMANY

A film maker, visual storyteller and photographer based in Saarland, Gernot has travelled the world to intercept the moon's shadow as often as possible, documenting solar eclipses with his wife and co-producer artist Pascale Demy in adventurous expeditions to the most remote locations. Gernot and his wife are active in astronomy communication and science outreach, and also present *The World at Night* portable planetarium show and exhibits across Germany.

169, 224

Jeff Dai CHINA

Based in Beijing, Jeff (Jianfeng) is the youngest *TWAN* member, and one of the most actively producing and travelling photographers in the team. He tries to preserve the remaining natural skies in his home country. Jeff seeks unexplored night scenes, from the remote wilderness of the Himalayas to the still pristine night sky above cultural heritage sites. His long-term project 'Silk Road at Night' takes him across Asia to photograph and exhibit images.

18 (top), 36, 57, 62, 68-9, 90, 105, 191 (top)

John Goldsmith AUSTRALIA

Based in Perth, Western Australia, John is also an astronomer who researched ancient Australian aboriginal connections with the night sky. In his long-term 'Celestial Visions' photography project he explores our place in the universe and the profound influences astronomical knowledge has on human culture. His photographic style relates astronomical events to our planet via the use of wide-angle lenses and natural light illumination.

38, 39, 229 (bottom)

Juan Carlos Casado SPAIN

Based in Catalonia, Casado collaborates with several institutions in Spain on educational and outreach projects. His images of the night sky have been exhibited in schools, universities, planetariums, science museums and publications world-wide. He is also involved with the Tierra y Estrellas (Starry Earth) project and Shelios Expeditions – since 2002 they have documented and often live-streamed celestial events such as eclipses and aurora from around the globe.

44, 102-3 (top)

Kwon O Chul KOREA

Based in Seoul, Kwon is an astrophotographer and timelapse producer who pushes the limits of technology to create incredibly high-resolution panoramic night sky videos and planetarium content. His photographic style looks for the harmony between celestial motion and star trails, ancient sites and beautiful landscapes. His film *Aurora: Lights of Wonder* won the Astro Award at the 2017 Fulldome Festival in Jena, Germany.

41, 83, 142, 168, 212-3, 230-1

Laurent Laveder FRANCE

Specializing in elegant landscapes under starry skies, award-winning photographer Laveder began pursuing astrophotography with the Comet Halley in 1987. He has since received several awards for his work and launched creative projects such as 3D starscape images and the Moon Games, which was exhibited across France. Laurent has a permanent gallery and print shop in Brittany, and has published photo books in French.

102-3 (middle), 170-1, 187, 198-9

Luc Perrot FRANCE

With a plane ticket, a backpack and a camera, Perrot discovers the world according to his instinct – in 1992, he put down his backpack in Réunion Island for the first time, fell in love with the island and moved to this southern hemisphere paradise. Luc works with the elements of nature and sky in search of the perfect composition. His award-winning work has been featured in prestigious publications.

46, 52, 77, 129, 144, 220, 221, 226-7

Miguel Claro PORTUGAL

The official astrophotographer of the Dark Sky Alqueva Reserve in Portugal, Miguel has moved from light-polluted Lisbon to the first designated 'Starlight Tourism Destination' in the world. He is also the author of two books, a science communicator and chair of the judging panel for Paris' annual Photo Nightscape Award (PNA).

10, 120, 196, 200 (bottom), 217

Oshin Zakarian IRAN-USA

Landscape and fine art portrait photographer Oshin believes that a strong emotional connection with nature helps a photographer produce greater impact in art and conservation. Born in Tehran and living in Los Angeles, his main interest is in capturing nature and historical landmarks at night during astronomical events. Oshin is one of the few *TWAN* members who uses a medium format film camera for some of his nightscape photographs.

19, 140 (bottom), 236

P-M Heden SWEDEN

Based near Stockholm Per-Magnus has loved astronomy since childhood and started astrophotography in 1999. P-M spends a lot of time outdoors in the Swedish mountains and forests, taking his family for stargazing sessions in natural surroundings. At home he also photographs from his backyard observatory. His style is unique, featuring mostly natural-looking images that resemble what is visible to the unaided eye.

29, 89, 100, 180-1

Pekka Parviainen FINLAND

Based in Helsinki, Parviainen worked at Turku University as a researcher and lecturer for 15 years. He began photographing the night sky in 1973 with film cameras. The cloudy Finnish skies led him to focus on other phenomena, including aurorae, mirages, and rare atmospheric events. He feels most at home under a wide-open sky, seeking beautiful sky phenomena to photograph.

22, 135 (top, bottom), 156, 192

Serge Brunier FRANCE

Author, TV presenter and photographer Brunier is based in Paris. He has twice won French Astronomy Book of the Year and was awarded the Henry-Rey prize by the French Astronomical Society. Brunier's 100-million-pixel mosaic of the Milky Way is one of his many long-term projects. The international Astronomical Union named asteroid 10943 after him in recognition of his work.

237 (bottom)

Shingo Takei JAPAN

Takei was fascinated by the starry skies as a child, and in 1997 he took up astrophotography when he saw a total solar eclipse and then the Great Comet Hale-Bopp. A year later he started to publish his works in astronomy magazines, specializing in landscape astrophotography focusing on the theme of 'harmony between mankind and the stars'.

20, 92, 93, 108, 216

Stefan Seip GERMANY

A Stuttgart-based author, lecturer and astrophotographer using both wide-angle lenses and telescopes, Seip is also an IT specialist, journalist and technology writer. With a life-long passion for the night sky, in 2003 he left IT to follow his true calling and became a freelance author and photographer. He travels globally for celestial phenomena and often organizes tours and workshops. He has published several books on astrophotography.

4 (left), 76, 78, 79

Stéphane Guisard CHILE

Native of Lorraine in France, Guisard lived in Chile for most of his career as an optics engineer at the European Southern Observatory's Very Large Telescope in the Atacama Desert. Being in an astronomer's paradise gave him unlimited access to the world's most pristine night sky. His photographic style includes high-resolution panoramas, 3D timelapse videos and virtual reality videos of the sky. He pioneered some of these techniques in the *TWAN* team.

40 (top right), 49, 130-1, 146-7

Stephane Vetter FRANCE

Vetter has been fascinated by the night skies since his adolescence, when he used to explore the Alsace forest looking for wildlife and contemplating nature. He graduated as a doctor before discovering his true calling in 2009, becoming a specialist in night landscape photography. He often explores the otherworldly night landscape of Iceland under aurora borealis. His photography has won several awards, including Wildlife Photographer of the Year 2011.

80, 82 (bottom), 87 (top), 101, 110, 138, 152, 211, 214-5

Taha Ghouchkanlu IRAN

Taha documents the night sky above the many wonders of Africa, Asia and his home country Iran. He found his passion as a teenager when he joined an educational observatory in Tehran. He started using telescopes to photograph planets and the deep sky in high school, going on to study aerospace engineering at university. The award-winning photographer and educator also runs a photo studio in Tehran.

30, 72, 96, 114, 174 (top), 222-3

Tamas Ladanyi HUNGARY

Based in the historic town of Veszprém near Lake Balaton, seeing the return of Halley's Comet in 1985 was Tamas' first contact with astronomy. Now an avid stargazer with a backyard observatory, he has discovered two new double stars catalogued by the US Naval Observatory. He regularly contributes to the Hungarian *National Geographic*. The Science Academy of Hungary honoured his work by naming asteroid 18128 after him.

17, 63, 134, 150, 183

Tunc Tezel TURKEY

Based in Bursa, Tezel has been interested in the night sky for as long as he can remember. He started astrophotography in 1992 and tries not to miss a single celestial phenomenon. Tezel favours wide-angle, natural-looking photos and loves to capture the motions of the planets in multi-month projects. In 2006 he took the first ever analemma photograph of a total solar eclipse, a unique feat that brought world-wide acclaim.

53, 95, 119 (left), 124 (bottom), 175

Wally Pacholka USA

Based in Long Beach, California, Pacholka's nocturnal wanderlust began as a kid growing up in a small town outside Montreal. He specializes in landscape astrophotography of America's national parks and natural landmarks. His photography earned him *TIME* magazine's 'Picture of Year' in 1997 and 2003. His images are found in many national parks' visitor centers around the country and published worldwide.

42-3, 56, 140 (top), 141, 207, 208 (top, bottom)

Yuichi Takasaka CANADA

A British Columbia resident who is often found in the Arctic latitudes, Yuichi developed an eye for a good picture while working as a cameraman in the 1980s. His love of colours in nature led him to his love affair with aurora borealis. He frequently documents aurorae in both hemispheres and organizes photo tours to northern Canada to view the lights.

82 (top, middle), 84-5, 88, 206

Yuri Beletsky CHILE

Born in Belarus, Beletsky spent all of his professional career in Chile as an astronomer for European Southern Observatory and then Carnegie Las Campanas Observatory. He uses his spare time to photograph the stunning night sky of Chile's Atacama Desert and the rest of the world. He has been an enthusiastic stargazer since childhood and discovered a passion for nightscape photography with the development of digital imaging technology.

70, 97 (right), 99, 122-3 (bottom), 126, 176, 203, 228 (right)

HOW TO TAKE NIGHTSCAPE PHOTOGRAPHS

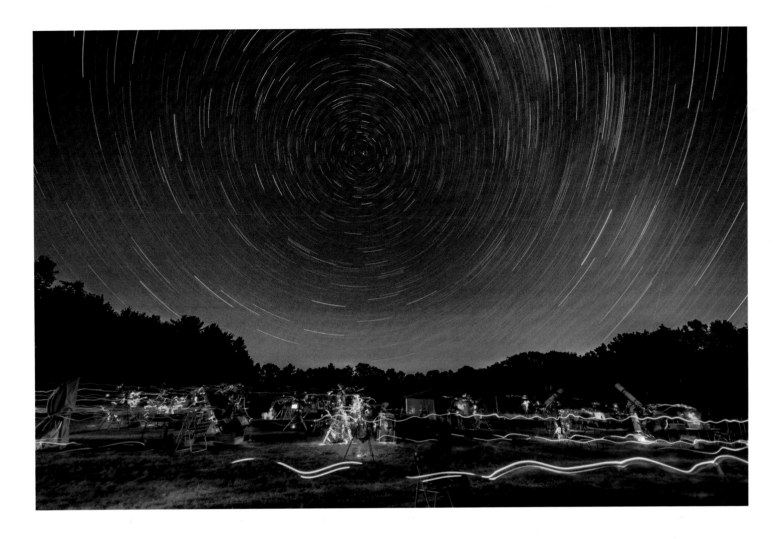

BASIC EQUIPMENT

Thanks to the rapidly developing technology of digital SLR cameras, starting nightscape photography is now far easier than it was in the days of analog photography, when most TWAN photographers began their careers.

Still, it is essential to have some knowledge of the night sky and practical astronomy in order to be 'in the right place, at the right time'. Planning is based on ideal weather and moonlight conditions, but factors such as geographic location, altitude and temperature, local topography and light pollution should be considered, too.

Compared to telescopic astrophotography, nightscape imaging is a low-gear endeavour; you don't need a vast array of high-tech equipment. A single camera with a fast, wide-angle lens, a tripod and a shutter-release cable are enough to get you started.

Keeping your equipment as compact as possible will also help you tackle the real challenge, which is getting to the right location. However it is very important that your tripod is sturdy and reliable enough for long exposures and windy nights. A proper ball head that can handle the camera load is far easier to use at night than a classic tripod head. A popular option for the frequent traveller is a carbon-fibre tripod, versions of which can be just as steady in wind as heavier aluminium models. An easy solution for making the system even more steady is to fill a bag with rocks or sand and hang it from the centre of the tripod.

CAMERA SETTINGS

The camera settings for many of the images in this book fall within the range of the 'golden numbers' of nightscape photography:

· exposures of 10 to 20 seconds
· ISO of 1600–6400
· lens aperture of f2–2.8.

We are bound to these due to the Earth's rotation (sky motion) as well as the physical limits of lens design and digital sensor technology. This type of photography requires cameras suitable for lowlight imaging with low noise performance in high ISOs – the highest practical ISO (6400 for many cameras) is necessary for when the night environment is very dark.

In moonlight or near cities you can create higher-quality images by reducing the ISO to 1600 or less. High ISO imaging, although sometimes essential at night, results in more noise, fewer colours and less dynamic range.

It is very important to capture all images in 'raw' format (plus an optional JPEG for quicker preview). Saving original files in a compressed-JPEG format alone will eliminate post-processing capabilities to enhance the image, to reduce the noise, to easily correct the white balance and to recover shadows and highlights. Image processing is an important part of nightscape photography, since these images are technically challenging.

EXPOSURE

When photographing the night sky, you need to take the movement of the stars and planets into consideration.

The apparent speed of a star's motion depends on how much your camera lens magnifies the view – the longer the focal length the faster the speed of the star, and the less time available to capture a pinpoint image.

For an average-resolution digital camera a simple equation known as the '300 rule' will give you the maximum exposure to use in order to avoid star trails: you simply divide 300 by the focal length of your lens (300/F). The result will give you the length of exposure you need, in seconds. For example, with a super-wide-angle 14 mm lens, ideal for wide views of the Milky Way, the maximum exposure is 300/14 – around 20 seconds before you will capture notable motion in the stars. If the camera is not a full frame, with a smaller crop sensor, the F should be multiplied by the crop factor of the sensor. On many models the crop factor is about 1.5x, but it is best to identify this on the camera sensor specification.

If your field of view is far from the celestial equator (either to the north or south) you can further increase the exposure. For instance midway between the equator and Polaris, you can exceed the exposure to 40 per cent and up to 70 per cent for the Big Dipper near the pole (or for the Crux and the Magellanic Clouds in the southern sky). Using this simple '300 rule' equation it's evident that, when using telephoto lenses, only a very short exposure is possible before you start to see star trails. That's why more nightscape photographs are taken using wide-angle lenses between 14 mm and 35 mm (10 and 24 mm for crop sensor cameras). The exposure limit for an 85 mm lens is only four seconds, for example, unless a portable star tracker device is used on top of the tripod. This cancels Earth's rotation by following the stars during the exposure, although the foreground will become blurry if the exposure is too long.

Since your goal is to collect as much light as possible during a short exposure, you should aim for fast optics. A lens with a larger maximum aperture (smaller minimum F-number) delivers more light intensity and reduces the needed exposure. The fastest lenses are usually prime, with fixed focal lengths. Most long-range zoom lenses are not desirable for low-light photography. For instance 18–200 mm or 24–105 mm f4 are very handy in daytime but too slow at night. The fast f1.4 prime lenses are some of the most popular among nightscape photographers, as well as short-range f2.8 zooms such as 14–24 mm or 16–35 mm.

POST-PRODUCTION

After an imaging session, the main challenge is how to create a natural-looking image.

While the natural daytime colours are evident, most photographers are not familiar with the natural colours of the night sky. They often shift the white balance or apply saturation in extreme ways as a result.

The natural colours of the Milky Way and the night sky are best preserved in a white balance range of 4000–5000 Kelvin. Much lower (colder) white balance results in a blue Milky Way, whereas it should be pale yellow (especially towards the galactic bulge). You should also try to avoid the habit of 'over-cooked' processing, in which the colours can become saturated, for example. In nightscape imaging, it is essential to preserve the originality of the scene.

Composite images, made using different lenses and a montage of daytime and night-time frames have their own value in art, but are not usually recognized as nature documentary photographs.

TAKING CARE

It's important to reduce the risks involved with night-time photography.

· Always inform others about your intended location and avoid shooting alone in remote locations.

· Being in a small team of two or three is the most pleasant way to experience night-time photography.

· If in larger groups, plan around such potential issues as having too many tripods, similar image results and moving flashlights in your photos.

· Always arrive at a location before sunset. This will allow you to become familiar with the environment and to identify potential obstacles around you.

· Always consider unpredictable issues regarding accessibility, wildlife, access restrictions and reactions from locals to your after-dark presence in their neighbourhood. Such risks are reduced when a photographer arrives on site earlier in the day.

PICTURE CREDITS

AUTHOR BIO

The World at Night founder and leader, Babak Tafreshi is an award-winning photographer working with *National Geographic, Sky & Telescope* magazine and the European Southern Observatory (ESO). Babak is also a freelance science journalist and astronomy communicator using all media. Born in 1978 in Tehran, he is based in Boston, United States, but could be anywhere on the planet, from the Sahara to the Himalayas or Antarctica. He is a board member of *Astronomers Without Borders*, an international organization designed to bridge between cultures and connect people around the world through their common interest in astronomy. He received the 2009 Lennart Nilsson Award, the world's most recognized award for scientific photography, for his global contribution to night sky photography. Since TWAN was designated as the first Special Project of the International Year of Astronomy 2009, Tafreshi cooperated with the International Astronomical Union and UNESCO as a project coordinator for IYA2009.

As a science journalist he has contributed to many television and radio programmes on astronomy and has interviewed world-renowned astronomers and space scientists. When living in Iran he was editor of the Persian astronomy magazine *Nojum* for a decade and has been a board member of the Astronomical Society of Iran's outreach committee where he directed many national astronomy events.

Babak started photographing the night sky above natural landscapes and historic architecture in the early 1990s, when he was a teenager. He has always been fascinated by the universality of the night sky; the same sky appearing above different landmarks of the world. He connects with the world-wide astronomy community through science journalism and his presentations and educational workshops. Photography, science stories and eclipse-chasing have taken him to all of the continents.

Cover, 2, 4 (centre, right), 5 (left, centre, right), 14-5, 16, 18 (bottom), 21, 27, 31, 32, 40 (bottom right), 48, 50-1 (top, bottom), 58-9, 60-1, 102-3 (bottom), 106, 109, 116-7 (bottom), 119 (right), 122-3 (top), 125, 159, 162, 172, 184-5, 188, 228 (left), 235

babaktafreshi.com @babaktafreshi

ACKNOWLEDGEMENTS

This book would not have been possible to produce without the support of my wife Shadi Hamedi, for understanding my dedication to the stars and long nights at the computer, and of my family, who have embraced the eccentric lifestyle of a night sky explorer. This collective work came to existence with the contribution of *The World at Night* members across the world; each introduced in the Photographers section.

TWAN project and our international group came together in 2007 with the support of the *Astronomers Without Borders* organization (astrowb.org), which became possible under the leadership of Mike Simmons. Most of the *TWAN* team has been inspired by the work of scientist astrophotographer David Malin, who has contributed to *TWAN* since the beginning as an advisor and was kind enough to write the book's foreword. Another source of inspiration to the team has been the pioneer Japanese nightscape photographer Akira Fujii who has contributed to this book with an image of Great Comet McNaught (page 132).

TWAN's main long-term way of reaching the public is website twanight.org, with thousands of captioned images. Since the beginning, webmaster and science journalist Shahob Saqri has been the dedicated power behind the website. Our other main source of public reach has been the Astronomy Picture of the Day (APOD), a long-running highly respected NASA webpage since 1995 (apod.nasa.gov). TWAN photos have been featured more than 300 times on this most visited astronomy page on the web. Astronomer and the APOD co-editor Jerry Bonnell supported TWAN as an advisor for many years. A few of the captions in this book are based on the fantastic text provided by APOD for the TWAN images.

I also appreciate my partner organizations who paved the way for a career that allowed me to dedicate time to the non-profit activities of TWAN for more than a decade: The European Southern Observatory (ESO) and specifically Lars Lindberg Christensen, the International Astronomical Union (IAU), specifically Pedro Russo, UNESCO, and *Sky & Telescope* magazine. *National Geographic,* which has been a constant source of inspiration to me since childhood, have published many TWAN images on their website since the launch of the project. Since 2012 I have been a photographer for *NatGeo* which helped immensely to start new ideas and share the messages of TWAN with the world-wide audience.

In the last two chapters of the book I have referred to the International Dark Sky Association (IDA). Without them some of our effort would become aimless. This non-profit organisation has been an essential element in allowing our images to communicate with the public about the importance of preserving natural night skies.

Mazandaran IRAN

A crystal clear winter night in the Alborz Mountains is captured in this star trail image. The setting moon shines on the mountains and the Haraz Road which connects Tehran to the Caspian Sea. Car trails are cut off by a tunnel. This image is made from a sequence of successive frames during several hours.

First published in 2019 by White Lion Publishing,
an imprint of The Quarto Group.
The Old Brewery, 6 Blundell Street
London, N7 9BH,
United Kingdom

T (0)20 7700 6700
www.QuartoKnows.com

A catalogue record for this book is available from the British Library.

ISBN 978 1 78131 913 0
Ebook ISBN 978 1 78131 914 7

10 9 8 7 6 5 4 3 2 1

Commissioning Editor Lucy Warburton
Project Editor Emma Harverson
Designer Isabel Eeles

This book has been composed in Avenir and Letter Gothic

Printed in China